PRISONS
ON U.S. TV

Sut Jhally & Justin Lewis
General Editors

Vol. 10

PETER LANG
New York • Washington, D.C./Baltimore • Bern
Frankfurt am Main • Berlin • Brussels • Vienna • Oxford

BILL YOUSMAN

PRIME TIME
PRISONS
ON U.S. TV

REPRESENTATION
OF INCARCERATION

PETER LANG
New York • Washington, D.C./Baltimore • Bern
Frankfurt am Main • Berlin • Brussels • Vienna • Oxford

Library of Congress Cataloging-in-Publication Data

Yousman, Bill.
Prime time prisons on U.S. TV: representation of incarceration / Bill Yousman.
p. cm. — (Media and culture; v. 10)
Includes bibliographical references and index.
1. Prisons—United States. 2. Prisons in mass media. I. Title.
HV9469.Y68 791.45'6556—dc22 2009011330
ISBN 978-1-4331-0476-3 (hardcover)
ISBN 978-1-4331-0477-0 (paperback)
ISSN 1098-4208

Bibliographic information published by **Die Deutsche Bibliothek**.
Die Deutsche Bibliothek lists this publication in the "Deutsche
Nationalbibliografie"; detailed bibliographic data is available
on the Internet at http://dnb.ddb.de/.

Portions of this work first appeared in a highly revised form
in *Communication and Critical/Cultural Studies*,
© 2009, National Communication Association

The paper in this book meets the guidelines for permanence and durability
of the Committee on Production Guidelines for Book Longevity
of the Council of Library Resources.

© 2009 Peter Lang Publishing, Inc., New York
29 Broadway, 18th floor, New York, NY 10006
www.peterlang.com

Printed in the United States of America

CONTENTS

ACKNOWLEDGMENTS

There are so many people to thank that these acknowledgments could begin to rival the length of the book if I don't rein myself in. But here is a partial list:

First and foremost I have to express my sincere gratitude to my dissertation committee at UMASS-Amherst: Michael Morgan, Sut Jhally, and Ernie Allen. Michael and Sut from the Department of Communication were particularly indispensable and I don't think they will ever know how much of an inspiration to me they really are. Their generosity and spirit are truly remarkable.

For various types of research assistance I would like to thank Dave Hyndman, Paul Lewis, Alice Schoenrock, Roger Desmond, Ryan S. King of The Sentencing Project, the reliable people at the Vanderbilt Television Archives, and the remarkable staff of an organization that has to remain anonymous.

The production of this book would have been much more painful if it weren't for the great support of two devoted and like-minded souls—Jack Banks and Lori Bindig. Thanks also to Lonni, Deb (Sunflower), Max, Mike, Jane, and Adele.

I also need to express my deepest thanks to the anonymous individuals who talked to me with great candor about deeply personal issues. My heart goes out to all of you.

Rachel, Nathan, and Kayla—you will never know how much I love you, the hopes I have for you, or how much better you make my life.

This book is dedicated to the more than two million citizens trying to survive each day inside America's prisons and jails... And to my father—Morris Yousman (1911-2002). I would never have cared if it weren't for your example.

CHAPTER I

Introduction
Incarceration in the U.S.

By the beginning of the twenty-first century over two million American citizens were incarcerated in the nation's prisons and jails. Another five million plus were on probation or parole. However, despite these startling numbers most Americans do not experience incarceration directly. Thus, media representations play a key role in influencing our perceptions of prisons and those who inhabit them. Many years ago, Lippmann (1922) argued that the mass media create a "pseudo-environment" in people's minds. In this pseudo-environment viewers, listeners, and readers come to believe that they possess intimate knowledge about places, people, and events, which they may have never experienced. Drawing on Lippmann's contention, and eighty decades of subsequent research on the impact of media stories and images on our perceptions of the world, in the pages that follow I will argue that because many of us have little personal experience with incarceration our primary source of information (or misinformation) about this "backstage" area of our society (see Goffman, 1959) is cultural products such as television programs and films. Research has previously established that the vast majority of U.S. citizens form their impressions of crime and the criminal justice system based on what they hear, read, and see in the media (Graber, 1980; McNeely, 1995). This may be particularly true for our impressions of prison since it is the most alien facet of the criminal justice process for most individuals. As Cheatwood argues, "Most people in the general public have formed their images of what prison life is 'actually' like from the mass media" (1998, p. 209). This information, images, and ideas then may become the basis for public opinion on issues related to criminal sentencing and incarceration.

In regard to the massive build-up of the prison industrial complex during the late twentieth and early twenty-first centuries, Angela Davis writes:

> Why was there no great outcry? Why was there such an obvious level of comfort with the prospect of many new prisons? A partial answer to this question has to do with the way we consume media images of the prison, even as the realities of imprisonment are hidden from almost all who have not had the misfortune of doing time.... The long-running HBO program *Oz* has managed to persuade many viewers that they know exactly what goes on in male maximum-security prisons. But even those who do not consciously decide to watch a documentary or dramatic program on the topic of prisons inevitably consume prison images,

whether they chose to or not, by the simple fact of watching movies or TV. It is virtually impossible to avoid consuming images of prison (2003, pp. 17-18).

Davis goes on to cite her interviews with women in Cuban prisons where most of the women she talked to said that their prior knowledge of prison life came from Hollywood films.

Because the United States has experienced an explosion in the rate of imprisonment unlike any in history (Chriss, 2007; Davis, 2003; Irwin, 2005; Mauer, 1999), dissecting and analyzing the representations that are at the heart of the popular imagination about prisons and prisoners is essential to developing an understanding of the current era of "incarcerate first, ask questions later." Dyer argues that:

> The only way that the war on crime can maintain its political appeal to the targeted electorate is if it continues to be masked in the illusion that it is being waged primarily against the violent criminals whose actions are greatly exaggerated by their sensationalized depiction on TV and in the movies (2000, p. 194).

Or, as Ferrell and Sanders succinctly put it: "[M]aking sense of crime and criminalization means paying close attention to culture" (1995, p. 7). Only after coming to understand the nature of popular culture images of prisons and prisoners can we then start to analyze the links between images, opinions, and policy, and begin to call popular notions into question while pointing toward alternatives.

While there has been a tremendous amount of research on crime, violence, and the media, a scant amount of it deals specifically with the representation of the prison industries by the media industries. Surette writes that, "An area long ignored and still understudied, is the portrait of corrections found in the popular culture" (1998a, p. xxi). Likewise, Cheatwood notes:

> Little previous literature about the relationship of mass media and the correctional system exists. Almost no one has considered the effect of media presentations of prison life on the public's perception of corrections, or the related process by which general public attitudes toward corrections become crystallized through the influence of these presentations (1998, p. 210).

Incarceration Nation

While various sources offer somewhat different statistics (based on what time frames are used, what institutions are examined, who is counted as an inmate, etc.), there is no question that, during the latter part of the twentieth century, the prison population in the United States rose to unprecedented and previously unimaginable levels

(Chriss, 2007; Davis, 2003; Dyer, 2000; Irwin, 2005). According to the U.S. Bureau of Justice Statistics, the number of Americans incarcerated quadrupled during the last twenty years of the century. In 2007, the combined population of state and federal prisons and local jails was over 2.3 million men, women and children. In 1985 that number stood at about 500,000 and even this figure represented a huge increase over previous decades (Mauer, 1999). According to Dyer (2000) the U.S. prison population at the end of the century was ten times greater than it was in 1970 and the U.S. was imprisoning a greater proportion of its population than any other nation on the planet.

Subsequent to the terrorist attacks of September 2001, the United States also globalized its prison industry, incarcerating so-called enemy combatants and suspected terrorists in Abu Ghraib in Iraq, Guantánamo Bay in Cuba, and in secret prisons throughout the world. As Hersh wrote about the U.S. transformation of Saddam Hussein's former prison, Abu Ghraib, into a U.S. military prison:

> Most of the prisoners, however—by the fall there were several thousand, including women and teen-agers—were civilians, many of whom had been picked up in random military sweeps and at highway checkpoints. They fell into three loosely defined categories: common criminals; security detainees suspected of "crimes against the coalition"; and a small number of suspected "high-value" leaders of the insurgency against the coalition forces (2004, p. 42.)

News of severely abusive treatment of inmates in Abu Ghraib was exposed to the world in 2004 when photographs of American military personnel torturing and humiliating their captives were leaked to the press. Prisoners at Guantánamo Bay have also been subjected to physical and psychological torture and subjected to other forms of inhumane treatment as a supposed intervention in the "War on Terror" (Klein, 2007).

While some outrage was initially expressed over these abuses, never mentioned in media reports of the nightmares at Abu Ghraib and Guantánamo Bay were the deep connections to domestic patterns of incarceration. Hartnett and Stengrim (2006) point out that many of the perpetrators of abuse in Abu Ghraib formerly worked in U.S. prisons where they learned how to abuse and humiliate inmates, and that much of the torture and maltreatment inflicted on prisoners of the U.S. military echoes human rights violations in U.S. prisons. As Angela Davis notes:

> These abusive practices cannot be dismissed as anomalies. They emanate from techniques of punishment deeply embedded in the history of the institution of the prison. While I know that it may be difficult for many people to accept the fact that similar forms of repression can be discovered inside U.S. domestic prisons, it is important not to fixate on these tortures as freakish irregularities (2005, pp. 49-50).

In fact, long before Abu Ghraib and Guantánamo Bay, U.S. corrections officers routinely tortured and ridiculed inmates in domestic prisons and even took photographs to document their abusive treatment "for fun" (see Parenti, 1999). Regarding this bizarre notion of entertainment, Hartnett and Stengrim quote Sontag who indirectly implicates trends in U.S. media when she writes: "It is hard to measure the increasing acceptance of brutality in American life, but its evidence is everywhere.... America has become a country in which the fantasies and the practices of violence are seen as good entertainment and fun" (2004, p. 29).

Immediately after taking office in 2009, Barack Obama offered official repudiation of the abusive practices of the Bush administration when he signed an executive order mandating the closing of the prison at Guantánamo Bay. He also indicated that his administration would not tolerate the torture of detainees, including the practice of waterboarding, which the previous administration had refused to acknowledge as torture. Yet, Obama's orders left a number of disturbing loopholes open and they stopped short of forbidding all harsh treatment of inmates. As the *New York Times* reported:

> But the orders leave unresolved complex questions surrounding the closing of the Guantánamo prison, including whether, where and how many of the detainees are to be prosecuted. They could also allow Mr. Obama to reinstate the C.I.A.'s detention and interrogation operations in the future, by presidential order, as some have argued would be appropriate if Osama Bin Laden or another top-level leader of Al Qaeda were captured (Mazzetti and Glaberson, 2009, p. A1).

Still, these are important developments. But it is also crucial to note that they do not portend any change in domestic prison conditions or in the rampant incarceration of American citizens. In fact, many of the prisoners in Guantánamo Bay will most likely be transferred to domestic prison facilities where they may still be subject to inhumane treatment.

It is also important to recognize that overseas military prisons and domestic prisons in the U.S. share ideologies, personnel, strategies of repression, and technologies to such an extent that Davis has called them "symbiotic" (2005, p. 124). And just as the military-industrial complex, and more recently Homeland Security, have become vital aspects of the U.S. economy, the prison-industrial complex has also established itself as a powerful economic entity.

Incarceration Economics

Davis defines the prison-industrial complex in this way:

> The prison-industrial-complex embraces a vast set of institutions from the obvious ones, such as the prisons and the various places of incarceration such as jails, "jails in Indian country," immigrant detention centers, and military prisons to corporations that profit from prison labor or from the sales of products that enable imprisonment, media, other government agencies, etc. Ideologies play a central role in consolidating the prison-industrial-complex—for example the marketing of the idea that prisons are necessary to democracy and that they are a major component of the solution to social problems (2005, p. 69).

During the latter part of the twentieth century spending on state prisons alone more than doubled, from less than $13 billion in 1985 to more than $27 billion in 1996. More than $150 billion is spent every year on the criminal justice system as a whole (Baum, 2000; Cose, 2000; Dyer, 2000; Mauer, 1999). These huge expenditures on projects such as prison construction inevitably come at the expense of other social programs. As more and more emphasis is placed on incarceration as the solution to a non-existent "rising crime" problem (Chambliss, 1999), other needs get pushed lower on the priority list. For example, the Governor of Virginia admitted that state plans to build twenty-five new prisons would have to take funds from public park programs and from the educational budget. In Connecticut, school budgets were reduced in order to accommodate hundreds of millions of dollars in spending on new prison facilities (Dyer, 2000). The same was true across the nation, and elementary and higher education, as well as other social programs, were both affected: "As virtually every state has increased its share of tax dollars devoted to corrections, funding for higher education has either declined or failed to keep pace with need" (Mauer, 1999, p. 180).

Furthermore, state budgets are not the only ones affected. Mauer (1999) reports that federal budgets for employment and training programs were cut by nearly 50% during the Reagan and Bush administrations of the 1980s and early 90s while spending on corrections increased 521%. This trend was actually exacerbated during the supposedly liberal Clinton administration. Clinton adopted much of the "tough on crime" rhetoric that had been traditionally associated with the Republican Party and made it his own. Just one year after Congress refused to pass a $30 billion economic package designed to provide jobs and development for poverty-stricken areas, the 1994 crime bill was passed. Clinton quickly signed off on this bill, which included a $30 billion commitment to the criminal justice system. $8 billion was set aside specifically for the construction of new prisons. Financial incentives for states that made their penalty structures more severe were introduced, as were sixty new death penalty offenses, "three strikes" mandatory lifetime sentences, and other measures, especially the so-called "war on drugs," all of which contributed to the prison population explosion (Chriss, 2007; Irwin, 2005; Mauer, 1999).

Dyer also notes the increasing influence of paid consultants to politicians and candidates (who rely heavily on public opinion polls that suggest that "tough on crime" rhetoric is the way to get elected) and the "emergence of an organized prison-industrial complex" (2000, p. 3) made up of corporations whose financial fortunes are dependent on the growth of the prison population. Dyer refers to this state of affairs as the "perpetual prisoner machine" because of the increasingly central place of the prison industry in the U.S. economy (2000, p. 3). As an example of this consider that the corrections industry has more full-time employees than any Fortune 500 corporation with the sole exception of General Motors (Parenti, 1999). Furthermore, many stockholders are invested in corporations that have ties to the prison industry and thus rely on an ever expanding prison population in order to continue generating profits (Dyer, 2000). Many companies are also dependent on prisoners as a source of cheap labor (Parenti, 1999). And all of this doesn't even take into account the latest trend of private, for-profit prisons run by companies like Wackenhut Corrections on whom states are increasingly relying to help them deal with the burden of overcrowded institutions (see Dyer, 2000; Parenti, 1999).

All of these trends were justified by the need to respond to what was really a non-existent violent crime wave.

Media and Fear of Crime

In actuality, crime was not on the increase during the latter part of the twentieth century. In fact, it was declining (Chambliss, 1999; Chriss, 2007; Mauer, 1999). However, public opinion polls demonstrated that many believed that we were facing unprecedented levels of violent crime in our society. Much of this misperception may be attributed to the saturation of violence in films and television programs and the emphasis on crime coverage in the news media (Chambliss, 1999; Dyer, 2000; Mauer, 1999). Gerbner, referring to years of research conducted under the auspices of his Cultural Indicators project, has noted that:

> Our surveys show that heavy viewers [of television] express a greater sense of apprehension and vulnerability than do light viewers in the same [demographic] groups. Heavy viewers are more likely than comparable groups of light viewers to overestimate their chances of involvement in violence; to believe that their neighborhoods are unsafe; to state that fear of crime is a very serious personal problem; and to assume that crime is rising, regardless of the facts of the case. Heavy viewers are also more likely to buy new locks, watchdogs, and guns for 'protection'.... Insecure, angry, mistrustful people may be prone to violence but are even more likely to be dependent on authority and susceptible to deceptively simple, strong, hard-line postures and appeals (1999, p. 16).

Dyer (2000) believes that media influence on public perceptions of crime is a key factor in the prison population explosion. But despite the focus on violent crime in both entertainment and news media, most of those who are being sentenced to prison in ever increasing numbers are not violent felons. Media attention is often devoted to so-called "superpredators"—out-of-control, violent youth who engage in binges of "wilding," mugging, murder, rape and mayhem. However, in a typical year:

> [O]nly 29% of all prison admissions were for "violent offenses" such as rape, murder, kidnapping, robbery and assault; while 31% of all entrants were jailed for "property offenses" such as fraud, burglary, auto theft, and larceny; 30% were "admitted" for "drug offenses" including possession and trafficking; and almost 9% were imprisoned for "public order offenses" such as weapons possession and drunk driving (Parenti, 1999, p.167).

Race and Class in the Criminal Justice System

Furthermore, the imprisonment binge has had a differential impact on various subgroups in U.S. society. While some wealthy Americans have actually benefited from their investments in prison-related industries, the poor and the working class, and Latinos and African Americans in particular, are severely overrepresented in the U.S. prison population (Cole, 1999; Davis, 2003; Irwin, 2005; Dyer, 2000; Mauer, 1999). Cole notes that, "The vast majority of those behind bars are poor; 40% of state prisoners can't even read; and 67% of prison inmates did not have full-time employment when they were arrested" (1999, p. 4). Thirty-three percent of prisoners were unemployed at the time of their arrest and 32% earned less than $5,000 a year (Dyer, 2000).

About 50% of all inmates are African American (Davis, 2003; Cole, 1999; Irwin, 2005; Mauer, 1999). The incarceration rate for African Americans is more than seven times higher than that for whites (Cole, 1999). These figures are ripe for misinterpretation and have been articulated to various ideological positions. Several legal scholars, however, have presented evidence that the racial disproportions of the U.S. criminal justice system cannot be explained by the pseudo-biological argument that whites are more law abiding. Rather, these disparities are due to imbalances that are pervasive in the U.S. economic and legal systems, ranging from inequities in wealth and opportunity to double standards in policing, adjudicating, and sentencing (see, for example, Cole, 2000; Parenti, 1999; and Reiman, 2001).

For example, the non-profit group Common Sense for Drug Policy (CSDP) reports that, contrary to many media images, white youth are more likely to both use and sell illegal drugs, but black youth are more likely to be incarcerated for drug crimes. Analyzing data from government sources such as the Centers for Disease

Control and Prevention and the U.S. Department of Justice Bureau of Statistics, CSDP discovered that while 42% of whites and 37.7% of blacks will use illegal drugs during their lifetime, only 37% of felony drug defendants in state courts are white, compared to 61% who are black. Of these defendants, 27% of whites are sentenced to prison while 43% of blacks receive prison sentences.

Putting this another way, survey research suggests that the users of illegal drugs are 76% white, 14% black and 8% Latino. Blacks, however, represent 35% of those arrested for drugs, 55% of those convicted on drug charges, and 74% of those sentenced (data from the U.S. Public Health Service 1992 survey, reported in Cole, 1999). Thus, at every stage of the criminal justice process, people of color receive increasingly more severe treatment than whites. The National Criminal Justice Commission refers to this as the "cumulative effect of racial discrimination on the criminal justice process" (Donziger, 1996, p. 108.). This organization also reports that African Americans and Latinos are more likely than whites to be arrested without cause. Meanwhile, whites are more likely to be released from jail prior to appearing before a judge or jury, and they receive lower bail assessments and more favorable plea-bargain arrangements from the courts (Donziger, 1996).

Despite these realities, there is little discussion in mainstream media of the race and class-based disparities in U.S. prisons and jails. Dyer notes that, "The media and our elected officials rarely discuss the inequalities between rich and poor within our justice system" (2000, p. 175). Cole asks us to consider whether this would be the case if the racial breakdown was different:

> [I]magine the public response if the current racial disparities in criminal justice were reversed. Imagine what kind of pressure legislators would feel, for example, if one in three young *white* men were in prison or on probation or parole. Imagine what the politics of the death penalty would look like if prosecutors sought the death penalty 70% of the time when whites killed blacks, but only 19% of the time when blacks killed whites (1999, p. 151).

The reverse of the figures Cole asks us to imagine provides a real picture of criminal sentencing in the U.S. In the absence of such contextual information, repeated images of violent black prisoners suggest that blacks are more dangerous, more criminal, more in need of institutional control than whites.

In the following pages I will examine both television dramas and news. One significant difference that emerged from my analysis of these genres is a disparity in how visible/invisible prisoners and the inner depths of the nation's prisons are in television news and drama.

The News/Entertainment Gap

Turning to the electronic news media first, despite the increasingly central role that the prison industry plays in the American economy and the increasingly powerful impact that it has on the lives of many Americans, particularly poor, working-class, and non-white Americans, the world of prison is still generally a "backstage" area, at least when it comes to Americans' main source of news—television. Using theatrical metaphors, Goffman (1959) wrote about communication in daily life as a performance. Just as in a theatrical performance, he suggested, there are frontstage areas of life where behavior and activity is on display for any potential audience, and backstage areas where the preparations for the performance occur, where activities are conducted in secret, not meant for public viewing. Adopting Goffman's terms, Surette (1998b) has suggested that the rise of electronic visual media has transformed many aspects of crime and criminal justice, which historically have been backstage activities, into frontstage activities (see also, Meyrowitz, 1985). However, while this may be true of some aspects of the criminal justice system, prisons and jails remain largely hidden, secretive areas when it comes to mainstream news coverage.

Chermak (1998) found that in his sample of print and television news stories dealing with the criminal justice system, only 17% were devoted to corrections, while 38% covered police activities and 45% dealt with the courts. Even this 17% figure is generous when it comes to the issue of media coverage of prisons because Chermak included stories about parole and probation in his count of corrections-oriented news items. Television news has long devoted substantial amounts of time and resources to the coverage of isolated incidents of crime. Studies reveal that as much as 43% of local news is devoted to violent content (Dyer, 2000). Despite this media obsession with crime and violence, once criminals are apprehended and convicted they tend to disappear into the system and are not heard from again, except in the case of relatively rare exceptions such as executions of "celebrity" inmates, or, even rarer, prison escapes.

While high-profile incidents such as these do receive some coverage, Shapiro (2000) has argued that mainstream media coverage of the conditions that America's two million plus prisoners live in is woefully inadequate. For example, since the Attica uprising almost forty years ago, the mainstream press has avoided covering prison rebellions and the inhumane living conditions that contribute to them, out of fear that such coverage could spark sympathy actions in prisons across the country. According to Shapiro, "significant disturbances" and politically motivated protests that occur in prisons usually go unreported. Simultaneously, however, prison life and prisoners are frequently the focus of fictional narratives in both television and film.

Films such as *Natural Born Killers, The Shawshank Redemption, The Green Mile,* and *Con Air* have been some of the most successful Hollywood products of the last decade. On television, prisoners are frequently seen in many of the most popular crime dramas such as *Law & Order.* HBO offered a serial drama set entirely in a fictional maximum-security prison, *Oz,* and Fox has the successful yet entirely fanciful *Prison Break.* This lack of documentation of prison life in the supposedly factual news media and the abundance of fictional representations available to viewers leads to questions about the distortions that may result from this imbalance of images.

Of course, this is not to suggest that news coverage itself does not offer its own set of distortions, as the "Willie" Horton case explored in some detail below makes clear. Yet, true investigative journalism that demanded entry into the nation's prisons, provided viewers with relevant information about the workings of the prison industry, and allowed inmates to have access to airtime, might at least raise questions about who America's two million prisoners are and what their daily life is really like. In the absence of this type of investigation viewers are left with the images and stories provided by the entertainment industries.

Public attitudes often have important policy implications, thus it is crucial to investigate how media representations of prisons and prisoners contribute to the public discourse on crime and punishment—a discourse that can shape public policy on issues such as funding for prison construction, the use of restrictive programs such as "three strikes" mandatory sentencing, and the refusal to consider alternatives to traditional punitive responses to crime. There is perhaps no better example of this relationship between media images of prisoners and public opinion on crime and corrections than the 1988 "Willie" Horton case.

The "Willie" Horton Fiasco: A Foundational Example

It is quite possible that the key figure in the 1988 run for the presidency was neither of the leading candidates, George Bush and Michael Dukakis, but a Massachusetts inmate, William Horton, better known as "Willie."[1] The political advertisement, "Weekend Passes," that the National Security Political Action Committee (NSPAC) created for their group Americans for Bush, has become legendary in the history of political advertising.

[1] Jamieson (1993) points out that Horton himself did not go by the name of Willie; this was a name given to him by the National Security Political Action Committee who created the infamous "Weekend Passes" advertisement.

William Horton was an African American inmate who was charged with committing a felony while on furlough from a Massachusetts prison. The Bush campaign utilized this incident to attack the Governor of Massachusetts, Michael Dukakis, who was ahead of George Bush in public opinion polls at the time. The text of "Weekend Passes" reads as follows:

> Bush and Dukakis on crime. Bush supports the death penalty for first-degree murderers. Dukakis not only opposes the death penalty, he allowed first-degree murderers to have weekend passes from prison. One was Willie Horton, who murdered a boy in a robbery, stabbing him nineteen times. Despite a life sentence, Horton received ten weekend passes from prison. Horton fled, kidnapped a young couple, stabbing the man and repeatedly raping his girlfriend. Weekend prison passes. Dukakis on crime.

This text was accompanied by images of Horton being led away in handcuffs and a sinister-looking mug shot. The creator of the advertisement, Larry McCarthy, admitted that these photographs were specifically chosen to make Horton look like "every suburban mother's greatest fear" (quoted in West, 2001). Lee Atwater, George Bush's campaign manager, vowed to make Horton a household name and said that, "[Horton] may end up being Dukakis's running mate" (quoted in Feagin and Vera, 1995, p. 117).

Parenti argues that the rhetoric of the "war on crime," that has been a part of political campaigning since the 1960s, often relied on codes to disguise the racism underlying its message: "Crime meant urban, urban meant black, and the war on crime meant a bulwark against the increasingly political and vocal racial 'other' by the predominately white state" (1999, p. 7). Parenti quotes Nixon Chief of Staff H.R. Haldeman who wrote that Nixon "emphasized that you have to face the fact that the whole problem is really the blacks. The key is to devise a system that recognizes this while not appearing to" (1999, p. 12). Parenti notes that this system became the "war on crime" and a massive financial investment in policing and the prison industry. One of the ways that this system was disguised, as Haldeman admitted it must be, was through the use of coded language. If urban is a code word for black, then suburban, in the context being analyzed here, must be understood as a code word for white. Thus, when McCarthy refers to Horton as "every suburban mother's greatest fear," we must understand both the gender and racial implications of this statement.

Subsequent to the airing of the initial Horton commercial, several other advertisements for George Bush were sponsored by conservative political action committees that reinforced the message that Dukakis was "soft on crime." One commercial featured a man who claimed Horton had attacked him, and another focused on the

sister of the man whom Horton had allegedly murdered.[2] In their respective adver-
tisements these individuals addressed the viewer directly, relating their versions of
what Horton had done and blaming Dukakis' "liberal" policies. A third commercial,
known as the "Revolving Door" ad, featured an image of inmates circulating through
a turnstile. An announcer intoned that Dukakis had a "revolving-door prison policy,"
because he had given furloughs to first-degree murders that were not eligible for pa-
role, and that many of these had committed crimes like kidnapping and rape while
out of prison.

The reach of these advertisements was extended by the quantity of news coverage
they generated. Despite questions about the ethics of these ads that some pundits
raised, the ads were played repeatedly during prime-time national news broadcasts.
Furthermore, most news media coverage did not question the veracity of the adver-
tisements' claims, focusing instead on the political gamesmanship behind them
(Simons, 2001). Jamieson's (1992) research reveals that many viewers did not distin-
guish between news coverage of the ads and the ads themselves, resulting in the news
media replaying of the commercials functioning as free advertising time for the Bush
campaign.

During a November 1988 broadcast NBC president Robert Mulholland made
the following statement on the MacNeil/Lehrer News Hour:

> I think during the campaign the average viewer starts to get a little confused. I'm expecting
> any day now to see Willie Horton endorse a line of jeans.... Some of the ads start to look like
> news stories, they're the same length, thirty seconds. Television is not just separated in the
> minds of the viewer between this is news, this is commercial, and this is entertainment. Some-
> times it all gets fuzzed up because it all comes into the home through the same little piece of
> glass (quoted in Jamieson, 1992, pp. 22-23).

Furthermore, much of the news analysis and discussion of the crime policies of
the candidates echoed the commercial. For example, on the CBS Evening News
broadcast of October 26, 1988, Dan Rather asked Dukakis' running mate, Lloyd
Bentsen, "Can't a person, or can a person, be deeply concerned about revolving-door
justice and laxity toward criminals, even when the criminal happens to be someone
who is black, and still not be a racist?" (quoted in Jamieson, 1992, p. 131).

Jamieson (1993) argues that the mainstream media tended to adopt the language
of the Bush campaign when discussing the Horton case, relying on terms such as
"slashed," "brutally," "terrorized," and "tortured" when describing the incident. She

[2] Jamieson (1992) points out that all the prosecution had established during Horton's original trial was
that he was in the car that was used at the crime scene. Others involved in the crime have said that Hor-
ton remained in the car and was not directly involved in the murder.

uses the term "newsad" to describe news segments that are almost indistinguishable from paid advertising for a particular candidate as in this example from an NBC broadcast from October 28, 1988:

> Ken Bode [NBC reporter]: George Bush was here [California] again today, again talking about crime.
>
> Bush: I believe in safe neighborhoods, and I say I believe it is time for America to take back our streets.
>
> Bode: Like everywhere else, the Democrats have been on the defensive about crime. Willie Horton's victims made a campaign commercial.
>
> Cliff Barnes in ad clip: For twelve hours I was beaten, slashed and terrorized, and my wife Angie was brutally raped.
>
> Bode: But mostly, Bush's tough talk on crime works, because it fits what Californians see on their news each day.
>
> Man: When you have gang murders in the headlines, day after day, I think the voters understand that there is only one candidate in this race who is truly tough on crime. Only one candidate for president who really supports the death penalty (quoted in Jamieson, 1992, p. 133).

News coverage rarely noted that the Horton commercials were both inaccurate and misleading. Jamieson (1992) points out, despite the advertisement's implication that "many" prisoners committed violent crimes while on furlough, Horton was actually the only Massachusetts inmate to do so, and that while 275 furloughed inmates escaped during the previous ten years of the Dukakis administration this number must be put in context. Two hundred sixty-nine inmates escaped while on furlough during the three years that the program was run under the auspices of a Republican governor who had actually initiated the program.

Despite the inaccuracies of the commercials and subsequent media coverage, there is no question that they made on impact on viewers. West (2001) reports that those who had seen the "Revolving Door" commercial were more likely to express the belief that crime and law and order were the most important issues for the nation. During the campaign those who said that Bush was "tough enough on crime" rose from 23% during the summer to 61% in October. Those who believed that Dukakis was not "tough enough" went from 36% to 49% of those polled. The results of this polling data were consistent with anecdotal evidence such as this from Robert MacNeil of the MacNeil/Lehrer News Hour: "Two women voters in Ohio told Judy Woodruff, 'I'm going to vote for George Bush because I can't vote for a man who lets murderers out of jail' " (quoted in Jamieson, 1992, p. 33).

Jamieson argues:

[T]he Republican use of Horton shaped the visual portrayal of crime in network news in ways that reinforced the mistaken assumption that violent crime is disproportionately committed by blacks, disproportionately committed by black perpetrators against white victims, and disproportionately the activity of black males against white females (1992, p. 133).

Horton thus was used as a synecdoche—as a stand-in for prisoners in general. In this manner, Horton came to symbolize a particular conception of prisoners as out-of-control, violent savages who require severe intervention by the state to keep them contained. Additionally, both "Weekend Passes" and "Revolving Doors" claimed that prisons are far too lax in their treatment of inmates. The Bush campaign exploited this by making explicit calls for more severe treatment of the incarcerated.

The William Horton case thus stands as a foundational example of the ways in which media images of prisoners influence public opinion and subsequent public policy. The arguments I present in this book are based on several theoretical perspectives on the powerful role that media culture plays in shaping our perceptions, beliefs, and ideologies. In the next chapter I lay out the major theoretical paradigms that frame my approach to media and ideology. In Chapter Three I survey previous research on media representations of criminals and the criminal justice system. Chapters Four and Five examine local and national television news coverage of incarceration. Chapter Six turns to fictional television portrayals of prisons and prisoners, examining prime-time drama, while Chapter Seven is devoted to an in-depth analysis of the first U.S. television series set inside a prison—the HBO drama, Oz. Throughout Chapters Four to Seven I augment my textual analysis of television words and pictures with insights drawn from a series of interviews I conducted with people who had spent time in U.S. prisons and jails. The personal experiences of these individuals, along with their reactions to television stories about prison life, provide much-needed context to the representations that I deconstruct throughout the book. In the concluding chapter I discuss the political and social implications of the patterns of representation of incarceration prevalent on U.S. television.

CHAPTER II

Media Power and the Social Construction of Fear

In this chapter I offer a brief review of several theoretical positions that ground my empirical study of television's representation of incarceration. The focus of the chapter is on foundational theoretical work that is useful in illuminating the role that the images and stories of media and popular culture play in shaping our perceptions of reality—such as semiotics, narrative theory, cultivation, agenda setting, and the work of British cultural studies scholars on ideology and hegemony.

Media and the Social Construction of Reality

To use the language of Berger and Luckmann (1967), reality is a "social construction." We create and re-create the meaning of our worlds every day, in our interactions with others and through the fundamental processes of communication such as language, nonverbal signing, and visual imagery. However, we also act upon the ideas of reality that we build together as if they are objectively real, even when our notions have little connection to circumstances in the "real" world.

Lippmann (1922) identified the media generated pictures in our heads as an aspect of a "pseudo-environment," but this phrase was not meant to discount the importance of these images. He also pointed out that the actions we take based on these ideas and images occur in the real environment. More recently, Bennett has argued the same point:

> Despite (or perhaps because of) their simplicity and familiarity, news images of the political world can be tragically self-fulfilling. Scary images of distant enemies can promote war or military interventions that in retrospect seem dubious (Vietnam, for example). Failure to report the full extent of real-life atrocities can delay timely actions (underplaying the extent of Nazi genocide and death camps may have delayed U.S. entry in World War II). Dominant political images when acted upon can create a world in their own image—even when such a world did not exist to begin with. Thus, the illusions of news become translated into political realities (2001, p. 22).

The scary images that Bennett refers to do not necessarily have to be images of distant enemies. We might rephrase Bennett's statement to make the point that scary images of domestic enemies can promote a war on crime that, in retrospect, may someday seem dubious. Television and other forms of media bring pictures of people, situations, events, and institutions that we have never encountered into the most

intimate spaces of our everyday existence. We lounge in our family rooms and watch the "lawyers" and "judges" and "defendants" of *Law & Order*. We lay in our warm beds and spy on "inmates" raping, assaulting, and killing one another in a maximum-security prison called *Oz*. While the U.S. prison population has expanded to previously unimaginable levels, most of us will still never have first hand experience of life inside one of America's penal institutions. Therefore what we read in the newspapers and what we see on movie and television screens becomes the primary source of our "knowledge" about who prisoners are and what life in prison is "really" like. Throughout this chapter I focus on a number of key theoretical perspectives on how television shapes viewer's perceptions of the world.

Television and Semiotics

Semiotics is a broad theoretical approach to understanding meaning that is founded in the notion that communication occurs primarily through signs and sign systems. From a semiotic perspective, anything that can be perceived by the human senses can function as a sign—a representation of some meaning. Semiotics draws on the linguistic theories of Saussure (1959) who suggested that a sign is composed of two parts: a signifier (a word, sound, image, smell, etc.) and a signified (the concept evoked by the signifier) and that the relationship between the two is arbitrary; there is no natural or necessary connection, rather it is arrived at by social convention.

Because the relationships between signifiers and signifieds are arbitrary, they must be learned by their interpreters— members of the culture who use these signs. Sign systems function, then, through codes that must be employed in order to determine meaning. Barthes (1977) distinguishes between two levels of meaning— denotative and connotative meaning. Denotative meaning is the direct relationship between the sign and the object or idea it represents. Connotative meaning is that which is found in the associations aroused by the sign. One way of understanding the difference between these levels of meaning is to use Fiske's example of the dual meaning of any photograph: "[d]enotation is *what* is photographed; connotation is *how* it is photographed" (1990, p. 86). Connotative meaning in particular is heavily influenced by cultural and social factors. Seiter points out that: "Connotative meanings land us squarely in the domain of ideology: the worldview (including the model of social relations and their causes) portrayed from a particular position and set of interests in society" (1992, p. 39).

Saussure (1959) also emphasized that signs must be examined in relationship to one another and that it is the difference between signs that defines meaning. Although Derrida (1988) and other post-structuralists have pointed out the limitations

of binary thinking, it is important to consider how often ideology works by establish-ing oppositions between concepts and proceeding as if these oppositions are natural and eternal. The obvious oppositions in media images of prisons and prisoners are the oppositions between law-abiding, peace-loving citizens, and violent, out-of-control criminals; what Douglas (1966) would have labeled a rigid sort of opposition between "purity" and "danger." Thus a mythic conceptualization of "free society" is under girded by placing in opposition images of those who purportedly contribute to the stability of the culture and those who disrupt this stability and must be punished or locked away in order to restore "harmony."

Barthes's (1977) work on what he called the "rhetoric of the image" brought to the forefront these mythic aspects of signs. Barthes believed that myths function, through connotative signs primarily, to make the dominant ideologies in a society appear natural and pre-ordained. Systems of mass media, particularly television and film, are the primary channels by which modern myths are communicated. Drawing on Metz (1974) my analysis of television representations of prisons and prisoners focuses on the five channels that films and television use to communicate meaning: images, written language, and the three elements of the soundtrack—voice, music, and sound effects.

Semiotic analysis cannot provide definite answers to how viewers actually decode television images. However, despite variations in audience interpretations of the meaning of television images, the importance of the storytelling role that the televi-sion industry fulfills must be acknowledged. Thus, I turn to narrative theory, and how it may be applied to television texts, to illustrate this point.

The Power of Narrative

Volosinov's (1973) critique of Saussurean linguistics highlighted issues of power and conflict over the production of meaning through language:

> Volosinov implicitly accepts Saussure's proposition that meaning is produced through semi-otic systems, but rather than seeing this as a natural and neutral process, Volosinov insists that the meanings are always the result of ideological struggles. That is to say, different groups in a culture—groups predicated on notions of, say, class, race, ethnicity, gender, age, profession, or religion—work to try and ensure that 'their' meanings are accepted. Because signs are, in Volosinov's terms, adaptable, carry a history of meaning, and can be used in dif-ferent ways in different contexts, the production of meaning is always open, always a struggle (Schirato and Yell, 2000, p. 26).

In television news and dramatic programming, it is generally not prisoners who con-struct the signs or who are allowed to tell their own stories. Rather, narratives about

prisoners and prisons are constructed and disseminated by a corporate media system that has emerged as the primary storyteller in the U.S. and other developed nations. Gerbner (1999, 2002) notes that the media, television in particular, tell most of the stories in the modern era, but he has also documented the many inaccurate and distorted images and ideas promulgated by the commercial media industries. Gerbner writes:

> For the first time in human history, children are born into homes where mass-produced stories can reach them on the average more than seven hours a day. Most waking hours, and often dreams, are filled with these stories. The stories do not come from their families, schools, churches, neighborhoods, and often not even from their native countries, or, in fact, from anyone with anything relevant to tell. They come from a small group of distant conglomerates with something to sell (2002, p. 13).

This is vitally important because human culture is based in narratives and story telling (Barthes, 1988; Berger, 1997; Fisher, 1987). Fisher says that humans "experience and comprehend life as a series of ongoing narratives, as conflicts, characters, beginnings, middles, and ends" (1987, p. 24). The knowledge, beliefs, and values of a culture are passed from generation to generation in the form of stories.

Stories teach us how to live, what is right and wrong, and who we are in relation to others. Therefore storytellers are extremely powerful pedagogic forces in any society.

This storytelling capacity of the media should not be underestimated. As Kellner writes:

> A media culture has emerged in which images, sounds, and spectacles help produce the fabric of everyday life, dominating leisure time, shaping political views and social behavior, and providing the materials out of which people forge their very identities.... Media culture helps shape the prevalent view of the world and deepest values: it defines what is considered good and bad, positive and negative, moral or evil. Media stories and images provide the symbols, myths, and resources which help constitute a common culture for the majority of individuals in many parts of the world today (1995, p. 1).

Particularly in the case of television, similar messages are delivered over and over again, across fiction and non-fiction, across genres, across drama, comedy, and news, and across advertising and editorial content (Gerbner, Gross, Morgan, and Signorielli, 1994; Shanahan and Morgan, 1999).

The Power of Television Narratives: The Cultivation Perspective

The cultivation perspective on television narratives focuses on this consistency throughout decades of television programming (Gerbner, Gross, Morgan, and Si-

gnorielli, 1994). Gerbner and his colleagues argued that the power of the television message is revealed in the cumulative effects of exposure to consistent messages over a long period of time on aggregate groups of individuals. Thus, cultivation theory does not ask, for example: does exposure to violence on television cause this or that particular individual to behave violently. Instead cultivation researchers ask: how are people's perceptions of the world shaped and influenced by repeated exposure to massive amounts of televised violence year after year? As noted in the discussion of narrative theory above, the power of television may be located in the role that it has assumed as the primary storyteller in modern society (Gerbner, Gross, Morgan, and Signorielli, 1994).

In the modern, industrialized world television has assumed primacy over institutions such as the family, schools, and churches in becoming the major common source of messages about our world. As noted above, most of what we know about the world we do not directly experience ourselves. We spend more time watching television than we do in any other "leisure" activity. The cultivation perspective is not just about the messages of television however. Cultivation also focuses on the institutional structure of the television industry and the consequences of television's primacy in modern day societies. Television is the way it is because it is created within a system where profit and not public interest is the main goal and where only the wealthy and powerful have any control over television content. The interests of the wealthy and powerful in any society are best served by maintaining the status quo. After all, why favor change in a system that is working to one's own benefit? Thus the power of television can be perhaps best be seen in the way that it contributes to the reinforcement of powerful ideologies. Thus, the " effect" of television might be seen not so much in change, as earlier models proposed, but in "no change" or the reinforcing of the status quo. From this point of view, television can be seen as a conservative force that may contribute to the slowing down of progressive social change.

Two examples that reveal this tendency are the attitudes of heavy television viewers on issues that are quite germane to the representation of incarceration on television: attitudes about race and civic equality, and attitudes about crime and criminal justice. Research by Gerbner, Gross, Morgan, and Signorielli (1982) and by Gross (1984), has revealed that heavy viewers, regardless of whether they identify themselves as liberal, moderate, or conservative, tend to converge on attitudes that are less supportive of social programs designed to ameliorate racial inequality, such as busing to achieve school integration, and that these viewers tend to be more intolerant when it comes to opinions about issues such as intermarriage between blacks and whites. In addition, many studies have established that heavy viewers of television are

more likely to perceive themselves as at risk of being a crime victim and are more likely to support severe and restrictive anti-crime measures (Carlson, 1985; Gerbner, 1992; Gerbner and Gross, 1976a, 1976b; Gerbner, Gross, Morgan, and Signorielli, 1980):

> Our ongoing research has found that exposure to violence-laden television cultivates an exaggerated sense of insecurity, mistrust, and anxiety. Heavy viewers buy more guns, locks and watchdogs for protection than comparable groups of light viewers.... The pattern of violence and victimization presents a mean world in which everyone is at risk (but some more than others). Happy endings assure the viewer that although evil and deadly menace lurks around every corner, strong, swift and violent solutions are always available and efficient.... These are highly exploitable sentiments. They contribute to the irresistibility of punitive and vindictive demands and slogans ranging from 'lenient judges' to capital punishment.... They lend themselves to the political appeal of 'wars' on crime, and drugs and terrorists that heighten repression but fail to address root causes (Gerbner, 1992, pp. 102-103).

The cultivation argument is not that television causes these attitudes, but that the stories told by the television industry make a contribution to our culture that is so ubiquitous that it cannot help but interact with a wide variety of other social and cultural factors such as race, gender, class, sexuality, education, etc., as we construct our perceptions of the world and our place in it. As Gerbner (2002) says, the stories that provide meaning to our world are now being told primarily by people who have nothing to tell but a lot to sell. Television in a commercial media system operates primarily to socialize us into the norms and mores of consumer capitalism. As such, television messages about the criminal justice system, the domestic army whose mission it is to protect the interests of the propertied classes, might be reasonably expected to be quite conservative in nature.

Agenda Setting, Framing, and Moral Panics

Another theoretical perspective that engages with the power of the media to shape our perceptions of reality has been labeled agenda setting. The original conception of agenda setting was the notion, attributed to the political scientist Bernard Cohen, that, "the press may not be successful much of the time in telling people what to think, but it is stunningly successful in telling its readers what to think about" (Cohen, 1963, p. 13). In other words, it was presumed that while the media may not be powerful in regard to influencing the positions we take on the major issues of the day, they are very powerful in determining which issues we rate as important. A number of studies involving surveys, experiments and field research lent empirical support to the hypothesis that the media agenda strongly influences the public

agenda (see Brosius and Kepplinger, 1990; Eaton, 1989; Funkhouser, 1973; Iyengar and Kinder, 1987; Mackuen, 1981; McCombs and Shaw, 1972).

As agenda setting research developed, however, it moved beyond the initial formulation to suggest that, in addition to determining what we think about, the media are also often very successful in telling us what to think. McCombs (1997), one of the originators of agenda setting theory, now acknowledges the power of the media to influence what we think in addition to what we think about. He argues that this is accomplished through how the media frame the stories they report. Research on media frames has shown that what is selected and/or excluded from media content, as well as what is emphasized and elaborated on, is crucial in determining the version of reality that is constructed by media stories (Tankard, cited in Griffin, 2000). Entman describes media framing in this way:

> To frame is to select some aspects of a perceived reality and make them more salient in a communication text, in such a way as to promote a particular problem definition, causal interpretation, moral evaluation and/or treatment recommendation for the item described (1993, p. 52).

Depending on what information is included or excluded from television coverage, which aspects are given prominent, in-depth attention and which are minimized, the U.S. incarceration explosion may be cognitively located somewhere along a continuum where the opposite poles may be understood as the following: (1) a righteous response of a society that has grown understandably weary of criminals who prey on the innocent, or (2) a further attack on the members of U.S. society who are already at the bottom of the hierarchy of power: the young, the poor, the non-white.

The power of framing is revealed by research on media generated moral panics. Hall et al. define a moral panic as the historical moment when:

> the official reaction to a person, groups of persons or series of events is out of all proportion to the actual threat offered, when "experts," in the form of police chiefs, the judiciary, politicians, and editors perceive the threat in all but identical terms, and appear to talk "with one voice" of rates, diagnoses, prognoses and solutions, when the media representations universally stress "sudden and dramatic" increases (in numbers involved or events) and "novelty," above and beyond that which a sober, realistic appraisal could sustain, then we believe it is appropriate to speak of the beginnings of a moral panic (1978, p. 16).

The work that this passage is taken from, *Policing the Crisis* (Hall, Critcher, Jefferson, Clarke, and Roberts, 1978), is a study of a panic over a non-existent crime wave in Britain during the 1970s. Similarly, U.S. television stories about "crime waves," and the framing of young black men as "superpredators" (Kappeler, Blumberg, and Potter, 2000; Macek, 2006; Miller, 1996) represent one facet of an extended moral

panic that is at the core of the rush to incarcerate. Thus, in addition to being influ-enced by theories of media agenda setting and cultivation, I also draw on the British cultural studies approach to understanding the products of the media industries as texts wherein ideological struggle is made manifest.

Beyond Agenda Setting: British Cultural Studies and the Reclamation of Power

Stuart Hall and Richard Hoggart formed the Centre for Contemporary Cultural Studies during the mid-1960s. The goals of the Centre were not just to examine me-dia, culture, and politics from afar, with the "proper" amount of academic distance and sangfroid, but rather, to actively engage in a political struggle in the "dirty world" (Hall, 1990, p. 17), to combine theory and practice in a "Gramscian project" (Hall, 1990, p. 17) that melded complex intellectual understanding with social activ-ism.

Extending Marx and Engels' insights into the cultural realm, and explicitly draw-ing on Althusser and Gramsci, cultural studies highlighted the importance of popular culture and systems of mass media in shaping public perceptions and attitudes. Stuart Hall, and others associated with the Birmingham center, found in Marx, Engels, Al-thusser, and Gramsci the kernels of thinking that suggested the importance of a no-tion of ideology to any field like media studies that seeks to understand the impact of social institutions. This recognition of ideology is precisely what both Hardt (1992) and Hall (1982) refer to when they note the differences between critical scholarship (which acknowledges the importance of ideology in maintaining relations of domi-nance and subordination), and administrative or mainstream media research agendas (which may be considered consonant with the dominant ideology, in that they accept the given social structure without questioning its naturalness). The examination of ideology in media texts can highlight the role that the media play in legitimizing and reinforcing power differentials in U.S. society. Hall has suggested, "...in any theory which seeks to explain both the monopoly of power and the diffusion of consent, the question of the place and role of ideology becomes absolutely pivotal" (1982, p. 86).

Marxist Perspectives on Ideology

Marx and Engels presented this notion in *The German Ideology*:

> The ideas of the ruling class are in every epoch the ruling ideas, i.e. the class which is the rul-ing *material* force of society, is at the same time its ruling *intellectual* force. The class which has the means of material production at its disposal, has control at the same time over the means

of mental production, so that thereby, generally speaking, the ideas of those who lack the means of mental production are subject to it (1981 [1845], p. 64).

This famous quote has been oft cited in critical media studies as the foundation for studies of the political economy of the media and the ideological role that the media play in any given society. Althusser's (1971) influential essay on ideology examined the insinuation of ideology into life practices. Media and cultural studies practitioners have made extensive use of Althusser's theoretical positions. Althusser is most concerned with the process by which a social order perpetuates and reproduces itself. He draws a distinction between two factions that operate in this process: "...the Government, the Administration, the Army, the Police, the Courts, the Prisons, etc.... the Repressive State Apparatuses" (1971, p. 143) and the "Ideological State Apparatuses" (1971, p. 143) including religious, educational, legal and political systems, family, and the systems of culture and communication within a given society. From an Althusserian perspective, the media are primary manifestations of the Ideological State Apparatuses. An examination of media content can therefore provide insight into the ideological assumptions promoted in that content.

Regarding the differences between these primary institutions of social control, Althusser writes, "...the Repressive State Apparatus [RSA] functions 'by violence' whereas the Ideological State Apparatuses [ISA] function 'by ideology'"(1971, p. 145). Althusser then immediately modifies this, noting that both apparatuses rely on both violence and ideology, but the RSA relies primarily on repression and secondarily on ideology, while the reverse is true of the ISAs. Thus, while an institution like the military uses violence as its *primary* method, it also uses persuasion and propaganda to win consent to its operations. This is accomplished through the military's extensive public relations branches. In the same way, ideological institutions like schools and the family will turn to corporal punishment when they feel their mission of ideological control is failing.

The key to Althusser's (1971) argument is the idea that ideology interpellates individuals as subjects (with a specific place in society, specific roles to play, specific behaviors that are acceptable or not) and most individuals tend to accept this subjection. Those who dissent from the social order are "bad subject[s]" (1971, p. 181), social deviants who thus require the intervention of the RSA to keep them in line and subsequently serve as examples to other potential deviants. The quintessential bad subject who is held up as an example to others is of course the prisoner (see also Foucault, 1995 [1975]). Thus, my focus on television images of prisoners is an examination of how the ISAs and RSA may often work to reinforce each other's shared missions of social control.

Articulation Theory and Ideology

Some of the most eloquent discussions of the complex topic of ideology in media
have been produced by Stuart Hall who writes, "[I]deologies do not consist of iso-
lated and separate concepts, but in the articulation of different elements into a dis-
tinctive set or chain of meanings" (1995, p. 18). Articulation is successful when two
concepts that do not necessarily share a natural connection are linked together in a
manner that suggests that they have always been and always will be associated. Medi-
ated images play a central role in constructing articulations between concepts (Hall,
1995). For example, Jhally (1990) has examined the manner in which advertising
often works by linking personal happiness and fulfillment with material possessions.
A classic example of this is the DeBeers advertising campaign that successfully con-
structed a connection between diamonds and romantic love/marital commitment
that now seems natural and unquestionable to many, if not most, Americans. Like-
wise, in U.S. television there is a pattern of criminality being articulated with particu-
lar conceptions of race, class and gender, to the extent that images of African
American masculinity are often the first evoked whenever criminals are depicted in
both the news and entertainment media. As Hall notes, this is a both a historical pat-
tern, with deep roots in European and U.S. culture, and a still-common aspect of
contemporary media content in that: "Popular culture is still full today of countless
savage and restless 'natives'... particular versions may have faded. But their traces are
still to be observed, reworked in many of the modern and up-dated images.... Blacks
are still the most frightening, cunning and glamorous crooks (and policemen) in New
York cop series" (1995, pp. 21-22).

Hegemony and Counter-Hegemony

Hall (1982) also argues that the Althusserian conceptualization of ideology ulti-
mately tends to give too much credence to the monolithic effects of the dominant
ideology and that Gramscian hegemony theory can more fully explain the struggles
that occur between conflicting perceptions of social reality. As often as Althusser is
cited in critical media and cultural studies literature, Mouffe (1991) argues that most
of Althusser 's (1971) formulations were prefigured in the work of Gramsci (1971),
whose theory of hegemony is a theory of both the reinforcement of structural, insti-
tutional power and a theory of resistance to that power.

 Hegemonic theories of the media such as those offered by Stuart Hall and his
colleagues at the Birmingham Center for Contemporary Cultural Studies thus draw
heavily upon the work of Antonio Gramsci (1971) for their inspiration. Gramsci's
(1971) central question may be phrased in this way: Why, under worldwide circum-

stances of capitalist repression and exploitation, has there not been a spontaneous mass uprising of the oppressed in opposition to their oppressors? Gramsci's focus is thus on the ways that the ruling class wins consent to its dominance from the very individuals who are most subjected to its control. Hall identifies Gramsci's central contribution as the notion that, "hegemony is understood as accomplished... principally by means of winning the active consent of those classes and groups who were subordinated within it" (Hall, 1982, p. 85).

From a Gramscian perspective, a class that maintains power purely through violence and coercion is in a fragile position relative to a class that maintains power primarily through the willing consent of the mass of people. Coercion and violence must be continually and constantly applied in the absence of consent, but when the majority of groups in a society accept the circumstances of power to the extent that they view historical contingencies as universal and natural, then coercion must be exerted only in exigent circumstances. It is interesting to reflect on the current moment in U.S. history and the rampant use of the repressive controls of the criminal justice system in light of Gramsci's perspective on coercion and consent. If we are facing a hegemonic crisis, as evidenced by the perceived need of the state to impose physical constraints on an ever-increasing proportion of its population, then might not ideological systems such as the media be employed to both justify this repression and, "hopefully," restore us to a moment of hegemonic equilibrium?

When hegemony works successfully it is because it works almost invisibly, suffused through the routines and rituals of day-to-day existence. Gramsci (1971) likened a society's notion of "common sense" to a hegemonic social order. Through this process, a singular moment in history is configured as universal; a reflection of a "natural order of things." The media play a powerful role in establishing a hegemonic picture of the "real world." The broadcast journalist Walter Cronkite would sign off his evening news broadcast with the phrase, "...and that's the way it is," after having actually presented just one particular perspective on world events. The concept of journalistic objectivity invoked here reinforces the idea that the media merely presents the world as "it is" to an audience that rarely questions whether that is really all there is to the story. Thus, elevating a particular perspective to the status of common sense can often effectively deflect analysis and critique.

Despite this, hegemony is not invincible. The hegemonic ideas of a society in actual practice are tested, probed, challenged and transformed by historical processes. Williams notes that hegemony is neither monolithic nor eternal: "It has continually to be renewed, recreated, defended, and modified. It is also continually resisted, limited, altered, challenged by pressures..." (1977, p. 112). Hegemony is always in

struggle with counter-hegemony. Feminist thought, for example, has rejected patriarchal assumptions about gender roles. African American activism has challenged the white supremacist structure of American society. As Williams states, in all historical eras there are "forms of alternative or directly oppositional politics and culture" (1977, p. 113) that serve to challenge the hegemonic.

The notion of hegemony that is drawn from the writings of Antonio Gramsci (1971) and developed and applied by cultural studies scholars is an extremely useful theoretical perspective for understanding media power, and the role of the media as an institutional force for maintaining the status quo, because it allows us to understand the active processes of ideological domination and ideological resistance simultaneously.

Policing the Crisis

As noted above, Hall, Critcher, Jefferson, Clarke, and Roberts (1978) utilized Gramsci's theory of hegemony in an extended study of the panic that arose in 1970s Britain over a non-existent crime wave. This study is particularly relevant to my focus on television and the representation of incarceration, as the current imprisonment binge in the U.S. may be thought of as a contemporary U.S. parallel to the 1970s crisis in British hegemony. It is also a seminal example of how issues of ideology and hegemony may be considered central to critical studies of media content. *Policing the Crisis* (Hall, Critcher, Jefferson, Clarke, and Roberts, 1978) is thus a landmark work in the field of critical cultural studies. As one author has described it, *Policing the Crisis* was:

> one of the most significant texts to emerge from the Centre for Contemporary Cultural Studies at the University of Birmingham, inspiring many studies of moral panics and influencing at least a generation of scholars.... It remains, almost a quarter of a century after its publication, perhaps the finest example of collaborative work in the humanities (Stabile, 2001, p. 258).

In this study of the moral panic over "mugging" that swept Britain during the 1970s, Hall et al. utilize the Gramscian notion that hegemony is constructed on a number of different levels—the social, the political, the economic, and the ideological. Thus, in their examination they study how a hegemonic response to a crisis was constructed through a coordination of efforts among various manifestations of what Althusser called the RSA and the ISAs: the news media, the courts, the police, Parliament.

In this manner, *Policing the Crisis* provides readers with a concrete manifestation of what Gramsci would have called a historical bloc—a melding of various class interests manifested in civil society but given legitimation and the potential power of

force through the state. Thus, in 1970s Britain voices of the church, Parliament, the judiciary, law enforcement, and "the common people" (i.e., crime victims), were brought together through the media to express a unified sense of outrage and a common call to arms: British society is falling apart at the seams and a return to repressive measures and a "law and order" system of control is necessary to put an end to chaos. This common cry brought together various factions of both civil society and the state that under "normal circumstances" are often not this cohesive.

This cohesion of diverse interests is key to Gramsci's complex notion of how hegemony functions in society. As Hall et al. point out, "Hegemony was no automatic condition; its very *absence* from Italian political life was what focused Gramsci's attention on it. But it was the condition to which liberal-bourgeois society 'aspired'" (1978, p. 203). This statement is also true of the particular historical moment that *Policing the Crisis* examines. In fact, it is the very breakdown of hegemony in the influx of large numbers of immigrants, the changing values and economic conditions of the working and middle classes, the influence of Americanization and a youth-oriented consumer culture, that produced the crisis that needed to be policed. Mugging was simply a metaphor, a peg on which the coat of law and order could be hung, a rallying cry that could legitimize calls for repressive policing and the erosion of civil liberties.

Here we can see what Gramsci meant when he wrote about power working through consent *and* coercion, direction *and* domination (Gramsci, 1971; Hall et al., 1978). The moral panic that arose around mugging was also a moral panic about the perceived breakdown of British society. This moral panic signified a "crisis of hegemony" in marked contrast to the "successful 'hegemony' of the immediate post-war period" in Britain (Hall et al., 1978, p. 216). As Gramsci (1971) has pointed out, the state operates most efficiently through the winning of consent to its power, but when there is the perception that this "universal" consent is breaking down, coercive measures must then be employed. As noted above, it is worthwhile to consider some parallels between the historical moment analyzed in *Policing the Crisis* and the current situation in the U.S.; in particular the extent to which coercive measures of state power are currently being employed in the U.S., and what this may suggest about the fragile state of hegemony in U.S. culture (see Parenti, 1999).

Policing the Crisis further demonstrates Gramsci's notion of coercion and consent working together, as it illustrates how consent is won for coercive force. This is the moment when the typical citizen puts down her newspaper and thinks, "Yes, things are out of control. Yes, I am afraid to walk the streets. Yes, *something must be done.*" Harshly punitive jail sentences, police terrorizing of black youth, and other measures

of control then are accepted as necessary to restoring order. My contention is that a similar process is at work in contemporary U.S. television representations of crime in general, and specifically, in images of prisons and prisoners.

Arriving at a thorough understanding of the relationship between consent and coercion, and the media's role in producing consent, forces us to understand that hegemony is not a manipulative trick. It is not the false consciousness of traditional Marxism. It speaks to real concerns and real conditions. It operates on the basis of how individuals actually experience their daily lives. Hall and his co-authors demonstrate this through their broad examination of the historical events of late 1960s and early-to-mid 1970s Britain: the emergence of battles over labor and employment conditions, the concerns over permissiveness and the counter-culture movement, and how all of this is tied into the panic over mugging and what they call "the exhaustion of consent" (1978, p. 218). This breakdown of hegemony set the stage for the rise of the "exceptional state" (Hall et al., 1978, p. 273) a long-term period of crisis in which increasingly coercive measures are justified as necessary, and the British people willingly enter "iron times" with the election of Margaret Thatcher and the rise of a new historical bloc (further explored in Hall, 1988). As Parenti (1999) and others would argue, the U.S. at the turn of the century might also be considered an "exceptional state" that has willingly moved into "iron times," when it is considered rational for 2 million U.S. citizens to be incarcerated and millions more to be under the control of the criminal justice system through programs such as parole, probation, halfway houses, boot camps, and home detention.[3]

Certainly, care must be taken when attempting to apply Hall et al.'s (1978) insights to other moments and periods in history, for Gramsci (1971) insisted on the importance of historical specificity to intellectual work. Having said that, *Policing the Crisis* should not be dismissed as relevant *only* to the one moment in time that it analyzes. In fact, as argued above, many of its insights are quite germane to an understanding of contemporary America: the explosive growth of the criminal justice system, the conservative call for even more repressive measures such as "three strikes" laws, the weakening of Miranda rights, and the scapegoating and demonization of particular groups in American society.

In this chapter I surveyed the foundational theoretical perspectives that ground my analysis of the representation of incarceration on U.S. television. I also introduced a key empirical study, *Policing the Crisis*, which serves as an important precursor

[3] Certainly the terrorist attacks of 9/11/01 did nothing if not exacerbate these trends and serve as justification for further erosion of civil liberties.

for my examination of the role that television has played in justifying the massive buildup of the prison industrial complex in the U.S. since the 1980s. In the next chapter I turn my attention to the insights offered by previous empirical studies of the portrayal of crime in U.S. media and it's impact on readers and viewers.

Media Stories about Crime and Punishment

The theoretical traditions reviewed in the previous chapter—from social constructivism to semiotics and narrative theory, from cultivation and agenda setting to cultural studies approaches to theories of ideology and hegemony—all point to the notion that our perceptions and understandings of the societies that we live in are largely shaped, molded, and defined by the institutionalized cultural forces that prevail in any given historical moment. As such, if we hope to understand any social "reality" in the twenty-first century, we must come to understand how that "reality" is depicted by the central systems of representation, such as the television and film industries. Thus, I will now offer a brief survey of prior research on media images of crime and criminals. I do not attempt to present an exhaustive account of the vast numbers of studies related to media and crime and violence. The literature in this area is voluminous; so much so that it may be considered a sub-field of media studies itself. The focus here is on those studies that are most relevant to my exploration of television representations of incarceration. Little research has been conducted specifically on this aspect of media portrayals, but there have been numerous studies of media images of crime and criminals in general.

U.S. television representations of crime are by no means monolithic or uncomplicated. Having said that, it is also important to recognize that research has uncovered certain recurring themes and patterns in crime-related media content and it is these common and repetitive textual constructions that may be most powerful in creating a set of images that viewers draw from when imagining and discussing crime in U.S. society.

Reiman eloquently suggests the importance of recognizing and analyzing the most prevalent images of crime and criminals in the U.S. media:

> Criminal justice is a very visible part of the American scene. As fact and fiction, countless images of crime and the struggle against it assail our senses daily, even hourly. In every newspaper, in every TV or radio newscast, there is at least one criminal justice story and often more. It is as if we live in an embattled city, besieged by the forces of crime and bravely defended by the forces of the law, and as we go about our daily tasks, we are always conscious of the war raging not very far away. Newspapers bring us daily and newscasts bring us hourly reports from the "front." Between reports, we are vividly reminded of the stakes and the desperateness of the battle by fictionalized portrayals of the struggle between the forces of the

law and the breakers of the law. There is scarcely an hour on television without some drama-
tization of the struggle against crime (2001, p. 163).

It is essential, then, that we come to understand the nature and implications of
the messages about crime that we are constantly bombarded with in our daily lives.
To begin with, television vastly over-represents the amount of crime and violence
that actually occurs in U.S. society (Surette, 1998b; Gerbner, Gross, Morgan, and
Signorelli, 1994; Shanahan and Morgan, 1999). In fact, violent crime, which is actu-
ally the least frequent type of crime, is the most likely to be depicted on television
(Brown, 2001; Dominick, 1973; Gerbner and Gross, 1976; Lipschultz and Hilt,
2002; Lowry, Nio, and Leitner, 2003; Newman, 1990; Oliver, 1994; Parenti, 1992;
Sheley and Ashkins,1981), and violent, crime-related programs are the most common
type of television drama (Comstock and Scharrer, 1999). Thus, as Reiman (2001)
suggests, crime stories are a central part of both the entertainment media that viewers
engage with in the pursuit of pleasurable leisure activities, and the news media that
we rely upon to provide us with information and knowledge about events in the
"real" world.

That's Entertainment? Images of Crime in the Entertainment Media

Surette (1998b) provides a historical review of how both the entertainment and news
media in the U.S. have portrayed crime, criminals and the criminal justice system. He
points out that crime has been a central theme in the U.S. media from the earliest
days of dime-store novels, the penny press and the nascent film industry. According
to Surette, early images of crime in entertainment media were often sentimental, por-
traying criminals as romantic heroes. While Surette's description may be generally
accurate, his argument that early portrayals of criminality tended to portray the
criminal in a romantic light is actually valid only as far as media portrayals of white
criminals are concerned.

As Wilson and Gutierrez (1995) document in their historical review of various
forms of media, U.S. cultural representations of Asians, African Americans, La-
tino/as, and Native Americans have long focused on their supposed criminal nature,
and these have not been romantic portrayals. Instead, criminals of color have been
portrayed as dangerous, immoral, and despicable, right from the earliest days of U.S.
mass communication. Thus, when Surette (1998b) points out that by the late-
nineteenth century the basic media stereotypes regarding criminality that are still
prevalent today had already been established, including severely negative images of
criminals and the notion that the causes of crime could be attributed to the moral

weaknesses of individual criminals, his analysis should be augmented by the acknowl-edgment that these sorts of portrayals of white criminals merely brought them in line with how non-whites had long been depicted.

Late nineteenth-and early twentieth-century detective thrillers that appeared in serial form in magazines and in cheap paperback novels were early examples of vio-lent media content that portrayed criminals as predators whose individual failings led them to a life of crime (Papke, 1987). The development of the early film industry at the turn of the century brought similar images of crime and criminality before larger numbers of people than had ever been exposed to them before (Surette, 1998b). The glamorous images of white criminals in films of the 1920s in fact led to public con-cern over what messages children were receiving from the movies that they attended in huge numbers. This in turn led to the Payne Fund studies, which were the first large-scale social scientific investigation of media effects on audiences. The pessimis-tic conclusions of these researchers, that movies had a degrading effect on audience's morals, were central motivating factors in the film industry's implementation of self-censorship of film content in the form of the Hay's production code, which put strict limits on what could be shown in the movies (Lowery and DeFleur, 1983).

One of the results of this self-censorship in the film industry was the shift from criminals being portrayed as heroes to a glorification of crime fighters in cinematic morality tales that reinforced the cliché "Crime does not pay." The depictions of crime and crime fighting in the movies also became increasingly more violent in the post-World War II era, as the film industry broke away from the days of self-censorship and began to compete with television as the primary entertainment source for most Americans (Surette, 1998b). As Bailey and Hale (1998) document, from the 1940s right up through the end of the century, crime-related films were never in short supply. From *film noir* to teen rebel films, from James Cagney to James Bond, from Bonnie and Clyde to Shaft and Dirty Harry, from Stallone and Schwarzenegger to Vin Diesel, images of criminals and crime fighters have always been abundant in Hollywood films.

Crime-related themes became a central part of television entertainment pro-gramming about a decade after the introduction of television into U.S. homes, and the amount of crime on television grew as the medium developed. Dominick's review of content analyses of television from the 50s to the 70s reveals that:

> [C]rime shows began to account for around one third of all prime time from 1959-1961. This trend leveled off during the 1960s but began to increase again during the early 1970s until it reached its peak in 1975 when almost 40% of the three networks' prime-time sched-ules contained shows dealing with crime and law enforcement (1978, p. 113).

Subsequent analyses would reveal that the "peak" in 1975 would be surpassed as the number of crime shows soared during the late 1980s (Cole, 1996). Surette reports that between the 1960s and 1990s approximately 25% of prime time entertainment programs featured crime themes as their main focus and that "the total amount of crime-and-justice programming available via television is [now] greater than ever" (1998b, p. 35).

There is also a vast amount of research on a related topic—violence on television. While not all televised violence is necessarily of a criminal nature (sports programming and/or shows that feature violent accidents or disasters spring immediately to mind), certainly much of it is. When it comes to just violence, rather than all of crime, for example, an extensive content analysis of over 2,700 hours of broadcast and cable television entertainment programming revealed that 61% of all of the programs in the sample included violent content and of 62 prime-time dramas, 82% included violent content (Smith, Nathanson, and Wilson, 2002). Regardless of the specific numbers that are offered by various studies, most researchers would agree that violent crime appears as a subject matter in entertainment television more than any other single thematic element (Comstock and Scharrer, 1999; Lewis, 1984; Parenti, 1992).

The Distortions of Entertainment Media Representations of Crime

In addition to the sheer amount of crime on television, researchers have also turned their attention to the nature of these representations of crime and the question of how closely mediated crime matches up with crime in the real world. Numerous studies have demonstrated that the television and film industries in the U.S. present a highly distorted picture of crime, criminality, and criminal justice (see Carlson, 1985, for example). One of the most important of these distortions is the focus on relatively rare violent crimes. As Surette notes in his review of years of studies, "the offenses that are most likely to be emphasized on television are those that are least likely to occur in real life, with property crime underrepresented and violent crime overrepresented" (1998b, p. 39). Lichter and Lichter's (1983) content analysis found that four types of crime—murder, robbery, kidnapping, and aggravated assault—account for 87% of the crimes featured on television. In actuality these crimes are the least common—murder, for example, making up .01% of all crime (U.S. Bureau of Justice Statistics, 1999).

In addition to this overrepresentation of violent crime and criminals, the portrayal of crime in U.S. television and films suggests that crime is an individual problem, caused by defective personality traits in criminals and best solved by violent

intervention by the authorities (Maguire, 1988; Surette, 1998b). Surette describes this media meta-narrative as a simplistic tale of good versus evil which isolates crime from its real causes—widespread social problems such as poverty, failing schools, unemployment, corporate abandonment of urban areas, and the like.

Race, Class, Crime, and Entertainment Media

Another distortion that some interpretations of television and film portrayals have suggested lies in the articulation of dark skin and criminality. Many media critics and historians (Bogle, 1993, 2001; Corea, 1995; Guerrero, 1993; Hall, 1995; Hall et al., 1978; hooks, 1992; Little, 1998; Pines, 1995; Rhodes, 1993; Rose, 1994; Said, 1978; Shaheen, 2001; Wilson and Guttierrez, 1995) have argued that there is a tendency in Western popular culture to present images that associate the defense of the moral order with whiteness, while those who are situated as threats to the harmony and stability of society are often depicted as non-white or non-European— Asian, Arab, Latino/a, Native American, and perhaps most often, black. Since the earliest days of U.S. cinema, films like *Birth of a Nation* portrayed African Americans and other people of color as savage and criminal.

While it is true that representations of race in the media are complex and multi-faceted, and that certainly not all Hollywood films and television programs depict all people of color as criminal, these sorts of portrayals are common enough that a clear tendency of negative stereotyping is apparent in U.S. media history (Bogle, 1993, 2001; Corea, 1995; Guerrero, 1993; Rhodes, 1993; Wilson and Guttierrez, 1995). Gray (1995a), however, points out that the articulation between race and criminality is actually a double articulation that is intertwined with issues of class. While middle- and upper-class African Americans, for example are often celebrated in programs such as *The Cosby Show*, "poor blacks (and Hispanics) signify a social menace that must be contained" (1995a, p. 431). These bifurcated images actually may work together to reinforce the notion that racism is no longer a problem in U.S. society (just look to Winfrey, Cosby, Jordan, Woods, and, especially now, Obama for proof) and therefore the poor and those who get caught up in crime and violence must be morally and otherwise deficient (Gray, 1995a; Jhally and Lewis, 1992; Lewis, 1991; Shanahan and Morgan, 1999).

Thus some have argued that there is a tendency in television serial crime dramas such as *NYPD Blue* to articulate criminality with poor and working-class African Americans while simultaneously representing middle-class blacks as respected authority figures (Bogle, 2001; Pines, 1995). In addition, Pines suggests that, "Some crime stories consciously set out to create 'positive' black characters. However, these liberal-

ised black characters often appear alongside a preponderance of 'negative' black vil-
lainous types in the story" (1995, p. 68). His assertion is supported by a quote from
an NBC spokesperson who said that the creators of the extremely popular 1980s cop
show *Hill Street Blues* "were simply going to have to *fictionalize* it to the extent of saying
that all criminals weren't Black. There are *some* white Anglo-Saxon Protestant thieves
and killers and pimps" and then added that the producers made a conscious decision
that the police on the program should also be multi-racial in order to avoid "prob-
lems that we might be confronted with as broadcasters…" (quoted in Bogle, 2001,
p. 274, emphasis added).

The tendency of some television dramas to highlight frightening portrayals of
young black male criminals is also apparent in many Hollywood films that feature
nightmarish images of urban areas overrun by the (primarily) dark-skinned under-
class. Gabriel (1998), for example, cites as examples of "urban nightmare" films the
rash of 1990s Hollywood movies like *Falling Down*, *Ghost*, and *The Bonfire of the Vanities*
that featured white males as the victims of black urban terror. However, this trend
was also apparent in earlier films such as those of the "Blaxploitation" era, or the
vigilante films of the 1970s and 1980s like *Dirty Harry* (which spawned four sequels
between 1973 and 1988) and *Death Wish* (three sequels between 1982 and 1987) that
featured armed white men "fighting back" against the dark-skinned menace (Guer-
rero, 1993; Macek, 2006; Parenti, 1992).

Misrepresenting the Legal System

While the images of crime and criminals in television drama and Hollywood films
are often hyperviolent and rife with racial bias, portrayals of the criminal justice sys-
tem may be equally distorted. When court proceedings are featured they tend to be
the (in reality) relatively rare criminal trials with opposing lawyers engaged in dra-
matic conflict before a judge and jury (Stark, 1987; Surette, 1989, 1998b): "The
confrontations, the oratory, and the deliberations in the media courtroom are in stark
opposition to the criminal justice system's daily reality of plea bargains, compro-
mises, and assembly-line justice" (Surette, 1998b, p. 44). In addition, courts are of-
ten depicted as being "soft on crime" and willing to let dangerous criminals off with
a "slap on the wrist" (Lichter and Lichter, 1983; Stark, 1987; Surette, 1998b), a
construction that has little relationship to the reality of contemporary practices such
as mandatory minimum sentences and "three strikes" laws. And the prison system is
even less visible in television than the courts (Surette, 1998b).

Other scholars have suggested that racial and gender bias is also evident in depic-
tions of the criminal justice system, as crime fighters are represented as predominately

white males who symbolize cultural myths of rugged individualism and who employ violence as the solution to all problems (Bortner, 1984). The broad-based Cultural Indicators project which has examined thousands of hours of television programming over several decades has established, among many other findings, that it is primarily white men who get away with using "legitimate" violence on television (see Shanahan and Morgan, 1999, for a comprehensive review). Thus, one interpretation of television's dramatic portrayals of crime suggests that when images of criminals and crime fighters in entertainment media are considered in concert with one another we see that viewers are often presented with a distorted picture of the world, where there is a tendency for whites and/or the middle class to be equated with goodness and stability while people of color and/or the "underclass" often symbolize chaos, evil and violence.

Furthermore, while the violence committed by these underclass criminals is depicted as something to be feared, violence perpetrated by the police is represented as a necessary response that should be sanctioned. There is little regard for the rights of crime suspects on most television programs (Arons and Katsh, 1977). Parenti notes that:

> [T]he police behavior portrayed on entertainment television habitually violates the constitutional rights of individuals. The message communicated is that crime can be best met by state-sponsored illegality and brutality. Due process is something that has to be brushed aside so police can successfully subdue evil (1992, p. 115).

Thus, in both the portrayal of crime and criminals, and in the depiction of societal responses to crime and the criminal justice system, prime-time television and Hollywood films offer viewers images that are rife with distortions, inaccuracies and illusions. Surette sums up his review of the literature on media entertainment and crime with this indictment:

> The entertainment media's pattern with regard to portraying crime and justice can be summarized as follows: Whatever the media show is the opposite of what is true. In every subject category—crimes, criminals, crime fighters, the investigation of crimes, arrests, the processing and disposition of cases—the entertainment media present a world of crime and justice that is not found in reality. Whatever the truth about crime and violence and the criminal justice system in America, the entertainment media seem determined to project the opposite (1998b, p. 47).

Thus, while prime-time police dramas and Hollywood action films are entertaining viewers, they are also being treated to a version of the world that bears little resemblance to reality (Gerbner and Gross, 1976; Parenti, 1993; Shanahan and Morgan, 1999). Defenders of the entertainment industries might argue that audi-

ences don't want reality in entertainment media and that they turn to the news media when they desire accurate information about real world issues and events. Unfortunately, when we consider the literature on news media representations of crime, we find evidence of much the same themes and patterns of distortion that scholars of media and popular culture have found in entertainment media.

More Bad News: Images of Crime in the News Media

Several researchers have argued that news organizations have historically focused on tales of crime and deviance as a means of attracting curious readers (Chermak, 1994, 1998; Chibnall, 1977; Sherizen, 1978). While it is true that coverage of crime has been a mainstay in the U.S. press since the 1800s (Bleyer, 1927; Surette, 1998b), it is also important to note that the nature of this coverage has changed considerably over the years. In regard to the earliest forms of mass produced and distributed daily newspapers, the penny press, Surette describes their crime-related content as quite different than what modern-day consumers of news might encounter:

> Class oriented, these early papers portrayed crime as the result of class inequities and often discussed justice as a process manipulated by the rich and prominent. They contained due process arguments and advocated due process reforms, presenting individual crimes as examples of larger social and political failings needing correction (1998b, p. 55).

This description of early crime news represents almost the precise opposite of today's mainstream media coverage which tends to focus on individual instances of street crime committed by the poor and working class, and presents these events in an overly dramatic, personalized and fragmented manner; devoid of any context that might help viewers understand that crime can be attributed to many other factors than just individual moral weakness and dysfunctional personality traits (Bennett, 2001; Iyengar, 1991; Parenti, 1993; Reiman, 2001; also see Cloud, 1998 on the tendency in U.S. culture for political and social issues to be redefined as individual, psychological, and purely personal, or familial, concerns).

Studies have found that news of crime and criminal justice accounts for as much as 1/4 to almost 1/3 of the new stories in many newspapers (Dominick, 1978; Graber, 1980; Garofalo, 1981; Jerin and Fields, 1995; Lotz, 1991). It was with the emergence of the sensationalist press that the nature of crime coverage, as well as the quantity of coverage began to change. In contrast to the recognition of crime as a social problem related to issues of class, deprivation, and inequity in the penny press, the yellow press emphasized the graphic details of individual incidents and the personal gossip associated with high-profile crimes—aspects of crime that are still the primary focus of today's news media (Surette, 1998b).

Television and Crime Saturation

Television has surpassed print journalism as the primary source of news for most Americans (Bennett, 2001; Klite, Bardwell, and Salzman, 1997; Mauer, 1999; Potter, 2001), but television also features crime as a mainstay of its coverage, and as the medium of television news developed this became more and more the case. Studies of television news in the 1960s and 70s found that 10 to 13% of national news and 20% of local news was devoted to crime (Cirino, 1972; Graber, 1980; Lowry, 1971). However, those numbers have soared in more recent times.

The Center for Media and Public Affairs reported in 1993 that network news covered twice as many crime stories and three times as many murders as they did just a year before (cited in Mauer, 1999). Bennett (2001) reports data that reveal that from 1990 to 1998 the three big network news programs (ABC, CBS, and NBC) almost tripled the amount of crime coverage in their nightly broadcasts, and that the amount of news stories that focused on murder rose 700% in just three of these years (1993-1996). Furthermore, these trends in 1990s news coverage of crime had no connection whatsoever with real crime rates in U.S. society. Violent crime actually decreased during the 90s and the murder rate dropped by 20% during the same period that news coverage of murders was exploding (Bennett, 2001).

This trend is particularly apparent in local news, where many producers seem to subscribe to the "if it bleeds it leads" philosophy of broadcast journalism (Bennett, 2001; Entman and Rojecki, 2000). One content analysis of local television news in Philadelphia reported that 31% of the stories covered were crime-related and that 76% of these appeared during the opening segment of the broadcast (Yanich, cited in Mauer, 1999). Research conducted in 1995 revealed that a third of the local television news stories in a sample of 100 broadcasts dealt with crime (Klite, Bardwell, and Salzman, 1997).

News Media as Sources of Misinformation

As with trends in entertainment media, the tale is not complete with just a description of the large amounts of time and space devoted to crime stories. In addition, the nature of crime and criminals is severely distorted in most mainstream news media. Media coverage of crime tends to focus on individual incidents which are reported absent any sort of contextual information about how the crime fits into broader historical, social, or economic trends or the relationship between the reported incidents and overall crime rates (Potter, 2001). For example, as many have reported, the rise in media coverage of crime parallels a decrease in real crime in U.S. society, but *this*

important story is never reported in the news media (Bennett, 2001; Chriss, 2007; Dyer, 2000; Mauer, 1999; Potter, 2001).

In general, the news media, similar to entertainment media, provide a distorted picture of the world by devoting most of their time, space, and energy to those severe and violent crimes that are actually the rarest (Chermak, 1995, 1998; Ericson, Baranek, and Chan, 1991; Graber, 1980; Humphries, 1981; Sheley and Ashkins, 1981). In addition to the economic motives for this (news directors might claim that coverage of violent, spectacular crime drives up ratings and audience share), the value of novelty that journalists believe makes a story newsworthy also helps to ensure that out-of-the-ordinary events will tend to get the most attention. Journalists value deviance, and the more deviant a person or event is, the more newsworthy it is considered to be (Potter, 2001; Shoemaker, 1987; Shoemaker, Danielian, and Brendlinger, 1991).

The consequence of this is that due to the news media constantly focusing on oddities and relatively rare events, viewers are provided with a skewed picture of the world that they may take for being accurately representative of social reality. As Potter puts it:

> The irony is that we depend on the news to tell us what the norm is. In order to be well informed, we need to know how things typically work, what is likely to happen tomorrow, and what the relative risks of harm are. But the news media focus our attention on the deviant. Because we see so many portrayals of the deviant, we come to believe the deviant is the norm (2001, p. 94).

Crime as Mass Spectacle

As part of this tendency to emphasize deviance, the U.S. news media tend to also fixate on sensationalistic crimes involving celebrities or bizarre circumstances (Fox and Van Sickel, 2001). Furthermore, Fox and Van Sickel point out that tabloid-style reports of bizarre and sensational crimes are no longer confined to the "infotainment" newspapers and programs such as the *National Enquirer* or *Inside Edition*. Rather, these stories "have found their way into journalism's most respected sources of 'hard news' in the United States: CBS, NBC, and ABC, along with the nation's most esteemed newsmagazines and newspapers" (2001, p. 54).

This focus on celebrity crime or bizarre stories is only one of many ways that media coverage of crime in the U.S. is distorted. Parenti has pointed out that U.S. news organizations focus on street crime committed by working-class and poor individuals while de-emphasizing corporate crimes such as:

[M]onopolistic restraints of trade, illegal uses of public funds by private interests, occupa-
tional safety violations, unsafe consumer goods, and environmental poisonings— which are,
or should be, crimes, and which can cost the public dearly in money and lives. Every year
more than 14,000 workers in the United States are killed on the job; another 100,000 die
prematurely, and 400,000 become seriously ill from work-related diseases. Many, if not
most, of these deaths and injuries occur because greater consideration is given by manage-
ment to profits and production than to occupational safety and environmental standards. Yet
these crimes are rarely defined and reported as crimes by the news media (1993, p. 10).

Meanwhile, "affluent victims are more likely to receive press attention than poor
ones, leaving the false impression that most victims of crime are from upper- and
middle-class backgrounds" (Parenti, 1993, p. 10; also see Entman and Rojecki,
2000).

The Central Bias: News Media, Crime, and Representations of Race

Closely related to this class bias, there is also evidence of a racial bias in mainstream
news media coverage of crime (Parenti, 1993; Shanahan and Morgan, 1999). Several
studies have found that U.S. news tends to focus on African American and Latino/a
criminality in particular, while downplaying crime committed by whites. At the same
time, there is a tendency to feature white victims of crime while neglecting victims of
color. These two tendencies, along with a pattern of focusing on white defenders of
the law, lead Entman and Rojecki to conclude that, "Not only does local news depict
life in America as pervaded by violence and danger; this genre also heightens Whites'
tendency to link these threats to Blacks" (2000, p. 78).

Empirical studies of media content support Entman and Rojecki's (2000) con-
tention (Campbell, 1995; Dixon and Linz, 2000; Entman, 1992; Gilens, 1996; Pef-
fley, Shields, and Williams, 1996; Romer, Jamieson, and DeCoteau, 1998). Dixon
and Linz (2000), for example, conducted a quantitative content analysis of a random
sample of local television news in Los Angeles that revealed that African Americans
and Latino/as were more likely to be portrayed as lawbreakers than whites were and
they were less likely to be portrayed as defenders of the law. In addition, African
Americans and Latino/as were more likely to be depicted as lawbreakers than de-
fenders of the law while the reverse was true for whites. Furthermore, and impor-
tantly, these representations have little to do with statistical reality, as Dixon and
Linz revealed by comparing their data to real world ratios. This comparison revealed
that African Americans were significantly overrepresented and whites were signifi-
cantly underrepresented as criminals in comparison to real world crime statistics
gathered by the California Department of Justice. The results reported by Dixon and
Linz (2000) are consistent with earlier examinations of racial bias in crime reporting.

Romer, Jamieson, and DeCoteau (1998), for example, conducted a quantitative content analysis of 14 weeks of late evening news broadcasts in Philadelphia that revealed that African Americans were more likely to appear as perpetrators of crime than as victims and the reverse was true for whites. Again, these patterns were not reflective of actual crime statistics as reported by the Philadelphia police and the F.B.I.

In addition to the differences in the ratios of which races most often get identified with crime in the news there are also differences in how racial articulations are rhetorically constructed by media images. Campbell notes this about his analysis of almost 40 hours of local television news originating out of 29 U.S. cities:

> The newscasts viewed for this study were pervaded with threatening images of minority crime suspects—many shown in police mug shots, others bound in handcuffs closely guarded by police. Considering the general dearth of minority coverage in the evening news, these may be the most dominant images of nonwhite Americans (1995, p. 69).

Entman (1992) and Entman and Rojecki (2000) found evidence of many differences in both the frequencies and the tone of television news images of white and black suspects and criminals. For example, African Americans who had been accused of a crime were significantly more likely to be depicted in police restraints than whites who had been similarly accused. News stories about African Americans accused of crime were also four times more likely to picture the accused in a police mug shot than were stories about white suspects. Thus we see repeated evidence of racial discrimination in television news coverage of criminals and suspected criminals: "Blacks in the news tend to look different from and more dangerous than Whites even when they commit similar crimes" (Entman and Rojecki, 2000, p. 84).

This discrimination is compounded when the full spectrum of criminal justice news reporting is taken into account, as Entman (1992) and Entman and Rojecki (2000) also found evidence of racial disparities in how crime victims and crime fighters were depicted. For instance, crime victims in Chicago television news were more likely to be white, and the amount of time devoted to white victims was much higher than that devoted to African American crime victims, despite the fact that African Americans are proportionally more apt to be victims of crime in urban America. In regard to representations of law enforcement personnel and others who are working to fight crime, the disparity was staggering. Reporting on their content analysis of Chicago television news, Entman and Rojecki write:

> [T]he ratio of White officials to Black officials in local news stories is 12:1 (309 to 26), even though Blacks comprise closer to 35 percent of law enforcement personnel in Chicago. Measuring in seconds reinforces this point: 2,352 seconds were devoted to stories featuring

Black officials and 65,124 seconds to Whites, for a ratio of 28:1. Whites constituted the overwhelming majority of racially identifiable individuals in positive social roles (2000, p. 86).

Taken as a whole, these data suggest a pattern whereby African Americans are repeatedly associated with criminality and whites are continuously identified as both the primary victims of, and the primary defenders against, black crime. This media construction bears little resemblance to the real world but is repeatedly activated again and again by consistent images and themes in television news.

Thus, just as with entertainment media, African Americans, and other people of color, are often treated as "folk devils" in news media images of crime (Hall et al., 1978). Furthermore, this tendency is reinforced by both the routine images of local news, as demonstrated by the studies reviewed above, and by national news treatment afforded "celebrity" African American criminals like O.J. Simpson and William Horton, and out-of-the-ordinary events that receive saturated national coverage, such as the 1992 Los Angeles uprisings or the 1989 media constructed frenzy about "wilding." For a year after an upper-class white woman was allegedly gang-raped by a group of black and Latino youth in Central Park, the national news media frequently referred to "wilding" as a new crime wave that implicitly involved gangs of young people of color targeting innocent white people (Best, 1999). In fact, aside from the Central Park incident there was no evidence of any such crime "epidemic." Furthermore, DNA evidence subsequently revealed that it was a lone individual, not associated with the young men who were imprisoned for the crime, who actually committed the rape (Hancock, 2003).

Similarly, news reports of the uprisings in Los Angeles in 1992 (which occurred after an all-white jury had found the police officers who severely beat an African American motorist, Rodney King, not guilty), while purportedly providing a factual account of events, simultaneously framed these events as evidence of the violent and barely contained danger that blacks represent to whites. In actuality, approximately 72% of those arrested during the Los Angeles riots were either Latino or White (Armour, 1997; Reed, 1993; West, 1994). Entman and Rojecki make this point about media coverage of these civil disturbances:

> The power of the stereotyped associations of Blacks and lawlessness in journalists' own thinking is perhaps most graphically revealed by coverage of the Los Angeles civil disturbances of 1992. Despite the fact that this was a thoroughly integrated uprising in which the majority of those arrested were Latino, and quite a few were Anglo, media depictions heavily emphasized and often equated Blacks as "rioters" (2000, p. 92).

This association between the word "riot" and the notion of violent African Americans posing a danger to innocent whites is a common one, despite historical evidence that throughout most of the nation's history "race" riots were primarily instigated by whites against blacks, not vice versa (see Entman and Rojecki, 2000; Feagin, 2000).

The News about Crime News

Thus, the television news media, while operating as the primary source of "factual" information for most U.S. citizens, provides just as distorted a view of crime and criminality as may be found in the products of the entertainment media industries. As Surette (1998b) points out, there are actually more similarities than differences in how crime and criminals are represented in the fictions of Hollywood films and television dramas, and in the "facts" of television news. This would lend credence to Gerbner et al.'s (1994) assertions that television tends to present consistent messages across genres.

The entertainment and the news provided by the television industry work together in presenting a mythic tale about crime that suggests that crime is located primarily on the streets, and committed primarily by the poor and people of color (and particularly by poor people of color), and that the causes of crime are rooted in individual dysfunction while the solutions to crime may be found in severe punishment of these deviant individuals. Before considering the implications of this mythos, a moment should be taken to examine the literature on a relatively new media phenomenon that blurs the boundaries between entertainment and news media even further: the so-called "reality" crime programs that have become increasingly popular in U.S. television.

The Most Unreal: Reality Television

Surette describes the reality crime genre as programming that "entertains by sensationalizing real stories about crime and justice. It presents actual crime and criminal cases in a realistic light, sometimes in reenactments, sometimes as dramatized stories, and sometimes in documentary-style stories" (1998b, p. 71). Research on this genre suggests that the emphasis on violent content may surpass even that of hard news programs or traditional television dramas (Bennet, 2001; Cavender and Bond-Maupin, 1998; LaSorsa et al. 1998; Oliver, 1994; Rapping, 1999). Bennett (2001) cites a writer for one of the "reality" police shows who revealed that the following guidelines for what should be highlighted in each episode were displayed in the offices where the program's writers and video editors created the show:

Death
Stab
Shoot
Strangulation
Club
Suicide
(Seagal, cited in Bennett, 2001, p. 93).

Furthermore, Oliver (1994) found that, in addition to the over-representation of violence in the so-called "reality" police shows, there is also a tendency for police officers to be represented as white, while people of color are most likely to be depicted as criminals. Use of aggression by these white officers is thus implicitly sanctioned in these programs as a necessary way to control the menace represented by black and Latino (and white working-class) offenders. Rapping writes: "Rarely are Miranda rights read to anyone on *Cops*, at least on screen. Even more rarely does anyone ask for a lawyer. This, we are led to believe, is appropriate, for these people are uncontrollably irrational beings who cannot comprehend the rules by which we live" (1999, p. 267).

These law breakers are depicted as completely alien—the ultimate "Other" whose very existence is a threat to the social order. As Rapping suggests about the image of criminals on *Cops*:

> Out of control, primitive and subhuman, incapable of reason, unable to abide the law, unable to maintain family ties, he or she is a creature to be repressed, to be kept out of our borders by the harshest possible measures.... The actual acts committed by the tabloid criminals are, of course, not nearly dangerous enough to be compared with acts of terrorism. But the idea of inherent "otherness"—a term that marks the immigrant, the sexual deviant, and the drug addict—and the grotesquely expressionistic conventions by which the tabloids represent these people makes the comparison in kind, if not deed, emotionally resonant. The border dwellers on *Cops* are the dregs of society. But rather than presenting any cultural, political, or social context that might explain these subjects' deplorable conditions, these shows choose to represent these outsiders as alien, depraved, and inferior, suggesting that only the most repressive policies are appropriate for them (1999, p. 269).

The simultaneous operation of a format that purports to be real along with the highly inaccurate portrayals that are found in most of these programs is particularly disturbing, as viewers may accept the programs' claims of veracity at face value while all the while they are being subjected to false and misleading images. For example, Bennett (2001) cites the opening teaser from a Fox series entitled *World's Wildest Police Videos*: "What you're about to see in the next 60 minutes is real. Real cops. Real crooks. Real cases. Everything from real training to real shootouts. What you see may shock you, frighten you, anger you" (2001, p. 92). However, the program actu-

ally featured staged training exercises, framed in such a way as to suggest that they were actual police chases and captures. Programs such as this may thus present a veneer of reality that attempts to disguise both their true nature as sensationalized semi-fictions and their contribution to the increasingly blurred lines between news and entertainment. This is of particular concern when it comes to images of crime and violence because it represents the ultimate commodification of human tragedy; where the problems of a society that is rife with inequities become fodder for a commercial media system that appeals to our basest voyeuristic tendencies in order to maximize their earnings and profits. Taken together, the news, entertainment, and "infotainment" provided by the U.S. television industry represent a triumvirate of distorted message systems that help to sustain a mythos of crime and criminal justice in U.S. society.

Crime and Myth

Kappeler, Blumberg, and Potter (2000) catalog some of the features of the dominant crime myths perpetuated by the U.S. media. For example, one of the most common myths about crime is that there is a clear and rigid distinction between those whom we have categorized as criminal and those whom we think of as law-abiding. This is related to the notion of the criminal as the ultimate "Other," the deviant folk-devil (Cohen, 1972; Hall et al., 1978). In actuality, "evidence suggests that over 90% of all Americans have committed some crime for which they could be incarcerated" (Bohm, 1986, p. 201). In fact, crime itself is a social construction. In much the same way that there is no news until someone in the media industries defines something as news, there is no crime until something is defined as criminal by a given society. Some actions that are considered criminal behavior today will not necessarily be considered criminal behavior tomorrow. Yet we operate as if our definitions of crime are natural and eternal. The mythos of crime in U.S. culture helps to "reinforce the current designation of conduct as criminal, support existing practices of crime control, and provide the background assumptions for future designation of conduct as criminal" (Kappeler, Blumberg, and Potter, 2000, p. 3).

A second aspect of contemporary U.S. myths about crime is that they help to provide us with a resolution to the quandary that the most advanced nation on the planet also has rampant poverty, gross inequities in resources and income, and, subsequently, substantial amounts of crime and violence. Perhaps the most dominant myth about crime (and poverty, not incidentally) is that it is an individual problem that can best be explained by pointing to the moral and psychological failings of deviant people (Bohm, 1986; Kappeler, Blumberg, and Potter, 2000). As the review of

research on television images and stories of crime discussed in the preceding pages demonstrates, this myth is clearly promoted throughout television programming in news, entertainment, and "infotainment" genres.

Kappeler, Blumberg, and Potter (2000) also argue that myths about crime carry implicit (and sometimes explicit) guidelines for how crime and criminals should best be dealt with. "When we cast criminals into roles as social deviants and evildoers preying on innocent victims, we invite and feel justified in advocating draconian punishment" (2000, p. 4). The tendencies in media images of criminals that media researchers have documented support this articulation of crime and evil and reinforce an ideology that can accept only severe punishment (the death penalty, "three strikes" laws, severe treatment of juvenile offenders, longer sentences and more horrific prison environments, etc.) as the most reasoned and logical response to crime.

Images of Prisons and Prisoners—A Neglected Area of Study

Cheatwood argues that:

> Little previous literature about the relationship of mass media and the correctional system exists. Almost no one has considered the effect of media presentations of prison life on the public's perception of corrections, or the related process by which general public attitudes toward corrections become crystallized through the influence of these perceptions (1998, p. 210).

Despite the relatively little attention that has been devoted to media stories about incarceration, these images may play an important role in shaping the public's perceptions of inmates and the corrections system. As Munro-Bjorkland argues, popular culture representations of prisons and prisoners may be expected to influence viewers' attitudes about "the types of people who are or should be incarcerated, and prison conditions that should be tolerated..." (1991, pp. 56-57).

Foucault on Incarceration

In *Discipline and Punish: The Birth of the Prison*, Foucault proposed that punishment of deviants by the state is part of a larger system of state control that infiltrated into the lives of all members of a society: "[T]he guilty person is only one of the targets of punishment. For punishment is directed above all at others, at all the *potentially* guilty" (1995, p. 108, emphasis added). According to Foucault's historical analysis, prior to about the mid-1800s, when the most common form of punishment was publicly administered torture and execution, punishment was, to a large degree, a way of demonstrating the terrible consequences that awaited those who challenged social norms and mores. In this era punishment was a public spectacle that carried clear lessons

about political power. With the rise of incarceration as the dominant form of punishment, punishment has subsequently moved into the shadows. The terror that the state wreaks on deviants is no longer as visible, and yet still just as fearsome, perhaps even more so because of the mystery now associated with what happens to the convicted.

Simultaneously, the focus of punishment has moved from the body to the spirit; although it is prisoners' bodies that are locked up, this is an indirect means to imprisoning their souls. Although, Foucault admits, in the physical assaults and deprivations associated with imprisonment, "a trace of 'torture'" remains (1995, p. 16). The movement of punishment away from the public sector also helps to disguise its function as punishment—it is easier to talk of "cures" and "healing" and "rehabilitation" when the atrocities associated with the punishment industries are hidden from sight.

Yet, it is still necessary that punishment is always linked to crime in the popular imagination; thus, despite the relative invisibility of the prison system, popular culture became saturated with narratives about criminals and the negative fates that await them. This spectacle of crime and punishment in popular culture in a sense replaced the spectacle of public execution and torture. For the poor in particular there was an emphasis on images of criminals as degraded moral beings that superseded romantic visions of criminality in classical literature. Furthermore, popular images of criminals represented them as both far removed from "ordinary" life and yet still a threat to the lives of the "ordinary." Thus, although media is not his central concern, Foucault does touch on how popular culture and media images and narratives were constructed as morality plays for the lower classes. Thus, he writes about "a patient attempt to impose a highly specific grid on the common perception of delinquents: to present them as close by, everywhere present and everywhere to be feared" (1995, p. 286). He goes on to note some popular culture forms that promoted these sorts of notions:

> This was the function of the *fait divers* [a brief and sensationalist news item], which invaded a part of the press and which began to have its own newspapers. The criminal *fait divers*, by its everyday redundancy, makes acceptable the system of judicial and police supervisions that partition society; it recounts from day to day a sort of internal battle against the faceless enemy.... The crime novel, which began to develop in the broadsheet and in mass-circulation literature, assumed an apparently opposite role. Above all, its function was to show that the delinquent belonged to an entirely different world, unrelated to familiar, everyday life.... The combination of the *fait divers* and the detective novel has produced for the last hundred years or more an enormous mass of 'crime stories' in which delinquency appears both as very close and quite alien, a perpetual threat to everyday life, but extremely distant in its origins and motives, both everyday and exotic in the milieu in which it takes place (1995, p. 286).

Thus, Foucault's notions of the cultural significance of crime and punishment points to the importance of the images of prisoners manifested in cultural forms. Carnochan (1995), for example, points out that prison has been a central image in much Western prose from the picaresque novels of the sixteenth century, through Dickens, to modern authors such as John Cheever and Norman Mailer.

Popular Magazines and Representations of Prisoners

Turning to even more widely read forms of print media, Sloop's (1996) analysis of popular magazine articles about prisons and prisoners from 1950 to 1993 is strongly influenced by Foucault's work. Sloop writes:

> I argue that mass mediated representations of prisoners function as a public display of the transgression of cultural norms; as such, they are a key site at which one may investigate the relationship of the individual to culture in general, as well as the cultural articulation of "proper behavior." Hence, the cultural articulation of the prisoner and the punished teaches everyone, convict and law-abiding citizen alike, his or her position relative to cultural institutions that constitute the culture at large (1996, p. 3).

This argument is clearly consonant with Foucault's (1995) notions of the spectacle of punishment, noted above. Sloop explores popular discourse about prisoners and punishment through a rhetorical analysis of articles about prisoners that appeared in mass market U.S. magazines between 1950 and 1993. Sloop found over 600 articles during this time period that were relevant to his study. Sloop's (1996) rhetorical analysis of the discourse in these periodicals led him to conclude that in the four-plus decades his study covered there were several relatively distinct eras of differing representations of prisoners. For example, during the first decade, the 1950s, representations of prisoners tended to be quite homogenous. During this era, the prisoners discussed in these articles were overwhelmingly represented as white whenever race was alluded to in any way. These white inmates were drawn sympathetically; as generally good, altruistic, human individuals who had stumbled into trouble and were motivated to redeem themselves and capable of rehabilitation. Even prison riots were represented as being caused by inhumane prison conditions rather than by the innate violence of the inmate population. Toward the end of the 1950s, however, Sloop notes the initial emergence of another sort of discourse, one that represents prisoners as inherently dangerous and immoral.

This sort of portrayal was rare during the first era but in the second era, the 1960s, it became a common element in representations of, primarily, black inmates. Thus, Sloop (1996) argues that representations of prisoners in popular magazines became bifurcated during the 1960s. While white inmates continued to be looked

upon sympathetically, a counter-image of violent, dangerous black prisoners began to emerge. Sloop notes that during this era, "there is a consistent and increasingly strong association being made between white male prisoners with intelligence, moral autonomy, and rehabilitation, and African-American male prisoners with the binary opposites" (1996, p. 85). As indicated by Sloop's use of gender-specific terms in this comment, these sorts of changes in magazine portrayals of prisoners were only true for representations of male inmates. Indeed, throughout all of the eras in Sloop's study, images of female prisoners tended to remain fairly constant. Representations of female prisoners were highly articulated with notions of motherhood and virtue, and these prisoners were generally depicted as women who had been corrupted by other people and circumstances beyond their control.

During the third era, from 1969 to 1975, Sloop argues that the images of male prisoners underwent a second process of bifurcation. Whites were still represented as fully human and capable of rehabilitation while the images of black prisoners were now split. While both of the resulting images of blacks still articulated them with violence, for some that violence was portrayed as a justifiable reaction to a racist system, while others were drawn as monsters— essentially evil and completely irredeemable. Articles that touched on issues of prison rape and drug abuse consistently associated these problems with African American inmates. Sex itself was almost never framed as occurring between mutually consenting partners, but rather as violent abuse, primarily perpetuated by predatory blacks against helpless white victims. Furthermore, the prototypical male prisoner was now depicted as non-white despite the fact that approximately 65% of prisoners during this era were white (Sloop, 1996).

In the final period, from 1975 to 1993, Sloop believes there is evidence of a discourse that suggests that prison sentences are the "just desserts" for crimes and that prisoners should simply serve their deserved time. Issues related to the exterior social forces that contribute to criminality, discriminatory criminal justice practices, or the possibility of rehabilitation are considered irrelevant. However, as Gramsci (1972) and Williams (1977) might argue, the sediment of past discourses cannot simply be washed away in this era, and Sloop notes that:

> [T]he arguments of the past serve as a force in the present in such a way that African-American male inmates, depicted as untrustworthy, are represented as receiving their just desserts through prison sentences, while Caucasian inmates and female prisoners in general (the former represented as redeemable and the latter as needing reunion with family) are more frequently represented as serving their sentences through alternative systems of punishment (1996, p. 17).

During this last era, inmates were also increasingly portrayed as animalistic and hyper-violent in both magazines and the few films that Sloop (1996) discusses, such as *Attica* and the documentary *Scared Straight*. Furthermore, prisons were depicted as places where drugs and alcohol flow freely and where even prostitutes are available. While both white and non-white prisoners in this era were often depicted as violent drug-abusers, whites were still represented as potentially redeemable, and thus eligible for alternatives to incarceration, while blacks were depicted as so innately uncontrollable that prisons, particularly ultra-restrictive maximum-security prisons, were the only option for dealing with the threat that they posed to society. Sloop sums up his analysis of this tendency in popular magazine portrayal of prisoners by noting: "In effect, nonviolence and redemption become equated with white men and women in general; irrationality, violence, and an incapacity for rehabilitation are equated with men of color" (1996, p. 174).

The Prison Film as Sub-Genre

Turning to studies of prisoner images in electronic forms of media, there is a fair amount of literature on what Shadoian (1977) calls a sub-genre of the gangster film—the prison film (see, for example, Cheatwood, 1998; Crowther, 1989; Freeman, 1998; Mason, 1998; Morey, 1995; Munro-Bjorklund, 1991; Nellis and Hayle, 1982; Parish, 1991; Querry, 1973; Rafter, 2000; Roffman and Purdy, 1981; Shadoian, 1973; Shadoian, 1977; Zaner, 1989). Cheatwood argues that motion pictures are "the primary medium that has created and supported popular images of what incarceration is..." (1998, p. 210). Based on his content analysis of 56 of the 101 films he initially identified, Cheatwood, like Sloop (1996) in his analysis of magazine portrayals of prisoners, found evidence of four relatively distinct eras of prison films. Depression Era films (between 1929 and 1942) tended to present sympathetic images of wrongly confined inmates. Although the heroes of these films had been subjected to prison despite their innocence, the problems they encountered were never due to systematic problems in American justice, but rather were due to the corruption and evil of deviant individuals. Cheatwood also notes that:

> Few issues that are viewed as problems in the nature of corrections and society in later eras are considered at all in these films. Coercive individual violence, rape, racism, rehabilitation, and the other problems that we now focus on within institutions are almost never addressed (1998, p. 218).

The second era Cheatwood (1998) identifies is the Rehabilitation Era (between 1943 and 1962). In these films the hero is usually no longer wrongly convicted, yet they are still considered to be salvageable, if they will only cooperate with the hu-

mane staff and take responsibility for their own actions. In films of the third era, the Confinement Era (between 1963 and 1980), rehabilitation is no longer regarded so optimistically. This is congruent with changing views of rehabilitation in mainstream criminology of the day. Prisons are depicted as oppressive institutions in most of these films. Problems such as rape, racism, and drugs are depicted more than ever before and prisoners tend to be divided between a few upstanding individuals and many extremely violent, desperate, evil men.

In the final era that Cheatwood's (1998) study encompasses, the Administrative Era (from 1981 to 1995), most of the films in his sample are fantasy based—either science fiction, or horror, like *Escape from New York*, or rooted in romantic visions of the past, like the popular *Shawshank Redemption*. Cheatwood notes that during a historical era when the prison population was higher than it had ever been previously in U.S. history, many films about prison were quite distanced from reality, set in imagined futures or pasts but in no way dealing with the realities of the contemporary period.

Other studies of prison films have identified thematic patterns that persisted across various eras. Mason (1998) for example, notes that themes of escapes, battles with authority, and riots are common in most prison films. He also argues that a central overarching theme is the depiction of the prison as a machine. He notes that many shots in prison films are designed to give the impression of a highly structured, monotonous, and tedious environment, and that prisoners are depicted as being subject to the injustice of this inhuman system.

Contrary to Mason (1998), Munro-Bjorklund (1991) argues that prison films don't really deal with the mundane and monotonous aspects of the routines of ordinary prison life, but rather focus on out-of-the-ordinary high-intensity situations. While this is to be expected of a dramatic art form that needs to sustain viewer interest, it also can lead to a distorted perception of what life in prison is actually like for most people, most of the time. Thus, Munro-Bjorklund argues that:

> The standardization of elements such as riots, escapes, and capital punishment contribute to the image of the convicted criminal as someone to be feared and caged. Riots and escapes point to the continuing need for restrictive, secure, and isolated exclusion for those convicted of crime since even when the criminal is in prison, the potential exists for physical harm to others inside (riots) and outside (escapes) (1991, p. 57).

Another pattern that Munro-Bjorkland (1991) found was the recurring representation of the hero of the film as being wrongly convicted, thus justifying audience sympathy, while the "real" prisoners that surround the hero tend to be exaggerated caricatures of the most violent, vile, and threatening creatures who clearly must be

locked up in order to protect the innocent from the danger they represent. By portraying only the (often-white) hero as innocent and the rest of the (often-black) prison population as predatory and evil, the films are able to both play on the need for viewers to identify with heroes while simultaneously avoiding any indication that perhaps wrongful conviction is a legitimate social problem. This image of the bulk of the prison population as violent, untrustworthy and supremely dangerous further justifies the image of prison as fortress that Munro-Bjorklund also found to be prevalent in prison films.

Another study offers interpretations that are similar to those of Munro-Bjorklund (1991). In her analysis of crime films in general, Rafter (2000) devotes some attention to prison films as a genre, arguing that this genre emerged during the silent film era and continues to be popular to this day. She notes many similarities between prison films across the decades in terms of the cast of characters and stock plots and themes. In terms of characters, for example, Rafter identifies "convict buddies, a paternalistic warden, a cruel guard, a craven snitch, a bloodthirsty convict, and the young hero, who is either absolutely innocent or at most guilty of a minor offense that does not warrant prison" (p. 118) as recurring archetypes in prison films. Stock plots revolve around riots and escapes where the final resolution is a return to order and the triumph of the forces of "good" over the forces of "evil." Stock themes involve stories about rebellion and injustice, control and manhood, and the notion that appearances are deceiving, things are not what they seem: the good guys often turning out to be the bad guys, and vice versa, for example.

One of the crucial elements of Rafter's (2000) analysis is her theorizing of the attractions of prison films for the audience. She argues that these films offer viewers heroes to identify with in the form of the unjustly convicted, and highly moral, leading men, images of perfect friendships (always gendered as male) in the form of the buddies who will sacrifice and even die for one another, and fantasies of both sex and rebellion. Often the sex is an unacknowledged homoerotic attraction between the male buddies. The fourth element of attraction Rafter (2000) identifies is the way that prison films often make claims of authenticity. She notes that, "About half of all traditional prison movies assert that they are 'based on a true story' or are 'fictionalized accounts of an actual event.'... No other genre so loudly proclaims its verisimilitude"(p. 127).

Prisoners in Our Living Rooms

While there has been a handful of studies of prison films and print media depictions of prisoners and prisons, research on the image of prisoners that may be found in

television programs is exceedingly rare (Mason, 1995). The infrequency of this sort of analysis is matched by the relatively low attention, especially in comparison to the media obsession with crime, that television pays to prisons and prisoners. There have been few television programs that have had prisons or prison inmates as their primary focus (Schwartz, 1989; Surette, 1998b). The recent cable program, *Oz*, may be the first U.S. television series to be set in a prison and focus primarily on prison inmates and staff. More recently Fox has had success with the fantastical program *Prison Break*.

Despite this lack of programs that specifically focus on prisons or jails, I contend that prisoners do appear fairly regularly in bit parts and background roles in many popular crime dramas, such as *Law & Order* and *NYPD Blue*, and that there are occasions when individual episodes of a "non-crime" drama will focus on prisoners in the context of one particular story line. I also argue that these television images of prisons and prisoners may be very influential in shaping viewers' perceptions of incarceration. For example, Belgian researchers Van de Bulck and Vandebosch (2003) interviewed inmates about their prison experiences and how they compared to television stories about incarceration. The researchers were careful to not introduce the notion of media influence to their respondents, yet:

> It is noteworthy that the expectations of most of the inmates on entering the system were mainly based on television and movie images of prisons in the United States. They realized where they got their information from. They made explicit references to American audiovisual fiction. From it, they seemed to have been led to expect that the majority of inmates would be convicted of very serious crimes, that the experienced inmates would subject newcomers to an initiation ritual and that rape and violence were part of the daily fare of prison life (Van de Bulck and Vandebosch, 2003, p. 108).

Interrogating U.S. Television and the Representation of Incarceration

In the absence of much systematic research on the images of prisons and prisoners on television, we are left with a number of interesting findings and interpretations but also many questions. In subsequent chapters I hope to provide some clear answers to the lingering questions about how the U.S. television industry tends to represent life in America's prisons. These questions include: What images of prisons and prisoners are most commonly found in U.S. television news and dramatic programming? More specifically: What recurring thematic patterns and archetypal figures are dominant in television programs that feature images of prisons and prisoners? How do prime-time television dramas and television news cohere into a consistent or contradictory storytelling system that serves as a potential source of messages and lessons about incar-

ceration and the incarcerated? How do issues of gender, race, class, and sexuality inform these representations and how do these representations contribute to public discourse around gender, race, class, and sexuality? What are the potential public policy implications of the recurring patterns of discourse, representation, and signification in these programs? Furthermore, how do these images and stories of prison life coincide with or contradict the stories that prisoners tell about their own experiences in the U.S. prison system? How do prisoners themselves respond to the television industries' representations of their daily lives?

To answer these questions I immersed myself in television images of incarceration. I analyzed eight weeks of local news coverage on four stations located in Hartford, Connecticut, a midsized television market situated midway between Boston and New York. I also utilized the Vanderbilt Television Archives to examine national news coverage from 1990, 1995, and 2000. These three years were selected in order to provide a cross section of network news coverage of the penal system during a decade of rampant incarceration. As for fictional television representations, I examined four prime-time dramas that focus on the criminal justice system: *Law & Order*, *NYPD Blue*, *The Practice*, and *Oz*.

In order to provide a sense of context for this textual analysis of television images and narratives I also interviewed 26 individuals who had served time in prison for serious crimes. All but one of these respondents was male. Racial distributions were similar to the racial makeup of America's prison population: 12 blacks, 9 Latinos, and 5 whites. Ages of the respondents ranged from the early 20s to the early 50s. I asked my respondents to describe their daily routines and their relationships with other prisoners and prison staff. Specific questions focused on concrete situations related to the prison experience: sexual relationships, friendships, violence, upheavals, privacy, punishment, race relations, drugs and drug abuse, visitation, work, education, recreation and leisure, food, sleep, hygiene, health, safety, and therapeutic and rehabilitative programs. These issues have been identified as central to the lives of prisoners throughout much of the vast literature about life in America's prisons that has been created by prison inmates and those who work closely with them (for just a small taste of this abundant literature see: Abbott, 1981; Abu-Jamal, 1995; Burton-Rose, 1998; Cleaver, 1968; Conover, 2000; Girshick, 1999; Jackson, 1970; Lawes, 1932; Leder, 2000; Prejean, 1993; Rideau and Wikberg, 1992; X and Haley, 1964).

In the following chapters I utilize the theoretical perspectives outlined in Chapter Two and the insights of previous empirical research reviewed in this chapter to explore the television industry's stories of incarceration and I compare and contrast

these stories with those told by people who have actually lived inside America's prisons and jails.

CHAPTER IV

The News Hole
Local Television News and the Lack of Coverage of U.S. Prisons

"You got to realize—the media, the media makes everything look so bad, and they make the Governor like he's doing a great job. Department of Corrections—the Commissioner is doing such a great job. So everybody votes for him—everybody, you know what I'm saying, everybody believes that. So they're going to believe what the media tells them and what they read in the newspapers and therefore... keep up the good job... great job!"— "Cal"

An Era of Incarceration

The criminal justice system is composed essentially of three components: law enforcement, the courts, and corrections. While these three components are obviously linked, media coverage of the third component, corrections, has been the most neglected in terms of scholarly research (Cheatwood, 1998; Surette, 1998b). This chapter addresses this neglect through an analysis of local television news items about prisoners and the penal system. Examples of local television news for analysis were gathered through randomly selected week-long samples of the four network-affiliated news channels available in the Hartford-New Haven television market.

Scarcity of Coverage

The first and most obvious finding that emerges from this sample of eight weeks of local television news is the scarcity of coverage of the penal system. Out of the 56 broadcasts examined only 2 included stories about prisons. In the entire sample of 33 hours of news coverage 59 seconds were devoted to information about the prison system.

While it is impossible to definitively state what the "right" amount of coverage of prisons would be, these results may be interpreted by providing some contextual information. For example, the infrequency of items devoted to corrections in this sample stands in stark contrast to the attention devoted to other aspects of crime and criminal justice in these broadcasts. While only two broadcasts in the sample included any news at all about the corrections system, the reverse was true for other aspects of the criminal justice system. Only 2 of the 56 separate broadcasts analyzed

did *not* feature crime-related news of one sort or the other. Most broadcasts included multiple stories of unsolved crimes, police activities, arrests, sentencing, criminal court proceedings, and the like. In fact, prisoners were most likely to appear on screen, not in their daily state of incarceration, but in still photos or video of court proceedings during stories dealing with criminal trials, a pattern that I discuss in more detail below.

Thus, while corrections was almost never covered, crime and other aspects of the criminal justice system were central foci of this eight-week sample of local television news. This finding is consistent with the conclusions reached by previous researchers about the prevalence of crime coverage in local news broadcasts (see, for example, Entman and Rojecki, 2000; Kite, Bardwell, and Salzman, 1997). Again, to put this finding into context, this 59 seconds may be compared not just to coverage of crime in general but to other issues apparently deemed more important, or at least more worthy of airtime, by the gatekeepers of these four news outlets.

For example, the 59 seconds devoted to coverage of corrections in the entire eight-week sample might be compared to the amount of time devoted in just one broadcast to a story on the creative new advertisements that viewers could expect to see during an upcoming Super Bowl game—1 minute and 18 seconds. Or we could compare this 59 seconds to an item promoting the new season of an MTV program, *The Real World*, which ran 2 minutes and 19 seconds. Or, to put this finding into context, we could consider the January broadcast that spent 10 minutes and 28 seconds on an impending snowstorm that was threatening the state. In fact, the list of examples of items that received much more attention than the corrections system could go on and on. The point, however, is this: While reporting on crime is one of the mainstays of local television news, only two of the three branches of the criminal justice system receive substantial coverage. While the activities of the police and the courts were featured in nearly every broadcast in this sample, corrections was nearly invisible, receiving far less coverage than even questionable "news" about the entertainment industry and the like.

Prisons without Prisoners

The first broadcast, which included a news item about the penal system, offered a total of 37 seconds of coverage in two back-to-back stories. The first story appeared 5 minutes and 17 seconds into the broadcast and was a brief (17 seconds) note about the aging of Connecticut's prison population. No actual scenes of prisons or prisoners were shown during this item. The news anchor merely read the item while the camera remained fixed on a close-up of his face. To the right of the anchor's face was

an accompanying graphic in a box that filled almost a quarter of the screen. This box contained the words "Prison Population" and a somewhat blurry photo of a row of prison cells. Prisoners' arms could just barely be seen poking out of the cells. The text of the news item read as follows:

> Anchor: The state's prison population is getting older and fast. The number of inmates in Connecticut's prison system that are over the age of 60 has more than tripled in the past decade. The Department of Corrections says that there are 185 such inmates, 2/3rds of them committed crimes later in life and half committed violent crimes.

This item was immediately followed by another brief (20 seconds) note about plans to renew a contract with Virginia to house inmates in order to alleviate overcrowding in Connecticut institutions:

> Anchor: Speaking of prisoners in the state, Connecticut's Prison and Jail Overcrowding Commission is recommending the state renew its contract with Virginia to ship several hundred inmates there. Right now 500 Connecticut inmates are housed in Virginia's Greenville Correctional Center. They were originally sent to Wallens Ridge Prison but were later moved after controversy surrounding the deaths of two Connecticut prisoners.

While the anchor read the above text, file footage of an unidentified prison (or prisons) appeared on the screen. First, a shot of an empty hallway and closed cell doors sliding open with the words "Shipping Out of State" along the bottom of the screen and a note that this was file footage. Then, a shot of an empty metal stairway and two tiers of empty cells. Next, an exterior scene of a prison tower ringed by barbed wire and surrounded by large floodlights. Then several quick exterior shots of prison walls, floodlights and barbed wire. Finally, the item ended with a brief image of two white officers, a male and a female, talking behind what appears to be some sort of metal gate.

What stands out most about these two items, aside from their brevity, is that no actual prisoners appeared in the visuals used to accompany either story. The first story utilized a still photograph that included barely visible prisoners' arms sticking out of cells, while the second story showed scenes of an actual prison (or prisons—it was impossible to tell if the footage was filmed at one institution or several), but no inmates could be seen at all. This is particularly interesting because of the nature of the story itself. This was an item about steps being taken to alleviate prison overcrowding. Yet, ironically, the images that accompanied the text were of a prison environment that was devoid of prisoners. Instead, the viewer was offered exterior footage, a brief shot of two corrections officers interacting with each other, and scenes of empty cells. Thus, even in one of the rare moments when prisons were the focus of a local television news story, prisoners themselves remained invisible. In fact,

based on the shots of empty interior areas of the prison, it was impossible to tell whether any one had ever lived in this environment. Everything that was shown appeared immaculate and new. The floors and walls almost sparkled. There was no sign that human life had ever intruded on this pristine environment. These scenes very well could have been taken directly from public relations footage of a brand new facility before it had ever even been used.

The only other news item about prisons in the entire sample was another very brief story (22 seconds). The item began with a close-up of the anchor and the exact same graphic, described above, of slightly blurry cells with prisoners' arms sticking out of them that accompanied the first prison story noted above. This time, however, the words in the graphic read, "Prison Expansion." The anchor read the following text:

> A prison expansion plan is growing in Somers. The Northern Correctional Institution was supposed to add 600 beds but that number is up to 720. The 20% rise is on the agenda of the state Bond Commission meeting tomorrow. Correction leaders are expected to ask the Commission for the green light on a $500,000 study of the plan which would look at the effect on Somers.

This text was accompanied by a series of visual images. First, the graphic noted above. Then a blue sign with the words "Northern Correctional Institution" and the seal of the state of Connecticut. A background of green trees blowing in the breeze surrounded this sign. The words "Expansion Plan Growing" appeared at the bottom of the screen, along with a note that this was file footage. The next shot was of something that appeared to be a water tower standing in a green field. Then there were two brief close-ups of barbed wire fences, the first in front of a brick building, and the second in front of green trees. Next a brief shot of a white male corrections officer standing in an area that was presumably just outside the prison and allowing an automobile to pass through, followed by another shot of the blue sign surrounded by greenery, and finally two more close-ups of barbed-wire fences.

As in the first two items, this story was marked both by its brevity and by the lack of any images of prisoners whatsoever. One might reasonably presume that the need for an expansion plan might be somehow related to conditions of overcrowding, yet again, no prisoners at all were visible. In fact, this item retreated even further than the previously discussed story from providing any documentary images of prison life by never showing any interior signs of the prison at all, and barely showing the exterior. Instead viewers were shown multiple outdoor images—a sign, surrounded by greenery; something that resembled a water tower, surrounded by greenery; a fence, surrounded by greenery; and a corrections officer…surrounded by greenery. Just as

the images in the previous item, described above, signified a sense of pristine cleanliness, the images in this story were all very peaceful—green bushes and trees swaying in the breeze. Presumably this is a very different image than that which prisoners of the Northern Correctional Institute might think of when its name is invoked. Again, there is something ironic here—a story about prison expansion accompanied by multiple shots of the outdoors, an outdoors that the prisoners themselves probably do not get to experience very much.

Prisons without Context

Thus, in the entire eight-week sample only three brief stories about prisons were aired, and in these three, prisoners did not exist. It is not just that they were not heard from; they were not even seen. In addition to these images thus providing viewers with no sense whatsoever of what actually occurs in Connecticut's prisons, the information that was provided was baffling because it was devoid of context.

In the first story viewers were told that Connecticut's prison population is aging. A viewer might wonder why this is so. What might be some of the possible causes for an aging prison population? Stricter, longer sentences, more restrictive parole boards, the effects of mandatory minimum sentences and three-strikes laws; none of these, or other possible factors, were discussed. Furthermore, what are the consequences of an aging prison population? How might facilities need to be changed in order to accommodate an older population? What are the potential economic issues at stake here? Should older and younger inmates be segregated from each other in order to protect older inmates, or might older inmates be a calming force on a younger, potentially more volatile population? Are these older inmates receiving the proper medical care that they might require? According to several of the ex-inmates I interviewed prison medical care is indeed a serious issue for inmates of all ages. For example, during one focus group respondents were asked what happens if a person gets sick while they are locked up:

> Harry[4]: You got to wait for a sick call. You sign up.
> Daryll: You sign for a sick call and you got to wait for them to call you.
> Harry: Half the time they don't call you, they don't do anything.

And in another group:

> Interviewer: What happens if you get sick?
> Evan: Nothin'.

[4] I rely on pseudonyms to protect the anonymity of the respondents. In addition, I changed the names of the facilities that interviewees refer to at their request.

Ray: Give you penicillin and see you later. Or Tylenol.

Nomar: Like, I broke my ankle... they give me some ice and give me something to drink and that's their whole attitude.

Evan: I take (inaudible). It's a medication I have to take every day. If I don't I can go into a coma and die... and there's no reversing the coma. It would go four weeks at a time... they wouldn't have it in the facility.

The closing sentences of the report informed viewers that 2/3 of the aged prisoners committed crimes "later in life" and that 1/2 committed violent crimes. These final notes provide a sense of ideological closure to the story. Certainly, this random information might short-circuit any questioning of the wisdom of incarcerating the elderly.

The second story also dropped random pieces of information on the viewer without providing any background or context from which to make sense of what was included in the report. The viewer was told that Connecticut would most likely renew a contract to send prisoners out of state in order to alleviate overcrowding in local institutions. Why are Connecticut prisons overcrowded, however? Again, what are the causes of prison overcrowding? More generally, why does the U.S. increasingly lock up more and more of its citizens? Are there other ways to alleviate overcrowding than by "shipping" prisoners out of state? What alternatives to prison might be possible? What are the consequences of prison overcrowding? What is it like to live in such conditions? What does prison overcrowding look like, what does it lead to, how might it contribute to unsafe or violent conditions? Again, the people I interviewed noted how overcrowding exacerbates problems behind bars:

Evan: And they're packing more inmates in, like Foxbury. That's supposed to hold anywhere between 1,000-1,500 inmates. They'll pack 2,000-2,500 inmates in there at a time. I mean you got people sleeping in beds in the gym, sleeping in beds the (inaudible) room. There's no room to put 'em anywhere. They're doing the same thing in all of them.

Interviewer: Does that increase the problems that occur?

Evan: Yeah! You get more agitation. You can't even go to the bathroom without having to step over six people.

Ray: Like right now in Thomasville they have a dayroom, a TV room, a study room. All three of those taken by bunks—inmates that they just put in there. Extra inmates. That jail is only supposed to hold like 400 inmates. They got like 1,000. That's a security risk. Fire hazard. They could start a mini-riot in jail and they don't know what to do because... they only hold like 20 officers to 1,000 inmates.

The closing sentence of the previously mentioned item about sending prisoners out of state was even more problematic, however. The viewer was told that inmates "were originally sent to Wallens Ridge Prison but were later moved after controversy surrounding the deaths of two Connecticut prisoners." The item ended on that note

and the anchors moved on to an unrelated story about a fire. Viewers were told nothing about the circumstances surrounding the deaths of two Connecticut prisoners in a Virginia institution. Now, certainly not every piece of information relevant to every story aired in a half-hour or even an hour news broadcast can be afforded full background coverage. However, it would not have taken an inordinate amount of time to provide some basic background information that might have offered viewers a fuller understanding of some of the potential consequences of transferring Connecticut prisoners to Virginia. How long would it have taken in this broadcast to inform viewers that one of the two prisoners committed suicide and the other died after a being repeatedly shocked with an electric stun gun? Conceivably, viewers might also have benefited from the information that the American Civil Liberties Union sued the Connecticut Department of Corrections over these and other cases of inmate abuse in Virginia prisons, or that Wallens Ridge was the subject of an Amnesty International investigation, which reported that:

> Prisoners in Wallens Ridge State Prison (WRSP) are routinely abused with electro-shock stun guns, subjected to racial verbal abuse by guards, fired on with painful pellet guns, and placed unnecessarily in five point restraints, according to new reports received by Amnesty International. There is also concern about the treatment of mentally ill prisoners and a lack of rehabilitation programs at the prison.... The deaths of two Connecticut prisoners in WRSP last year, and mounting complaints about the use of force and alleged racist treatment of minorities in the facility, sparked a number of investigations into WRSP by organizations in Connecticut (Amnesty International, 2001. Available at http://web.amnesty.org).

The abuse that was of concern to Amnesty International and the ACLU came up spontaneously during one of my interviews. One of the respondents mentioned that he had done time in Virginia and talked about the treatment he witnessed:

> Mike: A dude died down there. They was just doin' a lot of... They got shockers, like if you don't like listen they shock you. Then they got guns, they got guns and they like on the roof and they got guns pointing at you. Down there they're like real, like country. They go by lines and stuff. Like if you go over a certain line, like when you come out your cell you got to stand on that line. You go over that line they can be forced to shoot at you with the rubber buttons.

The Amnesty International report goes on to state that a number of the allegations about abuse apply not just to Wallens Ridge but to many other Virginia prisons as well. To provide the full context for this story, and to make the information it provides relevant, would thus require a more thorough accounting of the background behind Connecticut's decision to continue sending inmates to Virginia despite a history of problems. Interviews with inmates, or ex-inmates, who have been in Virginia institutions would be one place to start. But even in the absence of this type of in-

depth coverage, which would require an investment of both resources and air-time, it would not have taken much of either to provide at least some context to this story.

The final prison story that appeared in this sample of local television news was also an extremely brief item that appeared without any real context. Viewers were told that a prison expansion plan was growing even larger and that a $500,000 study was in the works, but this information was never put into the context of the nation-wide prison boom that has enormous social and economic implications. Again, why the need for so many more prison beds in an era when crime itself was on the de-cline? Who is being locked up and why are they being locked up? Are prisons really effective in deterring or responding to crime? What do we really expect from prisons anyway? Rehabilitation? Punishment? What are the economic consequences of put-ting more and more funding into prisons and less and less into education and social welfare programs? How might concerned viewers be able to participate in the debate over whether prison expansion is really a sound political policy? In the absence of any attempt to deal with even one of these questions, this story, once again, provided little more than bits of basically irrelevant information. Lewis has called short news stories like the three under consideration here, "strange fragments from another story told somewhere else" (1991, p.131).

Episodic vs Thematic News Frames

Another way of looking at it is that these three stories are essentially examples of what Iyengar (1991) has called the "episodic" framing of news. Episodic news stories are based on case studies or single events. Iyengar distinguishes them from "thematic" stories that deal with more general or abstract concerns. Iyengar notes that, "The essential difference between episodic and thematic framing is that episodic framing depicts concrete events that illustrate issues, while thematic framing presents collec-tive or general evidence" (1991, p. 14). A story on the U.S. prison population explo-sion that went beyond reporting the latest statistical data and provided background information and discussion of the problem would be a thematic story, while the item cited above, on a particular prison expansion plan, is an episodic story. Both might be considered to "be about" the prison population problem, but only the former, hypo-thetical story, moves beyond a particular instance to provide what might be consid-ered "deep" background or analysis.

Iyengar cautions that most stories are not entirely one or the other, but that typi-cally there is a tendency for one or the other (usually the episodic) frame to be the dominant one. Thus, the first item cited above, on the aging of Connecticut's prison population, is not based on a single incident or a particular event, but it also doesn't

provide the type of background or analysis that one might expect from a fully thematic story. Iyengar also acknowledges that there are structural reasons why most television news tends to be episodic:

> [C]onstraints of time, advertising, and professional ethics explain why most television news reports focus on concrete acts and breaking events. Episodic reports present on-the-scene coverage of "hard" news and are often visually compelling. Thematic coverage of related background material would require in-depth, interpretive analysis, which would take longer to prepare and would be more susceptible to charges of journalistic bias. Moreover, there simply is not airtime available to present thematic background on all issues deemed noteworthy (1991, p. 14).

Iyengar's essential point about structural constraints is well reasoned. However, the notion of a lack of airtime becomes somewhat less defensible when one takes into account instances noted above, such as the 2 minute 19 second promotion of MTV's *The Real World*, or the 10 minute 28 second snowstorm story. The commercial nature of U.S. television news and the professional value of "objectivity" are stronger explanations for why discussion, analysis, and interpretation of news items are avoided. A story that attempted to analyze the prison population problem, or even one that defined it as a problem to begin with, would run the risk of being labeled as politically motivated or biased. This of course ignores the fact that simply reporting the ever-growing numbers of inmates *without* attempting to provide any explanations, or pose any questions, represents its own form of ideological bias.

In addition to this sort of internal professional constraint on the form that news can take, there is also the need for television news in a commercial media system to remain competitive in the bid for advertisers and high ratings. This inevitably will influence the form and content of the stories that are aired (see Bagdikian, 2004; Herman and Chomsky, 1988; and McChesney, 2004; among others, for discussions of advertising's influence on news content). In-depth discussion of unpleasant social realities that moves beyond lurid facts and stimulates critical thinking on the part of the audience is not believed to provide for the same sort of allure or congenial selling atmosphere that is required of news in a commercial media environment.

Regardless of the reasons why television news tends to be primarily episodic, however, Iyengar's research suggests that there are some definite social consequences of this type of reporting. Thus, one of the problems with this sort of brief, fragmented news report is that viewers do not receive enough information for them to connect the dots to the larger social issues at stake. All they are left with are individual attributions of responsibility. In the case of news about prisons and prisoners, viewers who receive only episodic news reports are unlikely to be able to identify the political factors behind the reasons why more and more Americans are being locked

up, why poor, working-class, and non-white citizens are more likely to be imprisoned, etc. Instead, all we are left with is the notion that if prisons are crowded there must be more and more criminals who need to be locked up, which must mean the world is an increasingly dangerous and terrifying place (see Gerbner, Gross, Morgan, Signorielli, and Shanahan, 2002). The issue here is not whether this notion is ideologically "right or wrong" but whether it is *factually* correct or incorrect. As many critics of the U.S. penal system have pointed out, the prison population explosion has not occurred because of any objective need to lock up an ever-increasing army of criminals. Even as the rates of crime, and particularly violent crime, declined during the latter part of the twentieth century, the rates of imprisonment continued to rise (see, among others, Abramsky, 2002; Austin and Irwin, 2001; Chriss, 2007; Davis, 2003; Donziger, 1996; Dyer, 2000; Irwin, 2005; Mauer, 1999; Reiman, 2001).

What did rise along with incarceration during this period, however, was the amount of crime displayed on television. Despite the few stories about prison that appeared in this sample, prisoners appeared, and were referred to (but not heard from), frequently. The context in which this occurred, however, may be said to represent the epitome of episodic framing.

A Parade of Prisoners

While prisoners were literally unseen in the few stories on prisons that I found in this sample, they did appear frequently in stories of arrests and court proceedings. I found 52 examples of stories that included images of prisoners in court or being transported in my sample of 56 broadcasts. These stories appeared in 34 out of the 56 broadcasts included in the sample. Thus, more broadcasts included images of, or references to, prisoners than did not. Every single one of these 52 stories represented an example of episodic rather than thematic reporting. They all focused on individual prisoners and specific events—an arrest, a disposition, a sentencing, etc.—without any references to more general issues related to crime or the criminal justice system.

Also similar to the results reported by Iyengar (1991), the focus of most of these stories was on prisoners who had committed violent crimes. For example, in their study of local television news, Klite, Bardwell, and Salzman (1997) found that violent crimes received the most coverage, and murder received more coverage than any other crime (53.3% of all airtime devoted to crime-related news). This frequency of coverage of violent criminals far outweighs the proportion of violent offenders in the nation's prisons and jails.

Distortions and Misrepresentations

In order to be fully interpreted, the tendencies in local television news portrayals of prisoners must be compared to data gathered from the other world, the world that surrounds our television screens, the world that, for lack of a better term, may be referred to as the "real world." For example, almost 87% of the stories in the sample that included images of, or references to, prisoners were about *violent* prisoners (or, at least, prisoners who had committed crimes of violence). However, data from the U.S. Department of Justice reveal that only about 30% of those newly sentenced to prison receive those sentences for violent offenses. Similarly, only 25% of parole violators that are returned to prison are considered to be violent criminals. Contrary to what the items in the sample would suggest, most of those who are sent to prison are committed because of property, drug, or public order offenses (Austin and Irwin, 2001).

This distortion is exacerbated when it comes to the most violent crime of all—murder. 63% of the inmates who appeared, or were referenced, in this sample were imprisoned for the killing of another human being. In reality only 2.7% of those who are newly sentenced to prison receive those sentences for murder or manslaughter. This number is even lower for parole violators who are returned to prison—1.4% (U.S. Department of Justice data, reported in Austin and Irwin, 2001). Viewers of local television news thus receive a highly skewed picture of patterns of incarceration, and the episodic nature of these news items reinforces this misinformation. Absent any discussion, analysis or background information, viewers are left with nothing but these isolated events and distorted images that suggest that the prison population is composed of, primarily, killers and other violent criminals. This is not to argue that there are no violent individuals in our nation's prisons and jails. The point simply is that local television news exaggerates and inflates the numbers of inmates who are imprisoned for violent behavior to such an extent that the inmate population depicted on television bears little resemblance to the actual inmate population in the U.S. When considering aggregate data, television inmates, like television criminals in general, are much more violent and commit much more heinous crimes than the inmates who actually reside in the nations' prisons and jails.

There are other distortions as well, in terms of who is really being sentenced to prison. For example, 59 inmates were depicted or referred to in these 52 stories. Almost 24% of these inmates were women. While the number of women incarcerated each year is growing at a rate that is even more severe than that of men, this is still a serious distortion of the gender makeup of U.S. prisons and jails where approximately 7% of the inmates are female. The number of female inmates depicted in this

sample of local television news may have been skewed by the frequency of items on high-profile cases involving female defendants such as Andrea Yates, the Texas woman who was found guilty of murdering her five children. However, this may also represent the tendency for more media attention to be devoted to cases involving females who commit acts of violence because of the relative novelty of this sort of occurrence. In a culture where violence is typically carried out by men, images of violent women appeal to the news media's drive to focus on bizarre, out-of-the-ordinary events while simultaneously providing a morbid spectacle for viewers who may be bored by stories that focus on the "usual suspects."

In addition to distortions involving gender, there were also misrepresentations of the racial/ethnic makeup of U.S. prisons and jails. Based on a subjective accounting, almost 58% of the inmates depicted appeared to be of white, non-Latino backgrounds, almost 14% appeared to be of black, non-Latino backgrounds, and 5% appeared to be of Latino heritage.[5] These figures represent a significant distortion of the racial makeup of America's prisons. As Austin and Irwin (2001) report, in actuality approximately 49% of U.S. prisoners are black and 18% are of Latino origins.

While the U.S. news media have been rightly criticized for over representing the amount of crime committed by blacks and Latinos (see, for example, Dixon and Linz, 2000; Entman and Rojecki, 2000), these results indicate an interesting reversal of this tendency when it comes to depictions of prison inmates. Representations of the incarcerated in this sample of local television news overemphasized the extent to which the prison population is made up of white inmates, and underrepresented the extent to which the prison population consists of black and Latino inmates. Again, because these were episodic news items that referred to only specific individuals and incidents without any references to the larger issues this can lead to distorted perceptions of how the U.S. criminal justice system actually works. As Cole (1999), Mauer (1999), and Miller (1996), among others, have reported, blacks and Latinos in the U.S. are actually more likely than whites to be arrested, to be found guilty, and to be sentenced to prison, even when it comes to the same types of offenses. The patterns represented in this sample, however, suggest just the opposite— that it is whites that are most likely to be under the control of the U.S. criminal justice system. This is a distortion that, combined with the media's emphasis on black and Latino criminality, and in the absence of other information, could lead viewers to the erroneous percep-

[5] These numbers include a few individuals who were counted more than once. Every time an inmate appeared in a separate story they were counted. Some individuals appeared in multiple stories across broadcasts. When race/ethnicity was at all ambiguous the individual was included in an "unknown" category.

tion that the U.S. criminal justice system discriminates against whites. After all, after viewing many hours of television news, viewers will have seen vast numbers of black and Latino criminals. If the incarcerated are simultaneously disproportionately depicted as white, viewers may come away with the notion that while blacks and Latinos commit the most crime, whites are the most likely to be sentenced to prison. In fact, the opposite of this is true.

Visual Images of the Incarcerated in Local Television News

The visual images that accompanied these stories about arrests and sentencing also contributed to representing the incarcerated as dangerous and violent. Often, still photographs of the inmates appeared on the screen while the anchor read the details of their crimes. All of these photographs were headshots of menacing looking individuals glaring at the camera. Often they were blurry or out of focus close-ups that appeared to have been taken for police files. Whether or not these photos were official police mug shots, they were evocative of much of the same connotative associations. It is useful here to consider what Sturken and Cartwright have said about the impressions generated by the mug shots of O.J. Simpson that graced magazine covers in 1994:

> The conventions of the mug shot were presumably familiar to most people who saw the covers of *Time* and *Newsweek*. Frontal and side views of suspects' unsmiling, unadorned faces are shot. These conventions of framing and composition alone connote to viewers a sense of the subject's deviance and guilt, regardless of who is thus framed; the image format has the power to suggest the photographic subject's guilt (2001, p. 24).

Time took things a step farther by darkening Simpson's photograph, thus evoking an ideological articulation between blackness and criminal danger. There was no indication of any such chicanery in the photographs that were used in these broadcasts. However, just the use of still photographs that resemble mug shots in this fashion does suggest a sense of guilt, criminality, and danger that is associated with the inmates that were thus depicted, as well as with the incarcerated in general in U.S. culture.[6] It is also important to recall what William Horton said about the still photograph of him that was so widely disseminated by supporters of George Bush during the 1988 presidential campaign:

> At the time the photograph was taken, I was a suspect in the rape case. I was still recovering from the gunshot wounds. After two surgeries, they took me from the hospital to the Upper

[6] During the course of my study, several people asked me if I was nervous about the prospect of conducting interviews with individuals who had been incarcerated.

Marlboro Detention Center, where I was placed in a cell in the hospital for three or four days. They alleged that while there, I attempted to escape through the ceiling. They then placed me in segregation, where I stayed for two and a half to three months, after which I was taken down, fingerprinted and booked. During that period, I was denied the right to have a shave or a haircut. I only had three or four baths during those several months. It was then that they took the picture. That's why I looked like a zombie. Again, it wasn't an accident. They chose the perfect picture for the ads. I looked incredibly wicked (quoted in Eliot, 1993, p. 203).

It is this sense of "zombie-like" wickedness that was suggested by the still photographs that were used to accompany many of the news stories about inmates in this sample. When video footage was used, typically it was of inmates either being transported to or from court or sitting in a courtroom during a proceeding. Often the inmate was dressed in prison garb, shackled or handcuffed, and escorted by several guards. The manner in which a Latino inmate who appeared in three of the items in the sample was consistently portrayed is typical of the sorts of visual images that were used. This inmate was always depicted in the custody of several guards who surrounded him as they led him down a stairway and out of a building. His face was barely visible and he was shackled in every shot. Many of the shots were taken from behind wire fences. While one could argue that these images were simply documenting reality, they also operated on another level—the connotative level. One interpretation of these images suggests that all of these elements—the guards, the handcuffs and shackles, the prison garb, the wire fences—may work together to signify three main ideas. First, the tendency for the inmates' faces to be hidden or unclear, combined with the prison clothing, served to depersonalize those who were depicted in this manner. They were not real, individual human beings with families, connections, histories, they were simply prisoners. Secondly, the elements included in the shots seemed to represent the dangerous nature of the inmates. Anyone who requires these sorts of physical restraints, along with multiple guards to accompany their every move, must pose a serious threat to those around them. In one of the rare shots when an inmate's face could clearly be seen, a young black male in custody appeared to be grinning, which, considering the context, could be interpreted as a sign of malevolence or derangement. Finally, however, these visual images also may suggest that the danger posed by these deviants was being dealt with. Yes, these are violent misfits who are liable at any moment to commit horrendous acts, but the power of the state has them under control. They are shackled, they are in the custody of society's protectors, they are behind fences. They are *contained*, as powerfully signified in one item by the shots of a black male inmate laying face down in the back of a police car.

In their study of local television news in Chicago, Entman and Rojecki (2000) found that blacks in crime stories were more likely to be depicted in handcuffs or police restraints than whites. This pattern also held true for the depictions of inmates in the sample of local television news I examined. There were 37 cases where determinations could be made about both the inmate's race and whether or not they were depicted in physical restraints. Only 10 of these 37 inmates were shown in restraints, but 50% of those were black or Latino. (As noted above, only 19% of the inmates depicted in the sample were black or Latino.) While whites were more than four times as likely to be depicted unencumbered by physical restraints, blacks and Latinos in the sample had about a 50/50 chance of being depicted in shackles (see Table One).

Table 1: Race and Physical Restraints

	White Inmates	Black/Latino Inmates
Physical Restraints	5	5
No Physical Restraints	23	4

Entman and Rojecki's conclusions about the implications of this sort of pattern in their study are applicable here:

> Such images attach a heightened degree of threat to Blacks, who seem to require physical control or restraint twice as much as Whites. Night after night the parade of Blacks in the literal clutches of police authority far more than White defendants sends a series of threatening images that insinuate fundamental differences between races (2000, p. 83).

Tabloidization and Local News about Prisoners

Another important pattern in this sample of local television news is the extent to which stories of prisoners in non-local cases were covered. These stories concerned prisoners who might be labeled quasi-celebrities because of the amount of media attention their cases drew. Local television news often tries to distinguish itself from the national news outlets through its emphasis on stories that are of primary concern to the regional markets that they serve. Producers can thus attempt to justify the amount of coverage devoted to local crime by falling back on the insistence that is of interest to area residents. However, in certain cases, this local emphasis seems to be

dispensed with. This is particularly the case when it comes to the "tabloid-type" story that Fox and Van Sickel (2001) believe is becoming increasingly common in the U.S. media. Examples of this were found in multiple stories that covered the latest developments in the trials of quasi-celebrities such as the "Hockey Dad" who beat another parent to death at his son's hockey game, or Andrea Yates, the Texas woman who murdered her five children, or the attorneys who were implicated in the case where a large dog that was supposed to be under their care killed a jogger. Although none of these stories were local to the market that this sample was drawn from, and all received saturation coverage in the national news media, they were still heavily covered by these local stations.

The "Hockey Dad" story and the Andrea Yates story each appeared four times in the sample, and each was featured as "breaking news" at the top of a broadcast. The Yates story alone received 5 minutes and 53 seconds of coverage during the broadcasts included in this sample, six times the amount of coverage devoted to stories about the penal system itself. This is particularly striking because this is a sample of *local* news. In other words, this story of a gruesome, bizarre case in Texas received six times as much coverage as the entire Connecticut penal system in a sample of local Connecticut news.

Again, the commercial nature of television news in the U.S. has to be considered the primary explanatory factor in cases such as this. The central reason why stories like the Yates murders draw saturation coverage from not just national but also local news outlets is because they are thought to pull in high ratings. Just like all of the other stories about inmates in the sample, the Yates stories were entirely episodic. They did not address the larger issues of domestic violence, mental health, child abuse, women's health care, and the like, that were certainly relevant to this case. Instead the stories focused solely on the bizarre details of the crime, the husband's reaction, the disposition of the court, etc. The way the Yates story was covered in these broadcasts does nothing to enrich viewers' understanding of social conditions in the U.S. in the way that in-depth coverage of the penal system might. However, it does ensure that advertisers are kept happy with the prospect of large audiences being fed sensational and arousing, but safe and unchallenging, material.

Perhaps the quintessential example of an episodic framing of a news story appeared in another national story that the local news outlets chose to cover, the sentencing of Jamil Abdullah Al-Amin (formerly H. Rap Brown, an activist who was most famous during the civil rights struggles of the 1960s) to life in prison for the alleged killing of a police officer. The anchor announced the crime and the sentence and Al-Amin's previous involvement with the Student Non-Violent Coordinating

Committee while video of Al-Amin in the courtroom was shown. The entire story was given 23 seconds of airtime.

There was no mention of any background information related to the crime, or Al-Amin's history, except for the one-second reference to his membership in the SNCC. There was no information provided, or discussion offered, regarding the historic conflicts between the police and black activist groups, or the animosity between the police and Islamic communities in the U.S. There was no discussion of any controversies that surrounded the case, for example Al-Amin's concern about whether he could get a fair trial after the 9/11/01 terrorist attacks profoundly influenced public opinion about Muslims in the U.S.

The issue here is not Al-Amin's innocence or guilt. Many will acknowledge that Al-Amin did have a history of violence, both in rhetoric and behavior. In fact, few activists have taken up his cause in the manner that, for example, thousands have rallied to support Mumia Abu-Jamal. The issue here is that it is difficult to determine why this particular story was even included in a local Connecticut news broadcast. There was no apparent local connection and all of the network news outlets had covered the story of Al-Amin's trial, including three mentions of it on NBC, the network that the local outlet that ran this story is affiliated with. It may have been the curiosity appeal this story offered as a novelty item because of Al-Amin's "celebrity" status, or its mythological and ideological value as a tale of justice prevailing in the battle of good vs. evil, or something as mundane as the affiliate having 20 seconds to fill and footage from NBC available to fill it. What is apparent is that the decision to include this story in the broadcast was not made due to there being some compelling reason to provide local viewers with relevant information.

Rather, this sample of local news showed over and over that news stories that featured images of, and references to non-local inmates, were included in the broadcasts as long as some type of celebrity or quasi-celebrity was involved or there was some bizarre aspect to the case. This type of gate-keeping process, as Fox and Van Sickel (2001) note, is what characterizes tabloid news.

Objectivity and Balance?

Regardless of whether the inmate was local or not, one consistency across all of the items is that prisoners, like children in an old-fashioned world, were seen but not heard. Interviews were conducted with officials of the criminal justice system and family members of victims but never with the inmates themselves. The language used to describe inmates in these interviews, and the terms used by news anchors them-

selves, reinforced the tabloid-like quality of many of the stories. News anchors described the inmates for viewers in terms such as the following:

> "A homeless man is behind bars in Hartford tonight."
> "A convicted killer is under arrest."
> "Former convicted sex-offender…"
> "Former sixties radical…"
> "Prosecutors painted Jones as a cold-blooded killer who gave no thought to the value of human life."

While one could argue that these descriptions were simply factual, what is interesting is the way they evoked stereotypes of who the dangerous members of our society really are (the homeless, radicals, former inmates), while reinforcing the more blatantly loaded terms that were offered by officials of the criminal justice system, and family members of victims:

> "This guy was a beast. He didn't deserve to be born."
> "He did not indicate remorse."
> "Beast."
> "Son of Satan."
> "Maniac."
> "Coward."

What is of concern to those who expect the press to serve the needs of a democratic society is whether this type of language fits within the professional standards of the news industry itself, which aspires to objective, or at least balanced, reporting. Again, there were no interviews with inmates or inmate advocate groups to balance the understandable anger and passion of family members of victims. Apparently when it comes to crime the value of balance is irrelevant, as prisoners were never given the opportunity to speak for themselves in any of these news items. The way the norm of objectivity has been constructed in the journalism profession, interviews with victims of crime and representatives of the criminal justice system are taken for granted as simply "part of the story" while interviews with inmates, or those who advocate on their behalf, would be considered biased reporting that was pushing a liberal or leftist agenda. What is also illuminating, however, is the rare occasion when this norm is violated. It is important to note that all but one of the phrases listed above was used to describe a black or Latino inmate. In contrast, we might consider these excerpts from an extended interview with the husband of Andrea Yates, the white woman who had killed her five children: "She believed what she was doing was in the best interests of the children…. They love their mommy. They don't hold this against her. They know she was sick. They know she loved them." This type of forgiving charac-

terization of an inmate did not appear in any other news item, although another white inmate was described by a friend as a "nice guy." No friends or relations of any of the black or Latino inmates depicted in these broadcasts were given access to airtime.

Conclusions about Local News and the Penal System

All in all, what emerges from my analysis of an eight-week sample of local television news about prisons and prisoners is a tendency toward misinformation and inadequate, distorted, and misleading images. Only three stories and 59 seconds were devoted to the Connecticut penal system in the entire eight-week sample. Not one of those stories dealt with the conditions inside these prisons and jails. Furthermore, these few stories were entirely episodic in nature. They dealt with specific events or specific bits of information but provided no background or context from which this information could be interpreted or made sense of.

However, while prisoners were not ever shown in their actual living conditions, they were far from invisible in this sample of local news. On the contrary, prison and jail inmates appeared frequently in stories of arrests, trials, and other court proceedings. These stories and images provided a distorted view of who is actually incarcerated in Connecticut prisons and jails, however. Inmates who had been sentenced for violent crimes were vastly overrepresented. Female inmates and white inmates were also overrepresented in comparison to their actual percentages in the prison population. In addition to these statistical distortions, the language that was used to describe inmates was often filled with loaded adjectives that were rich in negative connotations. The visual images complemented this sort of language and reinforced the notion that inmates are dangerous, violent, misfits who require extreme measures in order to keep them under control.

There was also a tendency in these broadcasts to feature trials of non-local inmates, prisoners who had attained a sort of quasi-celebrity status because of their backgrounds or the novelty of their crimes. This sort of story appeared frequently despite the supposed mission of local news to concentrate on issues that are relevant to the local communities they serve. The focus on violence, the use of loaded terms, the reliance on mug shots and footage of inmates in shackles, the tendency to highlight bizarre sorts of crimes, all fit the pattern of what is expected from tabloid-style news outlets.

There are a number of explanations of why these patterns might exist that I will explore in more detail in the next chapter, ranging from the constraints that reporters face in gaining access to prisons and prisoners, to the professional norms and values

that influence what journalists believe is newsworthy. However, one of the most sali-
ent explanations for the tendencies noted above can be found in an acknowledgment
of the commercial nature of local television news in the U.S. These broadcasts exist
primarily because they are a potent source of profit. As Head, Spann, and McGregor
note, "It is not unusual for a network affiliate to make up to half its annual profit
from advertising during local newscasts" (2001, p. 276). Because of their fiscal im-
portance to a local station, local news broadcasts must be competitive in the ratings
and stay within the good graces of advertisers. These needs ensure particular types of
content; content that is believed to attract audiences and please advertisers. This con-
tent must be sensational and alluring but it cannot be too challenging or controver-
sial. Two professional journalists offer these comments on the state of local television
news that are highly relevant to the patterns discovered here when it comes to news
about incarceration and the penal system:

> Local television does little original reporting of significant community issues because news
> directors and producers doubt that viewers have the interest or patience to watch longer,
> more complicated stories, especially if they lack vivid video. Instead, event-driven crime and
> disaster coverage—with weather, sports, health, consumer, and entertainment news—
> dominates their newscasts. News directors believe these subjects attract the most viewers,
> who in turn attract the advertisers needed to produce profit margins (the percentage of total
> revenues retained as profit) of 40 to 50 percent or more. Completing a vicious circle, main-
> taining those profit margins means keeping news staffs small, which leaves the handful of re-
> porters on duty each day little, if any, time to cover local government or politics, business,
> education, environment or social issues that most affect people living in the communities
> they serve. At most stations, these subjects just aren't taken seriously anyway—they aren't
> part of the accepted formula for local television news (Downie Jr. and Kaiser, 2002, pp. 167-
> 168).

Thus, the focus on individual inmates who have been sentenced to prison for
violent crimes, but no coverage of the social conditions, which cause violence, or the
daily conditions that prisoners live in. Thus, a parade of prisoners, but no examina-
tion of why the prison population grows year after year after year. Thus, multiple
stories on non-local, quasi-celebrity inmates in a state that has 18 correctional facili-
ties and 19,000 inmates, but no discussion of what these local facilities are or are not
accomplishing, or what happens to ordinary inmates inside the walls of those facili-
ties.

The story about television news of incarceration does not end with local news,
however. In the next chapter, I explore national television news, in order to determine
whether the national networks provide more or different sorts of coverage of correc-
tions than the local affiliates.

CHAPTER V

Locking Down the Narrative
National Television News Coverage of the American Penal System

"I mean... I got a lot of things to say... you just don't have time for me." —"Evan"

In order to investigate national news coverage of prisons, I analyzed the three major broadcast networks' (ABC, CBS, and NBC) evening newscast for the years 1990, 1995, and 2000. These three years were selected in order to provide a cross section of network news coverage of the penal system during a decade of rampant incarceration. In 1990 a total of 14 stories on the prison system were aired, in 1995 44 stories, and in 2000 11 stories. This pattern was also reflected in the amount of time devoted to coverage of prisons and incarceration. The networks devoted an average of 32 minutes and 7 seconds to coverage of corrections in 1995, but only 13 minutes and 50 seconds in 1990, and a startlingly low 5 minutes and 33 seconds in the most recent year in the sample, 2000. When all three sample years are taken into consideration, each network devoted an average of 16 minutes and 17 seconds per year to coverage of the prison system during their flagship evening news broadcasts.

One way to put these figures into an appropriate context is to consider how much coverage in national evening news broadcasts is devoted to other aspects of crime and the criminal justice system. The Center for Media and Public Affairs (see http://www.cmpa.com/) conducted analyses of crime coverage on ABC, CBS, and NBC evening news throughout the 1990s. Using their data it is possible to compare the number of stories devoted to crime with the number of stories on corrections as indicated here. Thus, in 1990, ABC, CBS, and NBC evening news together ran 14 stories on prisons and the penal system, while they ran 542 stories on crime in general. A spike in crime coverage matched the spike in coverage of prisons found in 1995 also. That year, the three networks ran 2,574 crime stories in their national evening news broadcasts, the highest number in the decade. This was the year following the introduction of the Clinton "Violent Crime Control and Law Enforcement Act of 1994" which introduced many of the policies that resulted in the "prisonization" of America being escalated (see Parenti, 1999). That year, in comparison to 2,574 stories on crime, the networks ran 44 stories on the penal system during their nightly evening news broadcasts. CMPA does not provide data for 2000, so the

nearest comparison can be made with 1999. While the network evening news broadcasts aired 1,613 stories on crime in 1999, they only aired a total of 11 stories on prisons during 2000.

In the three years combined, ABC, CBS, and NBC ran 4,729 stories on crime and 69 stories on the penal system. Coverage of corrections in these 69 stories in three years thus represents about 1.4% of the number of stories devoted to crime in an equivalent time period. Crime and criminals are thus a major preoccupation of the network news, but what happens to criminals after they are convicted is barely of concern.

Turning to a consideration of the major topics that were covered in the three year sample, Table Two provides a topical breakdown arranged by the number of stories that appeared in the three years included in the sample and Table Three lists the same topics arranged according to the amount of time granted to each.

Table Two shows that most of the coverage involved three primary sorts of stories: stories about violent unrest and riots in prison, stories about prison escapes, and stories about the growing prison population. These three topics together encompassed more than half (52%) of the stories in the sample.

Table 2: Topics in Network News Coverage of Prisons (1990, 1995, 2000) Arranged by Frequency of Stories

Topic	#of Stories
Escapes	14
Unrest/Riots	12
Population	10
Treatment/Rehabilitation Programs	8
"Get Tough" Prison Programs	7
Prison Economics	5
Prisoner Abuse/Fraud of the System	4
Health Care for Prisoners	3
Juveniles in Prison	2
Prisoner Rights	2
Drug Abuse by Inmates	1
"Beloved" Warden Retires	1
Total	69

Table Two also shows that stories that potentially would provide the most opportunity for criticism of the penal system, such as those on juveniles in prison, prison health care, and prisoner rights appeared much less frequently than stories of inmate misbehavior such as riots and escapes. In fact, stories on prisoner's rights being abused appeared only half as many times as those on prisoners abusing their rights (for example, by submitting bogus law suits or by fraudulently accepting welfare payments while in prison).

Examples of these stories are analyzed in-depth below. However, it should also be pointed out that the rank order of stories changes when the amount of time devoted to each topic is taken into consideration (see Table Three).

Several patterns become apparent from a comparison of the frequency of topics with the total amount of time devoted to each topic. The first is that while the order changes for many, the top five remain relatively the same. One difference, however, is that the category of stories on the economics of prisons (both internal economics regarding pay for prison labor, etc. and external economics—what the penal system costs taxpayers, etc.), becomes one of the top five topics when time rather than frequency is taken into account.

Table 3: Topics in Network News Coverage of Prisons (1990, 1995, 2000) Arranged by Time Devoted to Stories

Topic	Total Time
Treatment/Rehabilitation Programs	00:27:30
Population	00:18:00
Unrest/Riots	00:17:40
"Get Tough" Prison Programs	00:17:20
Prison Economics	00:16:30
Escapes	00:13:20
Prisoner Abuse/Fraud of the System	00:12:30
Health Care for Prisoners	00:11:10
Juveniles in Prison	00:10:40
Prisoner Rights	00:04:50
Drug Abuse by Inmates	00:03:20
"Beloved" Warden Retires	00:01:40
Total	02:26:40

This may be because these issues are fairly complex; thus they are not dealt with often, only five times in the three-year sample, but when they are covered they require more in-depth examples and explanations. On the contrary, the topic that appeared most frequently, prison escapes, is only sixth on the list when time of coverage is taken into account. This reflects the networks' tendencies to report often on prison escapes, but also that these reports are usually just brief episodic updates on the latest efforts to locate the escapees.

The most interest finding, however, is that upbeat stories on positive prison rehabilitation and treatment programs receive far and away the most coverage when length of story is taken into consideration. This reflects the networks' tendencies to both report these sorts of stories relatively often and to spend a substantial amount of time on these uplifting narratives. While this tendency to focus on positive images of prisoners taking part in beneficial activities may be considered a welcome relief from the frequent negative stories of prison riots and violence it should also be recognized as fairly misleading because:

> As a consequence of the redefinition of prisons as locations for punishment (instead of rehabilitation), overcrowding, and the new quickly constructed, remote prisons, the resources prisoners may use to accomplish a variety of goals—education, vocational training, and recreation—have dramatically decreased... only a small percentage of the inmate population is involved in meaningful prison activities. About a quarter of them are idle.... Very few are in low-paying prison industry programs, vocational training, or education programs.... What emerges is a picture of prison life that has minimal program opportunities and considerable idleness (Austin and Irwin, 2001, pp. 103-104).

Several of the ex-inmates I interviewed confirm this notion that there are few opportunities for involvement in rehabilitative programs. One person did say that there are opportunities to get involved in activities but blamed inmates for not being motivated enough to participate. However, another respondent remarked that while programs are available the waiting lists are so long as to be demoralizing. Another mentioned that she already had a high school diploma when she was sent to prison and therefore the educational programs were too remedial for her. These respondents had all served most of their time in Connecticut institutions, a state which, according to an administrator of the alternative incarceration program where I met with my respondents, has a relatively high number of programs available to inmates. Thus, the perceptions of these respondents that there are not many programs available may be even more justified from prisoners in other states. Most of those who I interviewed mentioned in conjunction with their comments about the lack of opportunity to get involved in programs that the terrible monotony of prison life is one of

the worst aspects of the experience and that it is a primary causal factor in prison violence and other behavioral problems:

> Miguel: Then the time goes slowly. You know what I mean. Every time you ask for the time, you're still in the same spot.
> Carla: It's boring.... You know what I mean, because they don't have enough activities, really for somebody to really exercise their brains.
> Marty: It's very repetitive. Like he said, I found it to be boring, because there is no stimulus. There's no books, I mean whatever you find, you find. I kinda disagree with that, I think the guy should have some kind of stimulus, you know, some kind of reading material.
> Mike: It's like you're so bored you want to get into trouble to make something happen you know.

In summary, the patterns of coverage in national evening news stories on prisons seem to suggest a focus on the most out-of-the-ordinary aspects of prison life: riots, escapes, and innovative and challenging rehabilitation programs. Meanwhile the less dramatic, but perhaps more important, issues—such as health care for inmates, the plight of juveniles in prison, the daily treatment of prisoners and issues pertaining to prisoner rights—receive rare and limited exposure.

Key Themes in Prison News Stories

Turning to an exploration of the key themes and recurring patterns in national news coverage of incarceration, I provide detailed examples and analysis of each of the following themes that I identified as central to the television news discourse on imprisonment: 1) Prisoners are dangerous individuals who should be feared. 2) Society therefore needs prisons to keep ordinary citizens safe. 3) Prisoners deserve the punishment that is meted out to them. 4) Simultaneously, prisoners are parasitic drains on society's resources. 5) Furthermore these parasites are well taken care of in America's prisons. 6) However, there are some criticisms that can be leveled at the U.S. penal system.

"Fear Factor"—Prisoners Are Dangerous

This was perhaps the predominant theme in the news stories that were examined, and clearly the central theme of the two most frequent story topics—Escapes and Riots/Unrest. In terms of their manifest content escape stories seem to have been intended as updates on the status of searches for the escapees, but there was more than that going on in these items. For example, in a January 1995 NBC story Tom Brokaw announced, "There is still no sign of those five murderers who broke out of a

Florida prison on Monday" while a graphic read "Still at Large." A December 2000 CBS story mentioned that an escapee had left a note reading, "You haven't heard the last of us," and that the men were now wanted for the murder of a police officer during a robbery where they had stolen handguns and shotguns from a sporting goods store.

Both of these stories were episodic in nature, focusing in on one particular incident but not providing any background information on the frequency of prison escapes, etc. Because of their episodic nature, both of these stories seemed to play to viewer fears of crime in general, and escaped convicts in particular. Although the chances of any particular viewer actually being hurt or menaced by an escapee are extremely unlikely, these stories served as updates of fear as much, if not more, than they provided important information. Altheide's insights into the relationship between crime news and fear are thus very salient in regard to this sort of prison escape story:

> News reports and other popular culture messages provide some very consistent images of crime and danger.... Crime is but one example of a larger array of images that promote the sense that the world is out of control. Helplessness is combined in many reports with a sense of randomness. This promotes incredible anxiety and fear that something might happen (1) which we know about (e.g. violent crime); (2) about which little can be done; and (3) which may occur at any time. The only response we seem to have is to wait and to prepare (e.g., get armed, lock doors, build walls, avoid strangers and public places).... Moreover, these responses also promote a very strong urge to get help from somewhere, anywhere. This is why audiences seem so willing to accept all kinds of definitions of what the problem is—the causes of crime, what can be done about it, and how limited our alternatives are—which usually involve the police and criminal justice system (2002, pp. 136-137).[7]

Helplessness and randomness: "Still at Large," "You haven't heard the last of us." An astute telemarketer might have chosen the moments just after these broadcasts to phone viewers with offers of great deals on home security systems. The NRA might have been wise to follow these items with recruiting advertisements. But aside from marketing and recruitment opportunities what else do news bites of this sort provide? Some might argue that these stories represented an example of the media playing a crucial surveillance role for society (see Laswell, 1948), but did these items

[7] Although written prior to the events, Altheide's (2002) insights are particularly relevant to the post-9/11 U.S. environment and the "opportunity-seizing" machinations of the Bush administration. The ideas presented here by Altheide were originally articulated, examined, and written about at length by researchers involved in George Gerbner's Cultural Indicators project. For a comprehensive analysis and review see Shanahan and Morgan (1999).

provide essential information or were they just part of a larger pattern of fear-mongering?

The second most common topic in the sample involved stories of prison unrest and riots. Like the stories on prison escapes many of these items also tended to be brief. Just as in the escape stories, the level of background information or context was negligible while the meta-theme of danger and fear was central to these stories. Two ten to twenty second stories, one from January, 1990 (CBS) and the other from April 2000 (ABC), were emblematic of the episodic nature of most of these items. In both items, the anchor reported that the riots involved black and Latino prisoners attacking one another, but no context was provided in terms of the larger issues of race relations in prisons, the actual causes of the animosity, what sparked the violence, etc. The closest to any discussion of contributory factors was a brief mention in the CBS item that the institution held over four times the number of inmates that it was intended to hold, and a similar note in the ABC story that guards had complained of overcrowding. But even these bits of information were left floating as mere fragments. Meanwhile, in the CBS story, visuals of empty areas of the prison in great disarray and of an injured person being helped off an ambulance contributed to the sense of danger and fear that such stories might be expected to arouse in viewers.

However, fear is indicative of a problem, and often news stories can be relied upon to highlight not just problems but also solutions to problems. For example, in October 1995, there was a rash of riots at four prisons across the nation, and on 10/21 and 10/22/95 all three networks included items on these disturbances in their nightly news broadcasts. Visuals of havoc in the four prisons that accompanied the NBC story conveyed an impression of danger, but the anchor assured viewers that authorities were able to gain control and restore order. This is a classic example of the tendency of the media to first arouse fear and then provide calming assurances that official forces are working to stabilize the situation.

It should be noted that all three networks did attempt to provide some context to these stories by noting that the disturbances came in the wake of a House of Representatives vote that defeated a measure intended to reduce the sentences handed out for those caught with crack cocaine. However, only ABC included the crucial information that sentences for crack are much more severe than those for powder cocaine and that this often results in black prisoners serving more time than whites. ABC did not go so far as to mention that this pattern is *not* because more blacks use cocaine but because 90% of those *arrested* for crack are non-white while 75% of those arrested for powder cocaine are white (Miller, 1996). Still, ABC deserves credit for at least attempting to include some contextual information in this story. The CBS and

NBC stories, on the contrary, stated that the prisoners may have been reacting to the political decision not to reduce the sentences for crack but leave out the most relevant information pertaining to this. For example, as Mauer (1999) notes, mandatory sentencing laws passed by Congress in the 1980s created absurdities such as 5 grams of crack resulting in a mandatory five year term while it takes 500 grams of powder cocaine to receive the same sentence. In the absence of this sort of information, the CBS and NBC stories seemed to suggest that out-of-control prisoners became violent simply because they wanted their sentences reduced.

This image of dangerous, violent, inmates, rioting out of sheer impudence comes through forcefully in a story that aired on CBS in February 2000. After a disturbance at Pelican Bay, a maximum-security prison in California, CBS aired a story where Dan Rather referred to the prison as a "war zone" and described the events as "a half hour from hell." In attempting to explain why violence broke out, CBS noted that a week before the riot a Pelican Bay officer had been found guilty of shooting an inmate and that since that incident two others had been indicted for assaulting inmates. A representative of a correctional officers' union stated that because of these cases, "They've got this thought now they can do anything without being shot." And, "Every time they come out they want to hurt somebody, kill somebody." This officer also noted that the inmates there are simply "people who do not get along with their fellow human beings. Period."

"Period." Thus, it is fruitless to look for causes of prison violence. These inmates are just *naturally* violent, *naturally* dangerous. They have to be contained by any means necessary, and holding officers who shoot and attack them accountable under the law only weakens the state's ability to contain them. This is an argument that plays on viewers' fears while simultaneously suggesting a solution to those fears: let the state control the inmates through whatever methods they choose, allow corrections officers to use any level of aggression without having to worry about answering to the courts for their actions.

NBC reported on Pelican Bay five months later, in a two-minute item that played up the most fear-inducing aspects of the story and then primed viewers to watch a follow-up program on the NBC cable news channel—MSNBC. The anchor began the story by reminding viewers of the riot that occurred in February. Then several inmates appeared on camera, talking about the rampant violence that they had seen at Pelican Bay. "You can get stabbed anywhere," one inmate said. The reporter used the term "predatory" to describe inmates and referred to the exercise yard as "killing fields" and "a gladiator ring." Grainy black-and-white surveillance video footage accompanied this report showing visual evidence of brutal inmate-on-inmate

attacks and the terror that can ensue in the yard. Once it could be assumed that the viewer was sufficiently aroused, the story ended with a note from the anchor that a program on Pelican Bay would be aired on the NBC cable outlet, MSNBC, later that night. Since this item did not really provide any contextual information about the causes or consequences of violence at Pelican Bay, or the larger questions related to incarceration and violence in U.S. society, but ended with a promotion for another program, should this be considered powerful investigative journalism or merely the transformation of a serious societal problem into a spectacle and commodity?

Stories like these, of escapes and riots, however, were not the only news items that seemed to capitalize on the emotional arousal brought on by messages of danger and fear. In another NBC story in June 2000, on a crackdown on contraband at Riker's Island, officers displayed a number of makeshift weapons that they found. As a knife was shown in close-up, this story, too, ended with a promo for an hour-long program about Riker's Island that would air later that evening on MSNBC.

The point here is not to argue that there are not many prisoners with extremely violent records in institutions across the country, or that places like Pelican Bay are not viciously brutal facilities. The real point is twofold. First, as noted above in the discussion of local news, the language and images of these stories tend to overemphasize and misrepresent violence and danger. Most of the nation's prisoners are not violent offenders. Most prisons are not Pelican Bay. While uprisings do occur in the nation's prisons, they are often politically motivated rather than just random, spontaneous eruptions of violence by naturally predatory inmates (see Shapiro, 2000). Second, these stories provide no context for understanding the prison violence that does occur, rather they simply play on viewers' fears in a manner that arouses and titillates, and sometimes sells other programming, but does nothing to contribute to informed public debate about the country's incarceration system. When riots do occur, why do they occur? If some prisoners are violent, why are they violent? Does the system contribute to and encourage violence? These and a myriad other questions might have been addressed in these reports, but except for rare and fleeting exceptions they were not. Instead, these emotional stories of fear and danger reinforced the notion that prisoners are somehow different, not quite human. This notion of the prisoner as an alien sort of being is more likely to be accepted as common sense than questioned or subject to critical thought. But is it true? Are prisoners really different than the rest of us?

Bohm (1986) argues that approximately 90% of Americans have committed some type of crime for which they could have been incarcerated. At first this might seem like an unlikely statistic until we consider crimes such as driving while under the

influence of alcohol, petty thievery, tax fraud, the use of illegal substances. How many Americans can honestly say that they have not taken things from their workplace that did not belong to them, or shoplifted small items, or gotten behind the wheel after having one drink too many, or smoked a bit of marijuana, or fudged the numbers on their income tax forms, or even gotten into a fight in a bar? All of these are offenses for which people can be, and have been, incarcerated. U.S. Bureau of Justice statistics report that approximately 70% of inmates have been incarcerated for non-violent offenses. Yet the images of prisons and prisoners in these news stories suggested that the incarcerated are not ordinary U.S. citizens. They are different, they are alien. Not by stepping over the often-permeable boundaries of law, but by having been caught and sentenced to prison, they have taken on a different status. They are no longer Us, they are no longer like Us:

> The construction of identity... involves the construction of opposites and 'others' whose actuality is always subject to the continuous interpretation and re-interpretation of their differences from 'us'. Each age and society re-creates its 'Others' (Said, 1978, p. 332).

Once someone is identified as a criminal and sentenced to prison they are no longer worthy of humane treatment—they are the Other.

This concept of the Others that societies use to construct their sense of identity has, of course, racial implications at its core (see Hall et al., 1978; hooks, 1992; Said, 1978). Hall et al.'s description of the way muggers became identified as Folk Devils in Britain during the 70s and 80s, and the racial overtones articulated with these images, is salient for understanding the racial aspects of America's fear of prisoners also:

> The Folk Devil—on to whom all our most intense feelings about things going wrong, and all our fears about what might undermine our fragile securities are projected—is... a sort of alter ego for Virtue. In one sense, the Folk Devil comes up at us unexpectedly, out of the darkness, out of nowhere. In another sense, he is all too familiar; we know him already, before he appears. He is the reverse image, the alternative to all we know: *the negation*.... The 'mugger' was such a Folk Devil; his form and shape accurately reflected the content of the fears and anxieties of those who first imagined, and then actually discovered him: young, black, bred in, or arising from the 'breakdown of social order' in the city; threatening the traditional peace of the streets, the security of movement of the ordinary respectable citizen... (1978, p. 161, emphasis in the original).

Like the mugging panic that swept through Britain that Hall and his co-authors are referring to in this passage, the news stories about America's prisons and prisoners in this sample also took on racial overtones. This was apparent in the way the items on prison riots noted above began by announcing that the violence occurred between black and Hispanic inmates. This was also apparent in the ways these news stories

accompanied their narratives of danger and fear with visual images of mostly dark-skinned men roaming the prison yards and cellblocks. One story on the prison population noted that prisoners are being released early to free up room, and accompanied this announcement with a shot of a horde of young men streaming through a gate. Every single man in the shot was black. In a 20-second story on the return of chain gangs to Alabama prisons the reporter who defined the situation was white, the armed guard shown giving orders while carry a large rifle was white, while all but two of a large crowd of manacled prisoners shown cleaning a highway were black.

In an April 1990 ABC story on the economic boost that small towns get from the prison industry, this distinction between Us and Them, "Folk Devil and Ordinary Citizen," was established through stereotypes and emotionally charged video footage. In a Manichean manner shots of mostly black male prisoners staring at the camera from behind bars, lifting weights, and dunking basketballs on the prison recreation yard were juxtaposed with scenes of smiling white children playing on a small town playground. Them and Us. The viewer heard from a white reporter, white sheriffs, and a white mayor while seeing scenes of some white, but mostly black prisoners. Us and Them.

In a similar manner that foregrounded white definers of the situation amid a background of mute non-white perpetrators, in the NBC story on Pelican Bay, three of the five prisoners interviewed about not being safe in the prison were white, the reporters were white, all of the corrections officers were white, the warden interviewed was white, but the prisoners shown milling about appeared to be mostly black and Latino. Just before the promo for the follow-up MSNBC program the reporter ended with the provocative statement that "The slightest of rifts can trigger an institution wide race war."

As Hall et al. noted in their study of the moral panic over "mugging" that swept through Great Britain during the 1970s and 80s, along with fear and panic comes a cry for protection. Because these Others, these Folk Devils, pose such a threat we must be protected from them—this is the second key theme that I will discuss.

We *Need* Prisons—To Keep *Us* Safe from *Them*

This theme was central to the stories on "Get Tough" prison programs, as well as to many of the stories on the growing prison population. An October 1990 ABC item, for example, began with Peter Jennings noting that the prison population had doubled since 1980. Jennings stated: "The problem is an obvious one... where to put everybody." This is actually a remarkable few seconds of television in that it is so ideologically charged while not appearing to be so. After announcing that the prison

population doubled in a decade there are many statements that could have followed from, "The problem is an obvious one..." Jennings could have said, "The problem is an obvious one... finding alternatives to incarceration." Or, "The problem is an obvious one... treating drug addicts as victims of a disease rather than criminals." Or even, "The problem is an obvious one... reversing the Reagan/Bush neglect of the poor that has driven so many to desperation." Instead, viewers were told that the only problem with the prison population doubling in ten years is where to put all of the bodies. Moreover, viewers were told that this is "obvious"—it is just common sense that we must find space to accommodate an ever increasing prison population rather than questioning criminal justice policy or finding ways to reverse the trends.

Later in the item the reporter announced that "the nation needs 1,800 new prison beds a week," but again this statement of "need" went unquestioned, unchallenged. Instead, the story framed this as an economic "opportunity" and a "benefit" for small rural towns that rely on the prison industry for fiscal health. A new prison that was being built in a small town in Texas was described as "hope for the future." The reporter pointed out that the vast majority of inmates in Sneedville, Tennessee, were actually from Washington, D.C., which is 400 miles from the prison. This, however, was noted as evidence of the town's entrepreneurial vision. There was no mention of how the practice of incarcerating people hundreds of miles from their homes tends to isolate inmates from support networks such as friends and families. The whole story was framed in a remarkably upbeat tone, without a hint of criticism: Of course we need more and more prisons and this is a positive economic opportunity. Furthermore, the racial implications of this story of primarily black inmates from D.C. being used for the economic gain of white Sneedville, Tennessee, also went unacknowledged.

Another upbeat story, on NBC in 1990, suggested that the way to ease the shortage of space in U.S. prisons was through turning to private prisons as a solution. Throughout most of this 4 minute, 30 second story, private prisons were praised as wonderful, efficient institutions (more on that below). During the last 86 seconds of the item, Tom Brokaw interviewed a critic of private prisons and asked him how he could be critical of something so innovative and cost-efficient. The critic, Ira Robbins of American University, tried to explain that private prisons are a temporary fix and that there are larger issues at stake but Brokaw responded by ignoring this point and insisting that private prisons are better than government institutions.

This tendency to provide some limited time to critical voices but then to squelch their perspective was apparent in other news items that reinforced the notion that we need prisons to keep us safe. In a May 1995 ABC story on the reintroduction of

chain gangs into Alabama prisons, a critic was allowed to voice her objections but this was immediately followed by the reporter announcing that polls show that citizens are in favor of chain gangs and that they will be used more in the future. This last comment in the item provided a sense of complete ideological closure on the issue: citizens approve of it and it will be happening despite any objections that might be raised. The problem is that there was no real ideological closure on this issue, yet the media ferociously tried to construct one. Marc Mauer of the non-profit group The Sentencing Project reflected on his experience with the media just after Alabama reinstituted chain gangs:

> In the weeks following the inception of the chain gang, I received numerous calls from reporters and producers. Many were just looking for the best "visuals" for the story, but a few of the more conscientious ones asked if I could aid them by providing research on the "effectiveness" of chain gangs. No such research exists—humiliation and control, not effectiveness, have always been the goal of such policies... [T]hey had tremendous difficulty finding an advocate for chain gangs. Could I help, they inquired, in finding such an individual? (1999, p. 175).

A brief CBS story on this topic also followed the same format. "Balance" was provided by referring both to criticisms and defenses of the practice, but closure was established through giving the last word, and a signature of approval, to the perspective of the Alabama Corrections Department: "Alabama prison officials say the program is designed to crack down on repeat offenders and save money. In the chain gang one guard can watch 40 prisoners." This was the last statement in the report and it was stamped with the CBS News brand, both visually and audibly. While the CBS News logo appeared on the screen and the CBS News theme music swelled, white clad prisoners were shown hard at work cleaning the highway. The picture faded as CBS went to a commercial. In another CBS story, this one from January 2000, on the incarceration of juveniles, a critic of the practice was interviewed for 14 seconds (in a 4 minute 30 second item), but the reporter closed the story by noting that despite criticisms, a steady increase of violent crimes committed by young offenders is projected and therefore youth facilities that "resemble the big house may be the only choice." In other words, America *needs* these facilities and there are no alternatives.

One sub-theme of the notion that we need prisons to keep us safe is that technology is the magic bullet that will assure that safety. For example, a story that was aired on ABC in 1995 took viewers on a tour of a new federal prison that was opening in Colorado. This facility was designed as a "supermax" institution that would house inmates with extremely violent backgrounds. Throughout the story the prison was lauded as a wonderful site that could be relied upon to keep its population under

strict control and supervision. Peter Jennings informed viewers that this "state-of-the-art" facility would "not hold many prisoners but it will certainly hold them." The reporter then compared the prison to a "fortress in the hills" that is as "close to escape proof as technology can make it." A warden informed viewers of just how much they should fear the prisoners that will be housed there, saying that they have proven themselves to be "highly assaultive, highly predatory, or highly escape prone." Thus, we should support the construction of institutions such as this one because these prisoners do not just present a danger to one another on the inside, but, if given the chance, they could be coming after us.

In a classic example of first arousing fear and then proposing a solution, the story continued by lauding the technology of the prison, from furniture that cannot be smashed because it is made of steel and concrete, to the electronically controlled double doors made of materials that cannot be broken through, to the 1,400 electronic gates and 168 video cameras for containment and surveillance. The item ended with the reporter noting that many of the prison's inmates will never be free again and that "when a prison is built like this one, authorities say, that is the whole point." As this was announced viewers were shown a shot of heavy electronic doors slamming closed with a solid thud. Throughout the story viewers were told that the prisoners would have their visits severely limited, that they would not be allowed any contact with other inmates, that they would be confined to their technologically escape-proof cells 23 hours a day, and only let out in manacles, and that they would never even have to leave the prison at all because of on-grounds medical facilities and an in-house court-room.

This information was framed in such a way as to make viewers feel secure that institutions such as this will really make them safer. Technology was lauded as a panacea for the problems of prison violence and disorder while the real human beings who this technology is being used to contain were both literally and figuratively invisible. There was never any critique offered, despite the fact that criminologists have warned that isolation and repression such as that which was so glowingly portrayed here, is extremely detrimental to inmates' mental health and may actually make them more aggressive and less able to cope with stress. Furthermore, while, as the story noted, many of these inmates will never be released from prison, some will, and often prisoners are released from extreme lockup situations like this directly to the streets (Austin and Irwin, 2001), a policy that seems designed to encourage rather than discourage recidivism.

In another story (NBC, June 2000) that focused on both the need for tough prisons to keep Us safe from Them, and the security that technology will provide,

correctional officers clad in the latest hi-tech protective gear were shown preparing for a paramilitary operation at Riker's Island in New York. Violent inmates were shown being forcibly extricated from their cells. An officer demonstrated how a Plexiglas shield served as both protection and a weapon because it was equipped with electronic stun capabilities. Technologically advanced equipment for scanning inmates' persons and property was displayed and the reporter announced that "state-of-the-art detector equipment... called the body orifice scanning system, or B.O.S.S. chair" is used to find contraband.

In all of these items inmates were first established as predatory and dangerous, but then viewers were assured that tough prisons and technology would keep Them contained and Us safe. The use of demeaning, repressive, humiliating and even violent practices by the state in keeping these inmates under control was rarely questioned. This tendency to either ignore or marginalize critical perspectives ties directly into the third key theme of these news stories on incarceration.

Prisoners *Deserve* Punishment

This theme rivaled the "need" theme as the dominant message of the stories on "Get Tough" prison policies. This theme surfaced repeatedly when criticisms of prison conditions and the treatment of prisoners were raised. For example, in the story on the search for contraband in Riker's Island, after an inmate was interviewed through a cell door, complaining about the harshness of the searches and that inmate property was destroyed, a correctional officer explained that "It looks like it's forceful but inmates have a way of secreting contraband...." During a 2-minute story on the return of chain gangs to Alabama prisons inmates on the chain gang were interviewed and expressed their feelings that the practice is demeaning (9 seconds), and a representative of the ACLU was allowed 13 seconds to note that this kind of treatment may only make people more resentful and potentially violent. However, each time a criticism was expressed, the practice was also justified, twice by claims that it will deter crime. An Alabama Corrections official also claimed that chain gangs are cost-efficient because they allow fewer staff to watch more inmates. As noted above, in response to the criticism by the ACLU, the reporter closed the story with the note that polls show that citizens "like the get tough nature of the chain gang and more prisoners will be put to work this way as early as next year." Ideological closure: if "ordinary citizens" support it, then the criticisms of academics and liberal organizations are moot.

The only "ordinary citizens" that ever seemed to be quoted or interviewed in the sampled stories, however, were those that believed prisoners should receive the harsh-

est treatment available. In an August 1995 CBS story about a tough sheriff who re-
fused to release any prisoners early, even though his facility kept getting more and
more crowded, an attorney for the inmates pointed out that the cells are so small that
inmates "have less square footage than federal regulations require research animals to
have." An inmate was also allowed to express his belief that these inhumane condi-
tions make people violent. However, these criticisms were quickly countered. The
reporter announced that the sheriff's actions were "popular with local residents,"
several of whom appeared on camera saying things like, "They're in there for a rea-
son, it's not a hotel," and, in the words of a woman depicted working on flowers and
identified as a garden club member: "Keep them in there."

People who have served time are aware that this sentiment does exist among
much of the population. One of my respondents spontaneously noted that society
doesn't care what happens to people in prison. When asked to elaborate on that he
replied:

> Evan: Because they say you deserve to get what you get. So, who cares what happens to you in
> there. The majority of society doesn't have no family in there, so they don't care. There's no
> rehabilitation—it's all about punishment. It's only going to get worse, that's all. Because it's
> gotten worse. I've been doing time for 20 years. It's gotten worse in the last few years. It used
> to be about rehabilitation.

However, there are two issues that must be taken into consideration when ana-
lyzing public opinion on incarceration. The first is that most of the public have had
their "knowledge" of crime and the criminal justice system constructed by media
images, which are often highly inaccurate and misleading. Public opinion, then, is
often built on faulty data, and this in turn influences public policy. As Dyer puts it:

> In today's political world, our elected representatives often make their important decisions,
> such as how to deal with crime, based upon the opinion of the masses, who admittedly base
> their opinions regarding crime on the distorted coverage of this issue provided by television
> and therefore have little or no knowledge of the facts of the issue. As a result of this chain re-
> action of ignorance, politicians have restructured the justice system in a manner that would
> be more appropriate for dealing with the quantity and type of crime in the world that we ob-
> serve through our television window—an imaginary world hundreds of times more violent
> and crime laden than the real world (2000, pp. 118-119).

Second, media often distort the tenor of public opinion for their own purposes.
Lewis (2001) offers the example of CBS News using the results of their own opinion
poll to justify their coverage of crime. CBS noted that nearly 30% of the public listed
crime as an important issue in political campaigns. But as Lewis points out, "law and
order issues were fairly low down the list of priorities in the CBS poll, and yet these

responses are used to make it appear that CBS is responding to public demand" (2001, p. 48). Furthermore, one could note that if nearly 30% listed crime as an important issue that means that the vast majority, over 70%, did *not* include crime in a list of important campaign issues.

While it is true that many Americans do seem to believe that "we should lock them up and throw away the key," there are alternative perceptions among the public, people who believe that we shouldn't decimate other social programs in order to build more prisons, people who believe that drug addicts deserve treatment rather than incarceration, people who believe punishment should not be the main goal of the penal system. Austin and Irwin cite the results of polls that support this notion:

> A national poll taken by the Wirthlin Group in 1991 found that four out of five Americans favored a nonprison sentence for offenders who are not dangerous. A 1991 California poll found that three-fourths of Californians felt that the state should find ways of punishing offenders that are less expensive than prison. In Alabama and Delaware, a focus-group analysis conducted by the Public Agenda Foundation found that when citizens were given detailed data about the crimes committed and the relative costs of various sanctions available to the courts, the public strongly supported nonprison sentences for inmates convicted of nonviolent crimes (who represent the vast majority of prisoners) (2001, p. 47).

A 1997 survey conducted by the Center for Governmental Studies at Northern Illinois University asked 854 adult Illinois residents about state spending on prisons and correctional facilities. Only 20% of respondents felt that spending should be increased, while 34% felt it should be decreased. The same survey asked respondents whether Illinois should provide education to people in state prisons. Only 32% of the respondents said that the state should not provide education while 65% said that the state should provide education to inmates. Similarly, a 1995 survey conducted by the Survey Research Center at Florida State University asked adult Florida residents whether more money should be spent on prisons or crime prevention programs. While 31% said that more money should be spent on prisons, 40% felt that more should be spent on prevention (see http://cgi.irss.unc.edu).

The results of polls like these suggest that there may be many people in the U.S. who are not fully in favor of the current trends in incarceration. Their voices are just not aired very frequently in the mainstream media. This lack of "ordinary citizens" expressing doubts or criticisms of the penal system in the media may perpetuate the notion that alternative viewpoints aren't legitimate. As previous research has suggested, when an individual believes that the weight of public opinion is against them, they are more likely to remain silent, rather than voice what they believe is a dissenting viewpoint (see Noelle-Neumann, 1993).

The three key themes that I've discussed thus far represent the central themes that were apparent in this sample of news stories on the penal system. Together they form a coherent discourse that suggests that prisoners are violent, dangerous Others who should be feared; they thus are deserving of punishment, and we *need* more prisons and tough incarceration policies both to keep Us safe and to give Them the punishment they deserve. This was the central overriding message of the stories in this sample. However, three other themes were also apparent, two of which complemented this discourse and one, which contradicted it.

Prisoners as Parasites

As noted above, the national network news stories I examined showed little evidence of any sort of questioning of the penal system or prison conditions on the part of "ordinary citizens." However, these stories did feature those who suggested that prisoners are merely parasites who continue to cheat the public even when they are behind bars. This sentiment meshes consistently with the key themes previously discussed, particularly the notion that prisoners are deserving of punishment. An NBC story from April, 1995 about lawsuits filed by inmates entitled "Con Games" featured several inmates who had sued over trivial incidents such as a missing pair of pants and a scratched television set. One litigious inmate was shown on camera barely suppressing a smile. Each inmate interview was accompanied by a graphic displaying their crime and their sentence: "Murder. 30 years. Sex Crimes. 20 years." This juxtaposition of their seemingly absurd complaints with the seriousness of their crimes served to establish that these men had no right to bring these lawsuits, no right to expect anything from the courts. The use of the term "Con Games" (the reporter also referred to inmates as "cons") implied that neither these men nor their complaints should be taken seriously as they were intended to flimflam taxpayers out of their money.

The reporter introduced the story by stating, "From interrupted cable TV service to smooth, rather than chunky peanut butter, America's prisoners are suing." This statement implied both that inmate lawsuits are entirely frivolous and that inmates live comfortable lives where their biggest problems revolve around cable television and what type of peanut butter they will be served. While it may be assumed that both of these examples are real, whether they are representative of the type of lawsuits brought by inmates is the more important question. For example, far from a matter of preferring one type of peanut butter to another, Parenti (1999) cites a case where an inmate sued after losing his hand while working in a prison factory. He was awarded $928.

Rather than referring to injustices such as that, NBC continually stressed how expensive inmate lawsuits are to taxpayers, a theme that seemed designed to raise viewers' ire. Two attorneys general were interviewed; both showed little respect for an inmate's right to sue. One noted that, "Prisoners are picking the taxpayer's pocket," and the other commented that, "It's just a bunch of junk the prisoners think up because they don't have anything better to do."

However, this was not the only discourse that was apparent in this story. Although the time allotted to a dissenting perspective was severely limited, critical voices did get some airtime: An inmate who was interviewed explained that bringing lawsuits is often the only choice that prisoners have when they are confronted with poor living conditions (6 seconds). An ex-inmate who had become a prisoner rights advocate was also given a few seconds to state that important precedent setting cases in constitutional law have come from prison lawsuits (8 seconds). While the total time devoted to these critical voices (14 seconds in a 2 minute and 30 second story) was clearly not equal to the time given to deriding prisoners' rights to sue, the story did close on a somewhat challenging note. The reporter ended the story with the statement that, "Back in the 80s the trend was to put criminals behind bars and keep them there, now the inmates say they are afraid the trend is to keep them quiet." While one could point out that when this story was aired in 1995 the trend was *still* to "put criminals behind bars and keep them there" (and continues to be so to this day), this statement does represent a different type of closure in comparison to the stories noted above that resolved with statements that were dismissive of criticisms of the penal system.[8]

No such nod to prisoner rights advocates was apparent in a November, 1995 story that aired as an installment of the NBC Evening News series called "The Fleecing of America." In this story about prison inmates receiving government checks while incarcerated, the reporter continually made provocative statements such as, "No one knows how many tens of millions of *your tax dollars* still go to prisoners in city and county jails" (emphasis added). There was no attempt at "balance" in this news item at all, as if it was only common sense (a term that Brokaw used at the top of the story) that there was only one side to *this* story. Every viewer in the audience was addressed as if they were sure to agree with the perspective offered by both the officials interviewed and NBC News itself. Thus, the story ended with an official stating, "You and I, that pay our taxes, and to have that money diverted to an inmate,

[8] A year after this story was aired the Prison Litigation Reform Act was passed. Through a series of provisions this act makes it virtually impossible for most inmates to bring lawsuits, regardless of the seriousness of their case. See Parenti (1999) for a discussion of some of the details of this act.

it's absurd." The reporter, Lisa Myers, replied, "So absurd, that not even the federal government defends this fleecing of America." So absurd and so much for objectivity. The viewer of this item was interpellated in such a way as to suggest that there really was no other legitimate perspective. Myers's statement clearly supported those who were trying to thwart inmates from receiving these payments, but it also implied that the federal government could *usually* be expected to defend frivolous spending of *your* tax dollars.

This story, and others that depicted prisoners as parasites, were also rife with particular perspectives in regard to the issues of race and Otherness (Us and Them) noted above. For example, every single official (five in total) interviewed in this story was white, as was every Sheriff and correctional officer depicted, as well as the reporters, Brokaw and Myers, while the inmates who appeared were both black and white.

It is also illuminating to compare this story to another that aired in 1995, this time on CBS), that also framed inmates as parasitical but for a very different reason. The NBC story explicitly stated that prisoners should not receive government checks while incarcerated, even though those who were receiving these funds must have been eligible for them prior to being sentenced to prison. Prisoners who did continue to receive checks were drawn as cheats and parasites, draining money from honest taxpayers. There was no discussion of whether some prisoners might need the payments in order to support family members on the outside who may also have been dependent on these funds. While many viewers might be expected to agree with the perspective that inmates should not receive government payments (and the story proceeded from the assumption that *everyone* in the audience would agree with this position), another story that appeared in 1995 on CBS framed inmates who earn money *working* in prison also as parasites, because they were said to be draining jobs and income from workers on the outside.

Filmed inside a small furniture plant in Delaware the reporter noted: "In theory it sounds good, prisons are filled with idle hands so why not put them to work? But the harsh reality as anyone will tell you in a small company like this one, is that any work done in a prison means less work for someone else." The owner of the company then stated, "I have 20 hard working employees who are trying to earn a living, provide for their families, and to have that be cut into by prisoners is appalling." Here, again, is the notion that prisoners are different than Us. Can't prisoners be hard working? Don't prisoners need to provide for their families also? The word itself, "prisoners," as used by the owner of this company, seemed to imply that they are no longer human, they no longer face the demands that human beings face, they no

longer deserve the rights that human beings deserve. They are just Prisoners—cheats and parasites. This was not just the view of this factory owner, however. CBS News was complicit with this framing of inmates and non-inmates as binary opposites: "It's a dilemma prison authorities worry can only get worse—how to keep more and more idle hands busy so they stay out of trouble, without taking a hard earned paycheck out of an honest worker's pocket." Are prisoners' hands "idle" of their own volition? Because they don't want to work? Because they are lazy? Can't a prisoner be an "honest worker" even if they have been convicted for a crime? These sorts of questions were not aired in this story.

While the story noted at the top that prison workers may only earn 70 cents an hour with no benefits, the rest of the story presented prison labor as a scam perpetrated on the American public—prisoners being rewarded with the privilege of being able to work while they take money out of "honest workers' pockets." Prison labor is in fact nowhere near as widespread as this story implies. Less than 5% of the nation's prisoners actually have jobs on the inside, less than the percentage of inmates employed in 1980 (Parenti, 1999). Furthermore, this story may distract viewers' attention from the real source of "honest worker" misery in the United States, corporations that manufacture their products in developing nations where they can get away with horrible working conditions and starvation wages while avoiding their fair share of taxes. Like the workers in the developing nations of the world, those few inmates who do work in prison are in fact not parasites but victims of exploitation; being paid real wages that are much less than minimum wage (sometimes as little as 15 cents an hour), and working in unsafe conditions (Parenti, 1999).

Prisoners Are Well-Taken Care of in U.S. Prisons

The fifth key theme I identified builds on the notion that prisoners unfairly take advantage of opportunities like prison work. This is the notion that there are lots of opportunities for America's prisoners and that they receive good treatment while incarcerated. In an example of the importance of language in media framing, an April 1990 ABC item stated that a white Sheriff in charge of a Southern jail "looks after" 120 prisoners. Black prisoners were shown engaging in recreational activities, playing basketball and lifting weights. The term "looks after" is connotatively loaded and, in this context, profoundly misleading. The Sheriff was described as if he was serving a parental role; caring for and tending to the men that are imprisoned in his institution. But these men are not children, they are certainly not *his* children, and his job is not really to "look after" them, it is to keep them contained. The phrase implies the provision of comfort and nurturance, neither of which is standard operating

procedure in America's prisons and jails. The racial connotations of this description can also not be ignored. Describing a white Southern Sheriff as "looking after" primarily black prisoners recalls the way slavery was once framed as a benign institution by popular culture texts such as *Birth of a Nation* and *Gone with the Wind*. Rather than being "looked after," black prisoners often experience the injuries of racism on top of the indignities and abuses that all prisoners must deal with.

For example, Parenti notes multiple examples of evidence of racial hatred among correctional officers in California, including a group of guards who call themselves SPONGE—"Society for the Prevention of Niggers Getting Everything":

> [A] white guard carved a swastika in the wooden stock of his rifle; another had complaints filed against him by colleagues for fraternizing with AB [Aryan Brotherhood] prisoners; another proudly showed off his Ku Klux Klan membership card... a Jewish guard was handcuffed to a fence by fellow COs [Correction Officers], who happened to be Neo-Nazi skinheads; a Black guard had his new truck vandalized and was forced to request a transfer out of his highly coveted supervisory position (1999, p. 206).

All of this took place in a prison system that prided itself on its diversity, with nearly half the staff being composed of women or people of color. In Southern institutions, such as the one featured in the above news item, where the guards are primarily white, one might expect racism to be even more rampant. And, in fact, this is just what is suggested by an Amnesty International report on prisons in Virginia, for example (available at http://web.amnesty.org).

Thus, "look after" is a term that is paternalistic and misleading, especially when the racial context of the story is taken into consideration. This is not to suggest that the particular Sheriff depicted in this story is necessarily guilty of racism. I do argue, however, that the term is both inappropriate and ideologically charged when used to describe the relationship between prisoners and those who keep them imprisoned. In general, this is not a relationship that can be accurately described by saying that the prisoners are "looked after" by the guards. Rather, many of the ex-inmates I interviewed described their treatment by corrections officers (COs) as one that was often marked by maltreatment and disrespect:

> Daryll: Verbal abuse goes on like crazy.
> Carla: [B]ut then you have the COs who talk to you like shit.... The treatment is just so shitty. You know, they don't really respect you. You have to either take it or (inaudible). You humble yourself, because that's authority. But sometimes you can be the humblest person, and they still just shit all over you.
> Ray: [I]t's really like a military thing like, but some of the COs take it to an extreme, you know. They'll come up to your face because they know they have power over you, things like that. They try to demand something from you. All they got to do is ask you

nicely, and you'll take care of it, you know. But they'll make your whole day real messed up through the whole day, you know. They'll keep messin' with you and bother your head, you know.

These comments from ex-inmates should not be taken as objective reports about the "reality" of prison life, any more than news reports should be trusted as providing viewers with objective pictures of the "real world." Both are stories, and all stories are told from particular points of view. However, in *every* group of inmates interviewed, allegations of disrespect by COs came up spontaneously. This is enough of a pattern to suggest that, at the very least, inmates do not envision the relationship between themselves and their keepers as a benign one. It is highly unlikely that most inmates would ever think of those who guard them as people who "look after" them. The following conversation I had with two ex-inmates, a black male (Cal) and a white male (Evan), is instructive in terms of how those who have experienced it first hand perceive the relationship between prisoners and COs:

Evan: I've been doing time for 20 years. It's gotten worse in the last few years. It used to be about rehabilitation.

Cal: Now they just want to break you down.

Evan: Now it's all about mentally abusing you.

Cal: I'm not going to tell you there's no physical abuse by officers, of course there is, but it's mostly mental abuse you know?

Interviewer: What kind of things, when you say mental abuse, what kind of things?

Evan: They treat you like you're shit. That sums it up right there.

Cal: Down on you all the time.

Interviewer: Disrespect?

Evan: No matter what you do you get disrespected. The system bring a lot of problems on themselves.

Interviewer: Tell me what you mean by that...

Evan: They treat you like shit—they're gonna get you.

Interviewer: You think if they treated people with more respect, there would be less problems?

Evan: Not everybody, not everybody—there's pieces of shit and they're always going to act like pieces of shit. Those you can't change, you know what I'm sayin', but the majority of the population, if you treat them good, they're going to act good.

One of the most interesting things about this conversation relates to the point, noted above, that these are subjective opinions. Despite that, at the end of this dialogue one of the respondents acknowledges that all of the conflict between prisoners and staff should not be blamed purely on the COs. COs too, are unlikely to characterize their relationships with inmates as harmonious (see Conover, 2000), but they would most

likely view the inmates as instigating most of the conflicts. Several ex-inmates were able to admit that not all COs are abusive and that prisoners also instigate conflicts:

> Ray: I ain't sayin' that all COs are bad...
> Evan: There are some good COs.
> Ray: They got some real good COs there—I mean real good.
> Evan: But they're rare.

And in another conversation:

> Fred: It's not just them—it's us too.
> Marty: It's us too. It's all on how you want to make it, you know. You can make it hard on
> yourself. You see guys come in with chips on their shoulders. I was one of them. I came
> in here with a real bad heroin habit, and they don't give a shit in here, you know. I was
> real bitter, but my attitude changed.

Conflicts between inmates and COs thus have multiple causes, from CO prejudices to inmate behavior, to generalized aggression on both sides. Regardless of what the causes are, however, it is misleading to portray this complex relationship as nurturing and comforting, as the term "looks after" connotes.

Of course this was not the only news story in the sample to imply that inmates are both treated well and provided with opportunities for success while they are incarcerated. As noted above, stories on innovative rehabilitation programs received more airtime than any other topic in this sample, and the general theme that cut across these items can be encapsulated by these twin ideas of decent treatment and opportunities for success. For example, a September 1990 story on NBC focused on the heart-warming story of Robert Stanfil, an ex-inmate who stayed out of prison and ended up becoming a successful barber and town council member. This was an extremely upbeat, "feel good" story. The reporter was shown on camera with a huge grin on his face as he related Stanfil's Horatio Alger-like journey from a chronic offender to a man who almost was elected Mayor of his town. Stanfil was shown sharing a laugh with a customer, a man who was the last person that he robbed before changing his ways. They joked that the man who was once Stanfil's victim now gets all of his haircuts for free. At the conclusion of the story Tom Brokaw shared a sympathetic smile with viewers.

This story was framed as a parable of individual accomplishment—here is a role model for what can be achieved by inmates who are willing to change their lives. As with all stories of this nature, systemic obstacles to success are ignored. Furthermore, this tale of an individual's success came with a caveat. Tom Brokaw introduced the item with the statement: "One man's success doesn't have to be the exception... if it's the right man." Stanfil now teaches barbering in prison and several inmates were

shown participating in this program, which is described as a shining example of what rehabilitation programs in prison can do: "In the last decade he has graduated 125 inmates. Only 7% who left prison came back." The moral of this fable—prisons provide opportunities such as these to inmates, and the "right" men will take full advantage and "turn their lives around" and "pull themselves up by their bootstraps," etc. Who are these "right" men, however? Robert Stanfil is a white man. Every inmate shown participating in his barber-training program in this news story was white. This may or may not have been intentional on the part of the segment's producers, but this question of intentionality does not mitigate the ideological ramifications of these visual images. It also fits a pattern that Sloop (1996) identified in his analysis of magazine articles about prisoners. Sloop noted that the prisoners who were portrayed as being capable of redemption and rehabilitation were almost always either female or white. On the contrary, men of color were frequently depicted as naturally deviant and violent and therefore incapable of truly changing.

Not all of the stories in this sample of television news fit the pattern that Sloop (1996) identified in magazine articles on prisons and prisoners, however. One exception to this pattern was an item aired on ABC in November 1990. In this story, both black and white prisoners were portrayed as reasonable, if flawed, human beings, working hard on recovery while participating in, and benefiting from, drug treatment programs during their incarceration. This story was also not typical of other news items in the sample, in that it offered a limited criticism of the penal system that was not instantly rebutted or challenged. However, this criticism was conveyed verbally and may have been counteracted by the story's visual imagery. At the beginning of the story Ted Koppel noted that while as many 85% of those arrested have drugs in their system, most inmates do not have access to drug treatment while in prison. The reporter also announced that there are only 15 treatment programs such as the one profiled in this story throughout the country. These statements may be taken as a critique of the U.S. penal system, particularly because Koppel also referred to the need for such programs as being "obvious."

These sorts of verbal acknowledgments that most prisoners do not have access to real drug treatment may, however, have been counteracted by a series of profoundly misleading visual images. Prisoners were shown living in comfortable, apartment-like settings, playing pool, sewing, reading in soft light. Everything looked very tranquil and comfortable. These images exemplify this theme that prisoners are given opportunities for success and are well taken care of while they are incarcerated. These images are also potentially misleading to viewers who do not take notice of the two brief statements that provide a verbal asterisk indicating that the program shown here

is actually quite unique. As one of the ex-inmates I interviewed explained about his experience:

> Ray: All my prison time has been prison time—they never put me in a drug program. Never. Never. Every time I went to the court—straight to jail. I had a drug problem.

Most prisoners do not live in the type of setting depicted in this story, and viewers can come away from this segment with the extremely inaccurate impression that doing time in the United States is "too easy."

This same tendency to portray prison life as comfortable was apparent in a story on private prisons that also aired in 1990 on NBC. This story began with the information that prisons all over the country were becoming increasingly overcrowded. Scenes of a motley crew of inmates, who had been released early in order to free up space, streaming through prison gates seemed designed to raise viewer anxiety. But then Tom Brokaw immediately spoke to this anxiety by assuring viewers that there is a solution to prison overcrowding that does not entail early release... private prisons. The reporter then began itemizing just how wonderful life is inside one of these privately run institutions: air-conditioning, modern living quarters, "state-of-the-art" security. Plus, we can build more and more of them so quickly. A professor from the University of Connecticut stated that, "It takes the government two to five years to go through this process, and a private company can do it in under one year." The reporter assured viewers that private prisons are also more efficient and cost-effective because they don't have to put up with government bureaucracy.

The coup de grace—the inmates love it: "Generally they tell you it's a world away from the gothic, multi-storied cell-block existence in most state prisons." A Latino inmate said that it was quiet and he could read and listen to his radio. A white inmate said that they have "every kind of schoolin' that there is, just about." Prisoners are shown doing complicated arithmetic and working on computers in well-equipped classrooms. A black inmate stated that the food was better than what he had received in state facilities and that the education programs were better also. Good food, great education, air-conditioning—what a life. The reporter then tied it all together in a neat ideological bow: "In a nation that seems to be demanding more prisons, but worries about their price, the private sector offers one solution, which, at the moment, seems to be working well."

This story did include comments from a professor at American University who was critical of the privatization of prisons. However, Brokaw's interviewing strategy seemed designed to marginalize this critic as an out-of-touch academic who simply didn't have any common sense: "Professor, this is an innovative approach, it apparently is cost-efficient, there is a major problem, how can you be critical?" The critic,

Ira Robbins, responded that private prisons don't address the larger issues related to criminal justice in the U.S., and provide only a temporary fix when what is really needed is hard work on national priorities and policies. Brokaw replied, "But in the meantime we do have a problem with prison overcrowding and these private prisons seem to be doing a much better job with education for example." Robbins was given the last word in this interview, but, perhaps not coincidentally, Brokaw ended the segment with a note promoting an upcoming feature about a tough, law and order approach to crime: "Reclaiming the streets of Charleston—A tough cop whose force intimidates drug dealers." Brokaw ended this statement with a confident nod to the viewer that might be interpreted as signifying—'You and I understand that this is the real way to deal with criminals.'

The vision of private prisons provided in this news story, as idyllic settings where prisoners lounge in air-conditioning, is sharply contrasted by Parenti's description of private prisons as "private hell" (1999, p. 221). At one private institution the wonderful food consisted of meal after meal of the same three elements: black-eyed peas, corn bread, and water. When prisoners were being punished they were provided with only peanut butter, bread, and water. Because private prisons are in business to make a profit, they often do so by "skimping on food, staffing, medicine, education, and other services for convicts" (1999, pp. 220-221). Despite these shortcuts, and amid continuing claims of cost-efficiency, studies have shown that states save little to no money by contracting with private prisons (see Austin and Irwin, 2001; Parenti, 1999). Meanwhile, Parenti's loaded term "private hell" actually seems like an apt description:

> [T]he GAO [General Accounting Office] found, among other things, that 80 percent of the CCA [Corrections Corporation of America] guards had no corrections experience; many of the guards were only eighteen or nineteen years old; prison medical records went unaccounted for while more than 200 chronically ill inmates were left untreated in general population; and almost no effort was made to separate violent psychos from peaceful convicts. Later inmate civil rights suits alleged that guards violated regulations by using tear gas inside; that prison tactical teams dragged inmates naked and shackled across floors; and that during cell searches convicts were forced to strip, kneel, and were shocked with stun guns if they moved (1999, p. 223).

In one private prison in Texas, in a prophetic foreshadowing of Abu Ghraib, a group of guards videotaped themselves abusing naked inmates by beating them, stunning them, and setting dogs on them. In a South Carolina private facility for juveniles, boys were tortured by cramming eighteen of them into a cell built for one person, and then making them all use paper cups for toilets (Parenti, 1999). Yet, from Tom Brokaw's perspective, "How can you be critical?"

These news stories about the good treatment and opportunities that inmates receive in prison are quite misleading. Yet these media images are very powerful influences on the public's perception of the penal system. As one women stated in an August 1995 CBS story on a tough Sheriff who refuses to adhere to limits on how many prisoners can be held in his facility—"I think they get enough in prison as it is."

Criticisms of the Penal System

The final key theme I identified received much less emphasis than the others previously discussed. This theme ran contrary to the tendencies of the other five key themes, in that it revolved around criticisms, rather than defenses of the penal system, and focused on injustices and the need to defend prisoners' rights rather than the need for tougher criminal justice polices and harsher institutions. This theme was apparent, for example, in the criticisms of private prisons offered by Professor Ira Robbins who was interviewed by Tom Brokaw. However, as noted above, in this story the critical perspective advanced by Robbins was overwhelmed by the dominant theme of the story—that private prisons are better for inmates and more cost-effective than state run facilities. Brokaw attempted to marginalize Robbins's perspective as merely the impractical musings of an academic.

Similarly, in an April 1995 NBC story on prisoner lawsuits, a brief amount of time was devoted to those who were critical of restricting inmates' rights to sue. An inmate voiced his concern about new policies that would restrict prisoners' access to the courts (7 seconds) and a prisoner rights activist noted that important legal protections have resulted from inmate lawsuits (9 seconds). Thus, 16 seconds of this 2 minute and 30 second news story was devoted to dissenting voices while the perspectives of those who defined inmate lawsuits as a frivolous waste of taxpayer dollars dominated the item. It should be noted, however, that the story ended with the reporter acknowledging that inmates believed they were being silenced by restrictions on their rights to bring suits. Similarly, a story on a riot at Pelican Bay, broadcast by CBS in February 2000, focused almost entirely on how violent and out of control the inmates were, but then ended with the note, "But critics of the prison system say the isolation and strict control at supermax facilities like Pelican Bay make inmate riots almost a certainty."

An ABC story, on prison chain gangs, allowed airtime to a representative of the American Civil Liberties Union who was extremely critical of this practice. This time the critical perspective was marginalized by noting that citizens favor chain gangs and that their use is inevitable. An ACLU representative was also given a few seconds in a

December 1995 NBC story on drugs in prisons. While the bulk of this story put the blame on the practice of allowing inmates to have physical contact with visitors, the spokesperson for the ACLU noted that corrections staff are also responsible for smuggling drugs into the prison, often as a way to increase their income because of the low-wages that are paid to many prison employees.

Another instantiation of this pattern of allowing very limited space to criticisms of the penal system, which then become overwhelmed by the hard-line approach advocated in the bulk of the story, was also found in an August 1995 CBS story on prison overcrowding. This news item focused on a sheriff who was refusing to let prisoners out on early release despite a court order saying that he must. Although his facility was overcrowded to the point of inhumanity, he was portrayed as a maverick hero in this story as he proclaimed: "I am not going to let the comfort of the inmates win out over the safety of the public." Inmates and their attorney advocate criticized this viewpoint. Again, however, these criticisms were countered by 'ordinary citizens' who spoke in support of the sheriff's 'get tough' policies with comments such as: "They're in there for a reason, it's not a hotel."

Thus, while criticisms of the U.S. penal system did appear from time to time in this sample of national network evening news stories, these critical perspectives tended to be marginalized, quickly refuted, or given very limited time. The other key themes identified here overwhelmed any sort of truly dissenting perspective that might have been nascent in these news items, while simultaneously advancing a discourse that framed prisoners as violent misfits who are a drain on society and who must be contained.

Conclusions—"2 Million Americans Imprisoned, Television News Looks the Other Way, No Details at Eleven..."

Suffice it to say that the news about prison news is bleak. In comparison to other aspects of crime and the criminal justice system, corrections receives limited and infrequent coverage. When prisons and prisoners are covered, the stories tend to provide distorted and misleading images that bear little resemblance to the reality that most prisoners experience on a daily basis.

Prisoners are portrayed as dangerous, violent, parasites, while the prison system itself is depicted as providing these unworthies with decent living conditions and plenty of opportunities for success. Muted criticisms of the penal system do appear in some of these news stories, but typically they are overwhelmed and marginalized by these other discourses.

While this summary offers a capsule version of what is provided in television news on prisoners and the penal system, what is just as important, however, is what *isn't* there, what viewers *don't* get to see, what is missed entirely by these infrequent accounts of life in America's prisons. Project Censored has been tracking the stories that the mainstream press in the United States *doesn't* cover since 1976 (see Phillips and Roth, 2008). During this time period they have documented hundreds of important issues that the American public know very little about due to media silence. I argue that the conditions that 2 million plus prisoners wake up to every day is one of the central stories that has been ignored by the mainstream media.

Based on my interviews with people who have served significant time in U.S. prisons and jails, the following is a list of just some of the issues related to incarceration that might have made for compelling news stories, but did not appear at all in any of the television news stories I examined:

- The disproportionate incarceration of people of color, and the reasons behind this.
- The disproportionate incarceration of the poor and the working class, and the reasons behind this.
- The rise in incarceration rates of women, and the additional hardships that female prisoners must face.
- The difficulties released prisoners have in finding employment.
- The sorts of non-violent offenses for which most prisoners are actually sentenced.
- The placement of non-violent prisoners alongside offenders with violent records.
- The state of medical care in the nation's prisons and jails.
- The state of nutritional services in the nation's prisons and jails.
- The state of educational and vocational programs, libraries, drug treatment and counseling services, etc. in the nation's prisons and jails.
- High turnover rates and inadequate training programs for COs.
- The ratio of inmates to staff in the nation's prison and jails.
- Inmate allegations of abusive treatment by, and corruption among, corrections staff persons.
- The complexity of sexuality among prisoners.
- The extent to which prison rape is a problem and whether anything is being done about it.
- The extent and causes of inmate suicidal behavior.

Carl Jensen of Project Censored has offered the following rumination about the mainstream media silence on certain types of politically charged and controversial stories:

> [S]ometimes a source for a story isn't considered reliable (an official government representative or corporate executive is reliable; a freelance journalist or eyewitness citizen is not); other times the story doesn't have an easily identifiable "beginning, middle, and end" (acid rain just seems to go for ever and ever); some stories are considered "too complex" for the general public (nobody would understand the intricacies of the savings and loan debacle); on occasion stories are ignored because they haven't been "blessed" by The New York Times or the Washington Post.... However, the bottom line explanation for much of the self-censorship that occurs in America's mainstream media is the media's own bottom line. Corporate media executives perceive their primary, and often sole, responsibility to be the need to maximize profits for the next quarterly statement, not, as some would have it, to inform the public (1997, pp. 15-16).

Many of the reasons that Jensen cites are relevant to explaining why television news tends to ignore the U.S. penal system, despite the fascination with crime that is on display in both local and national television news broadcasts. For example, inmates are not considered reliable sources, whereas corrections officials and politicians are. Furthermore, the way objectivity has been defined in the mainstream press, reporting the statements of powerful officials without comment is considered legitimate and professional, while questioning the perspective of these elites or asking some of the hard questions related to the issues noted above would be considered unprofessional and biased (Bennett, 2001).

The story of the mass incarceration of America's citizens is also not a story that is necessarily event-based, or as Jensen puts it, it does not have an identifiable beginning, middle, and end. Additionally, adequate explanations of certain aspects of the story, such as race and class inequities in incarceration rates, may very well be considered too complex, a point that is particularly salient for television news which requires brief, easily digested sound bites and images as the pegs upon which stories may be hung (see Scheuer, 1999).

However, there are also other reasons behind the lack of television news coverage of the penal system that are unique to this particular issue. For one, there have been tremendous obstacles placed in the way of those journalists who are motivated to investigate conditions inside the nation's prisons and jails. Many states have instituted polices that make it extremely difficult for journalists to gain access to inmates. For example, in California a journalist must first somehow get in touch with an individual inmate, then get his or her name added to a visitor's list, then get the Department of Corrections to approve a visit, then make arrangements for a specific visit

date and time. Reporters say all of this may take up to eight weeks, an unrealistic time frame in a news environment that values immediacy and timeliness. If a visit is approved, it must occur in the presence of guards, an arrangement that clearly would influence what the inmate feels free to discuss (Vosters, 1999).

For television news, the obstacles placed in front of reporters may be even more difficult to overcome. As Vosters (1999) notes, print journalists may be able to gain a certain amount of limited access to inmates if they are persistent, but in many states television journalists are not allowed any access to prisoners at all. However, not all of the blame can be placed on government restrictions. Vosters points out that the broadcast industry has done little to fight for access to prisons and prisoners. Except in the case of dramatic events such as escapes, riots, and high-profile executions, the values that television journalists use to guide them in deciding what stories are worthy of coverage mitigate against any concerns about being denied regular, ongoing access to prisons and prisoners.

Because television news is constructed almost entirely out of short, easily understood, dramatic events accompanied by exciting visual images, routine coverage of the larger social issues related to America's incarceration of 2 million plus people simply doesn't "fit the profile." As one local news director answered in response to my questions about his station's coverage of corrections, whether or not a story about the penal system will be broadcast depends on "whether it's newsworthy" (Anonymous, personal communication, 4/4/02). This statement implies that news worthiness is self-apparent; the news just occurs and reporters just report it. This perspective ignores the constructed nature of the news; that the news doesn't just happen but is defined by those who are in positions of power that allow them to decide what is newsworthy or unworthy (Gans, 1979; Hall, 1973; Hall et al., 1978; Tuchman, 1978).

As McChesney (1999) points out, when those with political and economic power are in agreement on an issue, there tends to be very little discussion of this issue in the mainstream press. It is assumed that because elites are in agreement, then there must be consensus. Dissenters are dismissed as out-of-touch fringe elements, or worse, as wild-eyed radicals and lunatics whose voices are not worthy of airing. McChesney (1999) uses the example of military spending as one example of this sort of "consensus" (non)story. The other example he offers is just what has been discussed in these last two chapters—the mass incarceration of American citizens. Criminal justice policy and the prison-industrial complex should thus also be counted among the ranks of those practices and institutions that seem to be beyond scrutiny in the current political environment.

But why does television news shy away from the supposed "watch dog" role of the fourth estate in favor of broadcasts that are composed almost entirely of episodic, fragmented stories, and sound bites and eye-catching visual images? Ultimately, we must return to Jensen's argument that a corporate media system driven by formulaic conventions, ratings, advertising dollars, and profit is unlikely to provide the public with in-depth coverage of stories that don't meet the goal of attracting the most demographically appealing audiences and putting them in a "buying mood." McChesney argues that:

> In recent years, the increased focus by the commercial news media on the more affluent part of the population has reinforced and extended the class bias in the selection and tenor of material. Stories of great importance to tens of millions of Americans will fall through the cracks because those are not the "right" Americans (1999, p. xix).

While "tens of millions of Americans" are affected either directly (by incarceration), or indirectly (by family members being incarcerated) by the U.S. penal system, these Americans tend to be the poorest Americans. While what occurs in America's prisons may be of great interest to them, could it be that it is simply not important to the gatekeepers in charge of television news because these are not the Americans that advertisers want to reach? As McChesney notes:

> [T]he portion of the population that ends up in jail has little political clout, is least likely to vote, and is of less business interest to the owners and advertisers of the commercial news media. It is also a disproportionately non-white portion of the population, and this is where class and race intersect and form their especially noxious American brew. Some 50 percent of U.S. prisoners are African American. In other words, these are the sort of people that media owners, advertisers, journalists, and desired upscale consumers do everything they can to avoid, and the news coverage reflects that sentiment (1999, p. xxi).

One point to add to this argument is that the *reason* many people who have been to prison don't vote, is that in several states anyone who has been convicted of a felony loses their right to vote, *for the rest of their lives*. This is another important story that receives little to no coverage in the mainstream media.

Thus, television news tends to pay little attention to the fact that America has become an incarceration nation; a nation that "has 5 percent of the world's population and 25 percent of the world's prisoners" (McChesney, 1999, p. xx), primarily because the commercial imperatives of the corporate media system mitigate against dwelling on this ugly information. Yet, when it comes to entertainment media such as Hollywood films and television prime-time dramas, those that hold the purse strings of the culture industries are more than willing to put spectacles of imaginary prisons and prisoners on display as commodities for consumers to purchase. Thus,

the fantasy prisons and prisoners of popular films such as *The Shawshank Redemption* and television shows such as *Oz*, fill the void left by the hole in television news coverage of the prison-industrial complex. In the next chapter I turn my attention to television's fictional portrayal of prisons and prisoners.

CHAPTER VI

That's Entertainment?
Prime Time Drama and Incarceration

"It ain't nothin' like on TV."—"Frankie"

In May 2002, a commercial for the soft drink 7UP, appeared on MTV. The title of the advertisement was *Captive Audience*. The web site of the non-profit organization Stop Prisoner Rape (SPR) described the content of the ad as follows:

> In the ad, a 7UP spokesperson hands out cans of 7UP to prisoners. When he accidentally drops a can, he quips that he won't pick it up, implying that he would risk being raped if he were to bend down. Later in the ad, a cell door slams, trapping the spokesperson on a bed with another man who refuses to take his arm from around him (7UP to Pull TV Ad Under Pressure from Human Rights Groups, 2002, no pagination, available at www.spr.org).

After initial complaints from SPR that the advertisement was offensive to those who understand that prison rape is a real issue, Dr. Pepper/Seven Up, Inc. refused to stop running the ad. Finally, after almost 100 activist organizations began an organized campaign, the company decided to take the ad off the air.

This advertisement exemplifies the manner in which images of prisons and prisoners spring up frequently on our television sets, even in the most unexpected contexts. Imagine using incarceration and intimations of rape to sell soda.... While this initially seems outrageous, it should actually be understood as "business as usual," when the tendency for capitalism to commodify everything it encounters is taken into consideration. In this chapter, I examine the commodification of incarceration through an in-depth analysis of three prime-time television crime shows that regularly feature images of prisons and prisoners in their ongoing dramatic narratives about the battle between the forces of good and the forces of evil. Because these programs are used by the networks to lure audiences to the advertisements that are the "real" programming of commercial television even when it is not as blatant as the 7UP commercial noted above this is ultimately always a process of commodification—utilizing images of crime, violence, court-room drama, imprisonment, and degradation as spectacles that will entice the audience into sitting through sales pitches for beer and soda, automobiles and cruises, shampoo and diapers.

In perhaps the most explicit example of images of prisoners being used purely as a commodity, the Fox television network aired a program in 1998 called *Prisoners Out*

of Control. In the tradition of other Fox "reality" programs such as *When Animals Attack* (1996), or *When Good Pets Go Bad* (1999), the description of this program on the Internet Movie Database (http://us.imdb.com/) reads as follows:

> Another reality-TV show from Fox, this program features prison security camera footage showing prisoners resisting guards, fighting each other, and going on full-scale riots. From the brutal results of these incidents, we see that the slammer can be a dangerous place for everyone inside (Rocher, no date, no pagination).

The spectacle of violent conflicts and misery on display in this program serves the primary purpose of attracting an audience that may be sold to the advertisers who hawk their wares in between segments of attacks, stabbings, and beatings. There are two key results that are desired by the corporations who produce, distribute, and sponsor this programming—Fox and its affiliated stations will profit from the companies that pay to have access to the audience for this program, and the manufacturers will presumably be rewarded by increased recognition, and ultimately, sales of their products. It is safe to say that enlightening viewers' understanding of prison conditions is not a primary consideration behind the production of this programming, yet viewer perceptions of incarceration and the incarcerated may indeed be influenced by these violent images.

In response to this criticism, a defender of commercial television might argue that entertainment programs are not intended to educate or enlighten. As Michael Eisner, CEO of Disney, has said, "We have no obligation to make art. We have no obligation to make a statement. To make money is our only objective" (quoted in Wasko, 2001, p. 28). Even someone like Eisner might admit, off the record, that entertainment does much more than entertain (it also instructs, encultures, socializes, etc.). However, in this particular case, even if we accept the notion that a program like this may be *intended* as pure entertainment, we still might question the values of an industry that utilizes images of real-life prison violence and misery to stimulate and amuse viewers. The allusions to the Roman gladiator spectacles are so clear that they almost need no mention.

Yet viewers do seem drawn to images of the hidden world of prisons. Perhaps partially because prisons and prisoners are so mysterious to most middle- and upper-class Americans, and because they receive so little coverage in the news media, they seem to be a ongoing obsession of Hollywood writers and directors, cropping up even in programs and films that don't fit the sub-genre of the prison tale, and in contexts that would not naturally be expected to include such images. For example, a 2001 episode of *ER*, NBC's top-rated hospital drama, featured a subplot about an accident involving a prison van, which sent a group of female prisoners to the emer-

gency room where they promptly created havoc. A 2000 film about roaming karaoke competitors, *Duets*, includes a character who is an escaped convict. A love story about the career of a female television reporter, *Up Close and Personal* (1996), features scenes of a prison riot. Even comedies have often been set inside, or included scenes of, prisons—*Stir Crazy* (1980) and *Life* (1999) are just two examples.

This chapter focuses on still another source of frequent and persistent images of prisoners, broadcast television prime-time dramas. The programs under consideration here, *Law & Order*, *NYPD Blue*, and *The Practice*, include some of the most popular crime dramas that have aired on network television. All in all I examine 70 separate episodes of these three programs.

The Programs

NYPD Blue, *Law & Order*, and *The Practice* are long running, highly successful prime-time dramas that are watched by millions of viewers each week. For example, *NYPD Blue* debuted on ABC in 1993; the season analyzed here was the show's ninth. The show is now in syndication and is thus available to viewers on a daily basis. Although it originally generated controversy due to its tendency to push the boundaries of acceptable language and nudity on broadcast television, *NYPD Blue* has been wildly successful with both viewers and critics. It received high ratings and won 19 Emmy awards while being nominated for 82.

Law & Order is also set in New York and is also one of the more successful shows in television history. *Law & Order* debuted in 1990. The season examined here was the program's twelfth. That year it became the longest-running dramatic program that was currently on television. Still in production in 2009, *Law & Order* is the longest-running police series in television history. Extremely popular with viewers and critics, *Law & Order* has received many Emmy awards and its twelfth season generated the highest ratings in the program's history. It was the third highest rated television drama that year, reaching an average of 18.7 million viewers with each episode.

The other broadcast network series that I analyze focuses on defense attorneys rather than the prosecutorial side of the criminal justice system. *The Practice*, like *NYPD Blue* and *Law & Order*, also earned high ratings and won numerous awards. This show, which focuses on a small firm of defense lawyers in Boston, debuted on ABC in 1997. The season examined here was the show's sixth.

Images of the Incarcerated but Not Incarceration

Similar to local television news, images of the incarcerated in these dramas tended to involve scenes shot in courtrooms and prison interview rooms rather than actually

inside prison residence areas. While the incarcerated were most likely to appear in court in the news sample I examined, television dramas do seem to take viewers one step closer to prison life by including scenes of prisoners being interviewed in visiting areas, interview rooms, and the occasional cell. However, they tend to go no farther than that. No episodes included scenes of daily prison life that did not involve interviews between inmates and the police or inmates and attorneys. There were no scenes of prisoners interacting with each other or with guards. The protagonists of these programs are criminal justice workers and professionals such as lawyers, police detectives, and judges. The prisoners who appear in these shows tend to be one-dimensional, serving as mere backdrop, as plot devices rather than real characters.

Thus, these images tend to be quite superficial and shallow. Despite this, the incarcerated appeared frequently in the shows analyzed: Most of the episodes analyzed included inmates in court, or being interviewed in facilities such as Riker's Island, or characters who were clearly identified as ex-convicts and/or parolees (see Table Four).

Table 4: Frequency of Images of the Incarcerated in Three Prime-Time Dramas

Program	Episodes Analyzed	Relevant Episodes	Percentage
Law & Order	24	18	75%
NYPD Blue	23	14	61%
The Practice	23	14	61%
Total	70	46	66%

Across all three programs, inmates, ex-convicts, and parolees appeared in two out of every three episodes. Thus, while televised news about the prison system is relatively rare, those who are incarcerated in that system appear frequently on the nation's television screens, albeit in fictionalized personas and limited settings.

Key Themes in Dramatic Programming

As with the national news examined in the previous chapter, certain tendencies and patterns in these programs transcended both individual episodes and individual series. Certain recurring patterns of representation cut across all three programs and contributed to the creation of a discourse about prisons and prisoners that was consistently echoed throughout the programs. These key themes include the following

tendencies in the dramatic portrayals examined: 1) moralizing about guilt and inno-cence, 2) establishing and providing justification for the brutality of prison life, 3) defending the criminal justice system, and 4) using prisoners as plot devices.

Guilt and Morality—Rescuing the Innocent, Sympathizing with the Misguided, and Fearing the Evil

While most of the inmate characters in these programs were depicted as being guilty of the crimes they were accused of committing, in-depth analysis of the thematic tendencies in these texts reveals that the representation of guilt and innocence was more complex than a count of simple frequencies might suggest. Rather than a clear-cut division between innocent and guilty characters, my analysis revealed that while a few characters were framed as completely innocent, others were portrayed as essen-tially good but misguided people who had committed errors of judgment or who had simply "snapped" when confronted by circumstances beyond their control, while still others were depicted as monsters or beasts—evil incarnate. Thus, this theme revolv-ing around guilt and morality actually has three dimensions embodied by the repre-sentation of inmate characters as persecuted innocents, misguided souls, or evil beasts.

Rescuing the Innocent

While the truly innocent represented just a handful of the inmate characters depicted in these programs, they did appear in the defense-oriented show *The Practice*. These characters were framed in such a way as to elicit sympathy from the viewer, who could then whole-heartedly root for the defense attorney to win without having to confront the sometimes-unpleasant reality that even the guilty are worthy of and enti-tled to a vigorous defense. These characters tended to be represented not as victims of a failed legal system but as victims of deviant individuals such as "rogue" police officers or corrupt prosecutors.

Since the defense attorney often does win, a recurrent message in these dramas is that while there may sometimes be a delay, ultimately justice and fair treatment will prevail. For example, an episode of *The Practice* entitled, "Killing Time" featured the story of a black male inmate who had served 12 years for a murder he didn't commit. In this episode he is due to go before the parole board but must take responsibility for the crime, even though he is innocent, or the board will not even consider releas-ing him. He adamantly refuses to confess to the crime; despite this the board does release him. The audience is allowed to cheer because justice has at last been delivered to this innocent man. Interestingly, this episode does include some criticisms of the

criminal justice system itself. The defense attorney points out that DNA evidence has revealed that innocent people are convicted, and the inmate delivers this speech to the board:

> You have to make me say I killed him because otherwise you have to face the fact that you have an innocent man sitting in jail for 12 years for something he didn't do. You just want to pretend that you only have guilty people in prison.

While this sort of dialogue does criticize the U.S. criminal justice system, the program as a whole only goes so far in advancing a critical perspective on the workings of that system. For example, although the inmate going up for parole in this episode is black, the racial aspects of U.S. criminal justice system problems are not dealt with in this episode at all. In fact, by having both the defense attorney and the hard-nosed chair of the parole board portrayed by black actors, this episode manages to elide racial discrimination in the U.S. legal system entirely. The chair of the parole board is depicted as a stern woman who believes in strong law and order policies and a "get tough" approach to crime, but because she is black, her confrontations with the inmate who is up for parole are not likely to be construed as being racially motivated. When she somewhat skeptically announces that he was granted parole by a majority vote the viewer might assume that she, rather than the white members of the board, voted against him. This, and the fact that the inmate's release was granted after just a six-minute deliberation by a primarily white board, seems to confirm that race is not a relevant issue in parole hearings and that justice will win out, even if it is a delayed victory.

Although issues of racial discrimination did not come up often during my interviews, some respondents did indicate their awareness of the role that race really does play in the criminal justice system. For example, Carla noted, almost in passing, "[I]f my time is based on my color... I think that's fucked up." Another ex-inmate, Will, said, "The system's built for the minorities."

Race also comes into play, in some episodes in the manner in which stories of innocent black inmates being freed are juxtaposed with stories of sympathetic, but guilty, whites who are either given long sentences or executed. On the surface it may appear to be a positive tendency for the black characters on these programs to not be stereotyped as always guilty. However, when the entire plot structure of these episodes is taken into account, these stories may also suggest that it is whites who are most likely to receive harsh sentences, a proposition that is highly misleading. Again, some of the ex-inmates I spoke with referred to their own perceptions of racial discrimination in the criminal justice process. For example, during one interview re-

spondents began talking spontaneously about the number of blacks and Latinos in prisons and jails and one ex-inmate related this story:

> Carla (a black woman): My brother just got two years.... Never been in trouble a day in his life. Never did nothin' wrong. Finished school, went to college, had a job the whole time. He got caught with two ounces of weed. Meanwhile, I'm going to court... a white girl get up, got caught with ten bags of heroin, two bags of weed, and pills and got... not a nothing. Blew my fuckin' mind. And they want me to respect the system? Fuck it. I just can't.

Sympathizing with the Misguided

The line between who is truly innocent and who is guilty yet still worthy of our sympathy because they are essentially misguided is a blurry one in these programs. The second category of inmate characterizations, what might be called the "misguided souls," thus provides a bridge between the truly innocent and the bestial guilty in these television representations of prisoners. The misguided represent a liminal sort of character—not truly innocent and yet not entirely guilty, and therefore evil, either. These misguided souls were often depicted as people worthy of viewers' sympathy, even when their crimes were violent ones. For example, in a *Law & Order* episode, three young white environmental activists, two males and a female, are charged with arson and murder even though the death that resulted from their actions was inadvertent. These characters are depicted as sincerely remorseful and repentant. While they are not innocent, the program establishes that they are young and misguided and it is two radical adults, a lawyer and an environmental activist, who are the truly guilty in this case. Thus, while depicting the three young people as sympathetic, the program still manages to deride environmentalism through its framing of young activists as dupes of a corrupt radical agenda. As the prosecutor, Jack McCoy, says to them, "He's up on that farm pulling the strings and you three are too young or too stupid to realize it." This dismissal of environmentalism as an extremist agenda being forced upon people too young to know better is established in the program's narrative and solidified by other comments made by the prosecutors: "It's time they grew up," and the incredibly condescending, "Think they allow organic produce in prison?" By having these lines uttered by the program's heroic protagonists, the chief prosecutor and his assistant, they take on the stamp of ideological approval.

In other cases, the misguided were represented as individuals who resorted to violence when they felt there was nothing else they could do to protect themselves or their loved ones. For example, in other *Law & Order* episodes, a Latino male who murdered a white insurance executive who had refused his daughter a lifesaving medi-

cal procedure: " I did what I did to save my daughter's life." Or women who killed rapists or abusive spouses and lovers. Or a Latino male who accidentally shot a private investigator who was about to reveal a damaging truth about his son, "What I did, I did for Miguel." Or a white male who thought he was doing his part to fight terrorism by providing a vigilante with information about "suspicious" Arabs. Or, on *The Practice*, an older white male who robbed a bank because he had no health insurance and needed the medical care that is provided in prison, "I was just trying to save my life, I didn't want to get anyone killed."

This last example implies that for some people life in prison is better than life on the outside. However, the ex-inmates I spoke with did not have positive things to say about prison medical care. Rather, they talked about difficulties in getting the care that they needed when they were sick in prison and the questionable treatment given even to very ill inmates in prison medical wards and hospital facilities.

Racial Coding in Characterizations of Guilt and Innocence

The overriding moral message of these narratives and images when considered in the aggregate, then, is that some misguided souls are guilty of the crimes they committed and yet still deserve sympathy, and perhaps lenience, because they are not truly evil people. While examples of inmates who were portrayed as completely innocent ranged across black, Latino, and white characters, the misguided but guilty in this sample tended to be white or Latino, whereas blacks were likely to be represented as either purely innocent or completely bestial and evil. This pattern in the representations of black inmates may be related to the argument that Gerbner and his colleagues have made about the bifurcated images of blacks on television in general (see Shanahan and Morgan, 1999). Gerbner's argument is that blacks in entertainment programs tend to be represented as successful, upper-middle-class individuals, while blacks in news and "reality" programs tend to be depicted as violent criminals and drug addicts. Similarly, the bifurcation that was apparent in these programs was between completely innocent blacks who, after being freed from prison, could be expected to achieve mainstream success and the immoral, dangerous, savage, evil creatures that I discuss below. Thus, while for Latino and white inmate characters, the misguided souls represented a bridge between the truly innocent and the truly evil, for blacks there was little evidence of such liminality. Rather, black inmates, with few exceptions, were depicted as innocent and just like "Us," or as the Other—evil incarnate.

As with the more general bifurcation of black images on television that Gerbner and his colleagues discuss, this dimension of bifurcation may cultivate in viewers an

embrace of purely individualistic explanations of social problems. In the more general tendency this results in viewers adopting the position that affluent and successful blacks in programs such as *Ugly Betty, Grey's Anatomy, ER,* and *The Cosby Show* serve as proof that racism is no longer an obstacle to achievement and success in the United States. Thus, the poor and destitute, who are so frequently on display in the news and in so-called reality programs like *Cops,* must be completely responsible for their own failure to thrive in an open economy (see also Gray, 1995a; Jhally and Lewis, 1992). In the bifurcation between purely innocent and savagely guilty black inmates noted here, this tendency may serve to influence viewer perceptions that black inmates who are guilty are nothing more than beasts whose incarceration resulted purely from their own violent natures rather than from any other confluence of complex factors. The presence of entirely innocent black inmates in juxtaposition with the purely evil thus serves as proof that crime itself is merely a matter of individual choice and the presence or lack of moral character. Framing crime in this manner makes it logical to exhibit absolutely no mercy for the guilty. After all, if the guilty are inhuman, evil creatures by *nature,* then prevention, rehabilitation, alternatives to incarceration, and other programs that make sense when crime is recognized as an overdetermined *social* problem, are positioned as merely misguided attempts by liberals to distract our attention from individual responsibility.

The racial aspects of this are then particularly germane to the contemporary social context in the U.S. where blacks are imprisoned in numbers that far outdistance the incarceration rates of whites. The bifurcation of black inmates into groupings of the innocent, and therefore moral, and the guilty, and therefore evil, provides raw material for a discourse that focuses on individual explanations of crime, *particularly when it comes to black inmates.* The representation of many whites in liminal roles, not entirely guilty but not purely innocent either, allows for a more complex understanding of white criminality that takes into account other factors that can lead "good" people into "bad" behavior. Here we have an interesting variation on a phenomenon that social psychologists have labeled the fundamental attribution error. In traditional social psychology this refers to the tendency for individuals to recognize that their own behavior is influenced by a multiplicity of factors while simultaneously attributing the behavior of other individuals to stable and essential traits. Thus, I snapped at my kids because I was dealing with a terrible day at work, a severe headache, monetary worries, and a lack of sleep. My neighbor snaps at his kids, however, because he is a bad parent.

In the case of bifurcated representations of black inmates, the variation on the fundamental attribution error being proposed here may operate in this manner:

whites who commit crimes often end up in prison because of a number of factors, none the least being that they are victims of circumstances, misled by others, etc. Black criminals, however, are simply immoral creatures, violent and evil by nature. These attributions then impact on "commonsense" notions of how inmates should be treated. Thus, while the innocent and the misguided in these programs were both depicted as being deserving of humane treatment, the evil were deserving only of the harshest punishments available. Furthermore, evidence was provided that if they were not punished and contained to the greatest extent possible, ordinary, law-abiding citizens would pay the price. The third dimension in the theme of moralizing about guilt and innocence, then, involves the portrayal of the purely guilty as immoral, deranged, savage beasts who represent a clear threat to society and who, therefore, must be locked away or we will all pay.

Fearing the Guilty

This tendency is exemplified by an episode of *The Practice* in which a white attorney meets her client, a black man who murdered his white cellmate, in a prison interview room. He is dressed in an orange prison jump suit, has a wild, curly afro and his eyes constantly shift about the room. Ellenor, his attorney, shows him a photograph of the bloody corpse: "Your cellmate dead, your fingerprints on the knife, your confession to the murder. We don't win this one." He seems oblivious to what she is telling him as he replies: "I love court days. It beats watching TV. Food's better than state prison. I can hit on you." Both the visual and verbal signifiers in this scene suggest that this inmate is either insane or completely sinister, or perhaps both. With a sincere, earnest expression he tells Ellenor that the prison guards set him up. Ellenor asks if he is telling the truth and he bursts into a wide grin and says, "No! But I sure had you goin'!" When he makes it clear that he intends to lie in court, Ellenor says she cannot defend him. He then demands that the court allow him to put on his own defense and he arranges for another inmate to lie and take responsibility for the crime.

In the closing scenes of the program he is shown awaiting the jury's decision. He is now dressed in a suit and has given himself a neat haircut with a pair of scissors that he stole from the Judge's chambers. He tells Ellenor that he simply will not go back to prison. She tries to reason with him, explaining that even if he is found innocent of this murder he still must serve the remainder of his original sentence. He insists he is not going back. Ellenor suddenly realizes that there is no guard present. Then she discovers the guard lying in a bloody heap on the floor. The prisoner has stabbed him to death. He then threatens to kill Ellenor and makes her escort him out

of the building and into a cab. He escapes into the crowded Boston streets and the final scene reveals that the jury had been duped by him and was prepared to find him not guilty.

This program thus graphically represents the sheer danger that evil prisoners such as this black man represent to the public, while simultaneously warning that the courts are too easily taken in by these murderous individuals. Interestingly, however, this episode also included a sub-text that could be interpreted as a criticism of the U.S. penal system. Ellenor tells her colleague, Jimmy, that she had known the inmate for a long time and that he was changed by his prison experience. Jimmy confirms that prison will drive people crazy. The inmate continually speaks about the brutality of prison life and what it has done to him. Thus, there are some contradictory messages embedded in this program that simultaneously seem to suggest both that prisons serve to make individuals more violent, and that the U.S. criminal justice system is too soft on crime. This is evidence of Kellner's claim that media culture is often made up of ideologically complex, multivalent images and stories:

> [C]ultural texts are not intrinsically "conservative" or "liberal." Rather, many texts try to go both ways to maximize their audiences, while others advance specific ideological positions, but they are often undercut by other aspects of the text. The texts of media culture incorporate a variety of discourses, ideological positions, narrative strategies, image construction and effects (i.e., cinematic, televisual, musical, and so on) which rarely coalesce into a pure and coherent ideological position. They attempt to provide something for everyone to attract as large an audience as possible and thus often incorporate a wide range of ideological positions (1995, p. 93).

While Kellner's language may seem to suggest that this is a deliberate process by media producers, it would be a mistake to consider this a conscious ideological strategy. Instead, it is the notion of trying to appeal to as large an audience as possible, for commercial purposes, that is the key here. In attempting to do so television programs, like other forms of culture, will reflect at least part of the range of discourses that are prevalent in the society at large. Often, however, this same need to cultivate a large audience means that certain more challenging discourses will be ignored, or at least marginalized, in television programming, resulting in a narrow, rather than expansive representation of contesting arguments in the public sphere. As Gerbner, Gross, Morgan, and Signorielli put it:

> Competition for the largest possible audience at the least cost means striving for the broadest and most conventional appeals, blurring sharp conflicts, blending and balancing competing perspectives, and presenting divergent or deviant images as mostly to be shunned, feared, or suppressed (1982, p. 103).

Thus, despite some ideological contradictions and limited criticisms of the penal system, more often the evil nature of inmates was framed as a natural condition rather than being caused by the prison experience itself. Even in this same episode, the other inmates that are involved in the plot are depicted as odious creatures. For example, the inmate that lies in court for Ellenor's client is depicted as a large, frightening looking bald white man who is serving three consecutive life sentences for previous murders. He tells the prosecutor, "I'm a bad man."

Race and the Representation of "Evil"

It should be explicitly noted at this point that not every "evil" inmate character in this sample of network crime dramas was black. However, as noted above, there was a tendency for guilty black males to be depicted as particularly savage or immoral. This was a common tendency in the episodes of *NYPD Blue* I examined which repeatedly portrayed black ex-convicts and parolees in conflict with the detectives who, with one exception, were all white. This tendency for whites to be depicted as heroic defenders of civil society in conflict with the black forces of evil was exemplified by two episodes of this program in which an innocent white youth, who is forced to temporarily live in a youth detention facility because his mother has been sexually abusing him and there are no foster homes available, is depicted as having been brutalized by the primarily black and Latino young men who are shown sullenly glaring at him as they lay around watching television behind an iron gate. One of the white detectives confronts a black staff member about this and he coldly shrugs his shoulders and says there is nothing he can do. The white detectives then rescue the white youth by arranging for him to go into foster care with another white detective and his wife.

These types of characterizations demonstrate that while it would be misleading to suggest that only whites are depicted as innocent and good and only blacks are depicted as evil in *NYPD Blue* and other prime-time crime dramas, there are still definite tendencies for those who represent the forces of good to be *primarily* white, while those who represent the forces of evil are depicted as black and Latino with great frequency.[9] Indeed it is the presence of a small number of black police officers and attorneys on this program along with the depiction of some of the inmates they deal with as white that allows this program to reinforce negative stereotypes without ap-

[9] I use these terms, "forces of evil/forces of good" very deliberately here to indicate the manner in which *NYPD Blue* in particular tends to rigidly divide characters between good and evil, with the police heroes of the program representing the good while almost all others are either evil, or at the very least obstacles to the police fight against evil. While this tendency was perhaps most obvious in *NYPD Blue*, it was also a common aspect of the other crime dramas I analyzed.

pearing to be blatantly racist. This characterization of the program may seem to suggest that there is something intentional about both the stereotyping and the disguising of stereotypes that occurs in *NYPD Blue*, and that may actually be the case. Certain tendencies in racial representations in television programs are likely to be deliberate strategies on the part of television networks to fend off criticism.

For example, Bogle (2001) notes that at least once during the run of another successful police program that Steven Bochco created prior to *NYPD Blue*, *Hill Street Blues*, Bochco was forced by NBC to alter a script so that some members of a group of junkies who shot two police officers would be depicted as white. Bochco's original script represented all of the junkies as black and he argued that "the criminal element at this particular precinct was almost 100 percent Black or Chicano... *there are certain sociological realities here*" (quoted in Bogle, 2001, p. 274, emphasis added). An NBC spokesperson named Jerome Stanley was quoted as saying that the creators of *Hill Street Blues* "were simply going to have to *fictionalize* it to the extent of saying that all criminals weren't Black. There are *some* white Anglo-Saxon Protestant thieves and killers and pimps" (quoted in Bogle, 2001, p. 274, emphasis added). He went on to add that a decision was made that the police should also be multi-racial in order to avoid "problems that we might be confronted with as broadcasters..." (quoted in Bogle, 2001, p. 274).

While these comments were made about *Hill Street Blues*, it is not unreasonable to suggest that some of the same processes might be at work in Bochco's later programs as well, such as *NYPD Blue*. It seems apparent from the above quotes that some television producers and network executives do seem to believe that the forces of good are generally white and the forces of evil are often made up of people of color. This is certainly the pattern that is suggested by not just *NYPD Blue*, but by all of the broadcast network dramas I examined. These quotes also suggest that exceptions to this pattern, the few black and Latino attorneys and police officers that are depicted for example, may be deliberately utilized in order to deflect criticism and disguise the "sociological realities" that Bochco seems to believe he is tuned into.

However, as noted above, Kellner (1995) points out that media images are complex and often include ambiguous or contradictory images and discourses. Thus, by no means should it be assumed from the previous discussion that all of the inmates who were depicted as purely evil in these programs were people of color. Bestial white inmates were also represented in these dramas as people who committed the most savage crimes imaginable and then felt absolutely no remorse afterwards. A white inmate in an episode of *Law & Order* who has a history of rape and has murdered his latest victim exemplifies this type of characterization. When he is brought

to justice he smugly sneers, "She got what she deserved." Similarly, in an episode of *The Practice*, a white rapist who is already imprisoned is told that an innocent man is being brought to trial for a rape that the inmate actually committed seven years ago. The inmate replies, "It's official. I'm actually bored," and "I don't care. I wouldn't have cared seven years ago and I don't care now." Finally, after being offered a reduced sentence, he admits to the rape but still expresses delight rather than remorse. As ominous music swells, the camera moves in for a close up of his face as he relives the crime. He is clearly enjoying the memory as he muses:

> She was my first. I was strictly a burglary guy.... I cut her chest and licked the blood off the blade. I don't know why. Maybe I was crazy.

These examples of white inmate characters who are depicted as savage, unremorseful, and dangerous, demonstrate that it is not only people of color that are depicted as beasts in these programs. However, as noted above, while white and Latino inmates are depicted in a number of ways—as innocent, often as guilty but misguided, and also as purely evil—throughout these programs, blacks are depicted as either purely innocent or purely evil and savage, but nearly never as guilty but misguided. This tendency for black inmates to be represented as bestial cut across class positions, as epitomized by an episode of *The Practice* with the revealing title, "Evil Doers." In this episode, a black man in jail for rape gets his twin brother to testify that he actually committed the crime. The twin is depicted as an articulate physician, an oncologist, wearing an expensive suit and glasses. Although the attorneys believe that he is simply trying to establish reasonable doubt so that his brother will not be convicted, at the end of the episode it is revealed that he actually did commit the rape. As sinister music plays he is shown in a shadowy close-up bending back his ear to reveal an ugly scar:

> If we really get desperate I can just show them the scar where she gouged me with a key. My brother tried to tell you—you don't know what the truth is.

The "truth" that seems to be suggested by this episode, and by many of the other episodes of the dramas I examined, is that black criminals are evil by nature: Both of these twin brothers are savage criminals, despite the fact that one of them is a successful oncologist.

All in all, the greater diversity of representation when it came to white and Latino characters in this sample of network crime dramas allowed for more nuances in how white and Latino inmates were framed, while black inmates tended to be represented as either purely innocent or purely evil. The social implications of these tendencies of representation become evident when it is recognized that it is only the

innocent and the misguided that are depicted as capable of rehabilitation, or as worthy of humane treatment, in these programs. Those who are guilty but not misguided are depicted as naturally immoral creatures who must be severely punished or else they will wreak havoc on our fragile society. Thus, prevention becomes a moot point, rehabilitation becomes a moot point, and finding alternatives to incarceration becomes a moot point, particularly when it comes to black criminals. Sloop (1996) found a similar pattern of representations of black and white inmates in his study of magazine articles on incarceration. Sloop argues that popular magazines tend to represent only white or female inmates as capable of rehabilitation while black males are portrayed as naturally violent and in need of strict systems of control in order to keep their destructive natures in check.

Thus, in their depictions of the innocent, the misguided, and the evil, these programs may serve to legitimize and reinforce the "search and destroy" mentality of the U.S. criminal justice system when it comes to black males (see Miller, 1996). Furthermore, it is the supposedly violent and dangerous nature of guilty inmates that is positioned as the primary factor behind the second key theme that I identified in these programs.

The Brutality of Prison Life

Many of the visual images and verbal references to incarceration in these programs concerned the brutal nature of life in America's prisons. While this sort of discourse might have potentially opened up the possibilities of substantive criticisms of the U.S. penal system, as we shall see, the manner in which this brutality was framed diverted any possibility of systemic critique by placing the responsibility for the brutality fully on the shoulders of individual prisoners themselves. While there were some exceptions to this framing, discussed below, the overall tendency was clear. This theme, like the one discussed above, was also multi-dimensional. In this section I discuss how the brutality of prison life was constructed as a fact in these narratives and in the next section I examine how that brutality was them framed as a legitimate and justified response to criminality.

Often this discourse of the brutality of prison life was framed in such a way as to suggest that prison will either kill a person, or turn them into an animal. Which of these options prevails seems to be a matter, again, of a person's inherent nature. In an episode of *Law & Order*, for example, an inmate testifies about another prisoner, an innocent man who had been murdered:

> Three years ago Larry got shanked by another inmate. He died in the infirmary. Larry just wasn't cut out for prison life.

Larry is thus framed as a person who inherently was unable to survive prison. The "just" in this description implies a certain inevitability to his fate. This also implies that there are some people who *are* "cut out for prison life." Often, in this sample of network dramas, those who were victimized in prison were white while the predators who brutalized them were black. This tendency was exemplified by the episodes of *NYPD Blue* noted above that focused on a young white boy in a juvenile detention center who is assaulted by other inmates who are represented as hard looking young men of color. After dropping the boy off at the institution, the white detective turns to his partner and says, "What did we just do? Did we throw this kid in the fire? *They're* going to eat him alive in there." The boy is shown entering the facility as a group of tough, young, black men stare sullenly at him. In later scenes he is shown with a black eye and he rejects the magazines the detective tries to give him, saying, "*They* steal them." Although the races of the youth who prey on this boy are never made explicit verbally, the visual imagery of minority youth in the background makes it clear that the "they" who are continually referred to are black and Latino young men. The racial implications of this scene are further reinforced through the representation of the black staff member in charge of the facility as cold and indifferent to the white youth's plight. While one could potentially read this episode as a critique of the practice of incarcerating minors, it is significant that the youth of color are represented as the predators and the white youth is portrayed as the prey, thus deflecting criticism away from criminal justice policies while simultaneously blaming young men of color for the brutality of youth institutions.

In an episode of *The Practice*, a young white man who is actually guilty only of getting high and stealing CDs from a music store is unfairly sentenced to a maximum security prison for allegedly shooting a store clerk during a robbery. He is depicted as being highly at risk of being attacked by other prisoners. His white attorney tells him that she will petition to have him designated a vulnerable inmate and kept in solitary but she doesn't know if this will happen. She tells him to "stay alive in there" and the camera moves in to a tight close-up of his scared, numb face. Violin music swells and the attorney's voice fades out as she murmurs reassurances to him. The implication is that he *is* going to be brutalized. Similarly, another episode of *The Practice* includes a scene where a white prisoner smugly tells a prosecutor that he can live in prison. She informs him that she is sending out a press release claiming that he is a pedophile: "Try to live in prison now." He screams in anger and terror. The clear implication is that he will be either murdered or raped, or both, if that claim is made public. Again, while these episodes might potentially contain seeds of criticism of American penal institutions, there is also a sense, particularly in the latter episode, that these men are

getting what they deserve and thus that justice is ultimately served by prison conditions that are vile and dangerous. This tendency is discussed more fully below.

Despite this tendency, it is not *only* whites that are depicted as victims in prisons. As a black inmate in an episode of *The Practice* says to his attorney:

> More time in prison would be a death sentence for me. If I told you I killed him over cigarettes, because he stole my last damn pack, you wouldn't believe me. Guys in prison get killed over less. Guys in prison get killed for looking at somebody wrong. I can't take it anymore.

Of course, the inmate that this prisoner killed was a white man. So despite his own framing of himself as vulnerable, in actuality it is still another black character who is the victimizer and another white who is the victim in this episode also. Furthermore, this brutality is *always* framed as a question of individual deviance. It is rarely the prison system itself that is defined as brutal, but rather the evil, murderous nature of prisoners themselves. Prisoners will kill over a pack of cigarettes or a glance, not because the inhumanities of the prison system have brought about a situation rife with pathology, but because the individuals in prison are naturally dangerous animals. People who have spent time in prison, however, offered more complex reasons for the violent behavior of some prisoners. For example:

> Robert: Question—What does one do when one hears about a death in the family, or in my case, your daughter... your daughter's been raped for three years constantly. Okay? And it's her brother. What does one do with that information? Being incarcerated, already stressed out... suffering from depression, you know? What does one do with that information? How does one absorb it and deal with that? And this is something I went through, you know. Do I flip on the first person that bumps into me or rubs up on me the wrong way? Because... I mean... just going to chow, standing in line, somebody's going to bump up to you, somebody's gonna step on your new sneakers, that's if you got some.... Any little thing, you know what I'm sayin' can just... I mean, bam! Just somebody saying something that irritated you, you can just flip, you know what I'm sayin'?

Another important aspect of the racial dimensions of the depiction of violence in prison in prime-time dramas is that people of color who are victimized in prison are usually depicted as being brutalized not by white inmates or guards but by other minority prisoners. In an episode of *NYPD Blue*, for example, a Latino man who works stocking shelves in a supermarket has bought a stolen credit card and used it to purchase an expensive television. He is pathetic as he begs and pleads with the detectives:

> I can't do anymore jail time. I've been out of jail six months and straight. But I'm not making jack at the market and I wanted a Sony flat-screen. Please, I really don't want to go back to jail.

Aside from the obvious bit of product placement in this dialogue, there is also the implication that this man is just not "cut out" for prison. However, the real culprit is another person of color—it's revealed that he bought the credit card from a violent Latino criminal who is subsequently beaten by white police officers after he displays a smug and arrogant attitude. While these white officers do behave violently, the implication is that their actions are reasonable and just under the circumstances, differentiating it from the often unprovoked and sadistic violence of the inmates in these programs.

This beating, as all with all of the police beatings in virtually every episode of *NYPD Blue*, is framed as being completely justified. When the police use force in this drama, it is always in circumstances where the victim deserves his or her punishment. Often the victim is first depicted as an obnoxious, arrogant, cocky loudmouth who taunts the police until they respond physically. In these circumstances viewers are positioned to support, if not cheer on, the use of force by the detectives. While certainly not all viewers may respond in this manner, it is clear that the program is framing the use of violence by the police as justified in some way. At other times the police commit violent acts in vengeance for some unspeakable act on the part of the criminal or in order to extract a confession from an invariably guilty party. In these cases the acts of violence are heroic, again positioning the police as the defenders of good against the forces of evil.

Before moving on to the second dimension of this theme, the justification of prison brutality, however, it should be noted that despite the overwhelming tendency for these programs to present the brutality of prison life as an individual rather than systemic problem, due to the bestial nature of individual inmates, occasionally there were hints, albeit fleeting and subtle, of the notion that it is prison life itself that makes men savage, rather then the reverse. This notion, which could be interpreted as a critique of the U.S. penal system, was substantiated by comments from my respondents who discussed how prison life itself contributes to violent behavior:

Interviewer: When people do get violent, what usually causes it?

Tito: Stress. It's all the stress we goin' through. Lock down—like 24 hours. It's like you're going crazy.... I don't know how to say things.... You're tied down, you can't do nothin' else. You got like an itch. So it's gotta be frustrating for you to get to that itch. That's how it is.

Mike: It's that you're mentally so weak that you're just a time bomb now, because you can't do nothin'—things are just not going your way—so you have no choice—they feel that they have no choice but to bug out...

Tito: When you're on top of each other. Can't breathe.

Occasionally, the tendency for prison life to germinate violence was referred to in these programs. For example, in an episode of *NYPD Blue* a mother tells her son, "You go inside that jail, you come out like your brother—cold and ready to die." Similarly, during an episode of *The Practice* two defense attorneys have a brief conversation that suggests a criticism of the penal system: Ellenor tells Jimmy that she always liked her client but that since he's been in prison he's changed. Jimmy tells her that "it drives them all crazy after a while." Later, in the same episode, the prisoner testifies to a jury:

> Being in prison is the worst thing in the world. Unless you been there you don't know. You lock men up, they become animals. I seen guys do things to each other, kill each other for nothing.

This is a particularly interesting and ideologically contradictory moment. While the prisoner initially suggests that it is the process of locking men up that turns them into animals (rather than that they are animals to begin with, and thus must be locked up), he ends by saying that prisoners kill each other over *nothing*. The implications of that description of prison violence return us to the notion that the brutality perpetrated in prisons has no motivating or causal factors behind it. It just emerges as a natural occurrence because of the inherently violent nature of prisoners. This type of logic actually makes possible and encourages another dimension of the theme of prison brutality. While in the examples discussed above prison was framed as a savage place of violence and chaos, this framing was carried a step further in these programs—legitimizing and justifying this brutality.

Justifying the Brutality of Prisons

The most significant aspect of the theme of prison brutality was found in the framing of this brutality as legitimate. This dimension was constructed of various components, including images and narratives that suggested that harsh treatment of prisoners is both necessary and deserved, that often courts and corrections are too "soft" on convicted criminals, that rehabilitation doesn't work and parolees are dangerous, and ultimately, that the death penalty is the real solution to crime.

This justification of brutality is readily apparent in programs such as *NYPD Blue*. In this long-running, very popular, prime-time drama, the notion that harsh physical punishment by representatives of the criminal justice system is the most efficient and effective way of dealing with criminals is such a consistent and recurring pattern that it may be considered emblematic—one of the central defining elements of almost every episode. For example, in one episode an ex-convict is portrayed as an untrustworthy rat who only cooperates with the police after they threaten and physically

assault him. The juxtaposition of the heroic police officers (again, the forces of good) against the slimy ex-con (a representative of the forces of evil) suggests that he is deserving of the beating they administer to him. The quick and positive results that they get from assaulting him serve as justification for their actions as utilitarian in nature. During the next two episodes, a parolee and another ex-inmate receive similar treatment without there ever being any indication that there is anything ethically, not to mention constitutionally, suspect about the police assaulting citizens. In fact, once someone is verbally marked as being a person who has spent time in jail, "I know you've done time" the police snarl at a suspect in one episode, any treatment at all, no matter how harsh or humiliating, is framed as justifiable. Again, this is a consistent element in almost every episode of *NYPD Blue*.

The notion that brutal treatment of the convicted is justifiable was not just suggested through visual imagery and narrative logic, but was explicitly articulated in some of these programs when protagonists made claims that prison life is supposed to be unpleasant. Of course, the stories told by the ex-inmates I spoke with about endless hours of suffocating boredom; verbal, physical, and sexual abuse by guards and other inmates; overcrowded and cramped living spaces; and neglect of basic medical, psychological, and nutritional needs, reveal a world that is much more than "unpleasant." While few would argue that prisons should be attractive to inmates, the reality of prison life in the U.S. is often cruel and inhumane (Abramsky, 2002; Austin and Irwin, 2001; Davis, 2005; Girshick, 1999; Parenti, 1999).

For example, one interviewee noted:

> Evan: I've seen DOC (Department of Corrections) members punch inmates and then when the inmate swings back, three of them come in and stomp the hell out of him. I seen a guy get stomped so bad that he shit, pissed, and puked on himself. They cracked his solar plate, they fractured three disks in his spine, broke his knee, his right knee—shattered it completely. He had fragments of bone poking through his skin. That's how bad they stomped him. And the CO (Corrections Officer) swung at him first. It was on camera. And they didn't do anything about it. All of a sudden the tape disappears.

Another ex-inmate said:

> Daryll: A typical day in prison is hell, basically, for me anyway.

And, later in the same interview, Daryll talked about being miserable enough to attempt suicide:

> Daryll: I mean, I've lost it. I lost it before. Tried to hang myself a couple of times. I tried to cut up a couple of times. But it was something I had to go through.

Moreover, television dramas often seem to reinforce the notion that if prison life is beyond unpleasant, is harsh and often even inhumane... so what? Some interviewees noted their belief that this in fact is the position taken by most Americans. As one ex-inmate stated:

Cal: They [Americans] don't want rehabilitation they want justice.

When asked if you can't have both, he replied:

Cal: Not in this society. It's one or the other.

This disdain for the very concept of rehabilitation that this ex-inmate senses is articulated explicitly in an episode of *NYPD Blue*. Detective Andy Sipowicz, (portrayed by white actor Dennis Franz as an iconic example of a "tough on crime," nononsense law enforcement agent) sneers at a black parolee who is a suspect in the murder of another black ex-convict who had converted to Islam, turned his life around and become a community activist: "Did you get all rehabilitated, too?" Sipowicz's dismissal of the very idea of rehabilitation is represented as common sense. This down-to-earth wisdom is negatively compared to academic or intellectual perspectives on crime and criminal justice in a scene where Sipowicz dismisses a parole officer, who insists that the victim had indeed been rehabilitated, by disparagingly referring to him as a "sociology major." This anti-intellectual stance is given a narrative "stamp of approval" in the conflict's resolution when Sipowicz is proven correct and the "rehabilitated" ex-con admits that he did commit the murder. In this example, it should be noted that the ideological message is reinforced because it is articulated by the hero of the narrative. Despite his orneriness and occasional flashes of racism, particularly during the program's first few seasons, Sipowicz is framed as a sympathetic, brave, man of integrity. Viewers, particularly white males, are thus encouraged to identify with him.

The discourse in these programs about the merits of punishment versus rehabilitation was almost entirely skewed toward a pro-punishment stance, neglecting any consideration of why humane treatment, counseling, education, and the like might, at the very least, produce better outcomes when individuals are released from prison.

Not Brutal Enough

Instead of any questioning of a purely punitive philosophy, these programs were filled with images and narratives that suggested a corollary to the notion that prisons *should* be brutal places—a framing of courts and prisons as too soft on convicted criminals. Occasionally these texts veered away from images of brutality in the na-

tion's prisons and instead suggested that prisoners receive good treatment in jail and that in general, the criminal justice system should be a lot *harder* on prisoners.

Throughout the sample of programs verbal references to decent conditions in the nation's prisons were reinforced by the visual and auditory images of prison life that were fleetingly on display in these programs. Never were the overcrowded conditions that are the reality in today's prisons ever represented. Instead, prisoners were always depicted in quiet, almost tranquil, single cells, without any sign of the mass of bodies that are routinely packed into America's jails and prisons.

Again, these images of prisoners living in single occupation cells on quiet cell blocks runs counter to the experiences of the ex-inmates I interviewed:

> Tito: Where I just came from... they added more beds into the dorms. The dorm already has like 98 people, they added like 15 more beds to the dorm. You only got like three sinks, three stools, like four showers. Man, it's like mad chaos.

Another dimension of these portrayals revolved around the notion that the criminal justice system as a whole is not hard enough on the convicted. This was reinforced by story lines that had naive juries freeing obviously dangerous and violent felons, as occurred in multiple episodes of *The Practice*.

There was also consistent pattern throughout these dramas of framing parole as a flawed practice, again contributing to the "softness" of the U.S. criminal justice system. This was established through the repeated portrayal of parolees as irredeemable, dangerous individuals. On *NYPD Blue*, for example, a Latino male who had been in prison for eight years assaults the police lieutenant's mother just two months after being released on parole. Again, all of the visual images used suggest that it is obvious that this man should never have been granted parole. When he first appears on screen he is strutting through the street, drinking a beer. He has a shaved head and tattoos cover his neck. (Both shaved heads and tattoos are used frequently in these programs as signifiers of deviance.) There is no question that this is a dangerous man. Likewise, on *Law & Order*, a prisoner on parole makes death threats to his attorneys, unhappy with the job they did defending him, and another parolee is caught with a house full of drugs and a "dog arena" where he viciously sets up lethal dog fights for people to gamble on.

In an episode of *The Practice*, time is provided for an explicit, almost didactic, argument against parole. As a convict faces the parole board, the black female chairperson gives a brief speech that offers social scientific data to back up her reluctance to grant parole to the defendant:

Correct me if I'm wrong, but half of the men in prison today committed felony crimes while on parole. Again, correct me if I'm wrong but in 1991 thirteen thousand people were murdered in this country by criminals on parole or probation.

An episode of *NYPD Blue* also suggested that no parolees should ever be trusted, no matter how sincere they may seem. When an elderly woman is found dead after having been raped, the perpetrator turns out to be an ex-convict who lived in the building. While still on parole he raped and murdered her because she wouldn't lend him seventy-five dollars to retrieve his truck from a lot after it had been towed. Earlier in the episode this man had been represented as a forthright individual. He is cooperative and open with the police about his record and we are told that everyone in the building knows and likes him even though they know he is an ex-convict. "I'd trust him with my grandkids," one character says before the revelation that he is guilty. When he confesses he says, "I was determined to make it straight. It's just waiting around for the hammer to fall." The moral of this story? Even criminals who sincerely want to turn their lives around are incapable of denying their violent nature. Repeat criminal behavior by parolees is thus a foregone conclusion, according to the logic of these programs. The reasonable conclusion that can be drawn from these narratives of inevitable returns to crime is that prisoners should not be eligible for parole at all.

Thus, through a multi-dimensional discourse, the need for a severe and harsh incarceration system is repeatedly reinforced throughout these prime-time crime dramas. Occasionally this discourse explicitly arrives at an ultimate solution for violent criminals who can't be rehabilitated and deserve harsh punishment: the death penalty. In an episode of *Law & Order*, noted above, a prisoner is running an illegal dogfighting scheme from his cell. He tells the prosecutor, "I'm doing 25 to life, twice. What are you going to do? Take away my cigarettes for being a dog lover?" However, when the prosecutor threatens him with the death penalty (applicable, supposedly, because one of his dogs killed a person), he decides to cooperate. Thus a very tidy argument in favor of the death penalty as the ultimate form of coercion is presented in this episode, as well as a reification of the power of the state.

An episode of *The Practice* does seem to represent an anti-death penalty argument in a scene where a defense attorney makes an eloquent statement against the death penalty to a television news crew after his client is executed. However, this attorney is framed as a corrupt individual in the narrative, thus the episode ultimately presents an ambiguous, at best, perspective on the anti-death penalty stance that he advocates.

Throughout the sample, then, and in several different ways, the brutality of the U.S. prison system was framed as justifiable and legitimate and a discourse was pre-

sented that suggested that incarceration policies could well be even tougher than they already are. Closely related to this theme of justifying the brutality of the prison system, is a third key theme, one that suggests that the U.S. criminal justice system, as it is currently constituted, is a fair and just system. Working in concert with one another, these two key themes suggest a particularly harsh worldview, one that actually endorses the brutalization of human beings as an integral part of a system of "justice."

The System Works! (And when it doesn't it is due to individual not systemic problems)

This was one of the most consistent patterns to emerge from my analysis. Again and again, viewers were treated to crusading defense attorneys, good-hearted prosecutors, upbeat resolutions, and happy endings, suggesting that, despite the random problem that is brought on by corrupt individuals, the corrections system in the United States performs its duties without bias or undue harm. The representation of primarily white heroes fighting on behalf of people of color is similar to the tendency in Hollywood films such as *Dangerous Minds* or *Mississippi Burning* to present images of what Madison (1999) has called "anti-racist-white-heroes" in a manner that disguises the continuing mainstream dominance and legitimacy of a white supremacist system. Madison argues that through media images that focus on the heroic activities of white agents of racial progress, while pushing people of color into roles as mere victims or spectators, and suggesting that white supremacy is only manifest in extreme and blatant racial hatred, "The deeper cumulative, structural, and institutional nature of white domination is mystified and obscured" (1999, p. 406). Racism merely becomes a matter of individual prejudice or bigotry, easily overcome by the inherently egalitarian nature of the American system and the institutions that it is built upon.

An example of this mystifying and obscuring of institutional racism can be found in an episode of *The Practice* which explicitly presented the argument that race is not a factor in the workings of the U.S. criminal justice system. A homeless black male defendant, on trial for allegedly raping and murdering a young white college woman, tells his attorney that he was misidentified because the white witness thinks that all black people look alike. His attorney, a black male, dismisses this notion and tells his client that, "Race is not an issue here." The defendant responds, "I'm instructing you to make it an issue." Subsequently the attorney asks to be taken off the case and is turned down by the judge. The implication here is that when attorneys do bring up race in the courtroom, it is merely a cynical defense strategy. As the prosecutor says to the defense attorney, "Good lawyers manage without going racial." Hav-

ing the character who is reluctant to "play the race card" portrayed by a black actor reinforces the message that bringing up racial discrimination in the courtroom is illegitimate. After all, if even a black attorney views focusing on race as an immoral and disingenuous defense strategy then surely race must be truly irrelevant in contemporary criminal justice.

However, the creators of this episode were apparently not content that this would get their message across, because the narrative moves to a resolution that even more explicitly makes the argument that race, and the possibilities of racial discrimination, should not be discussed in the courtroom. The jury emerges as the voice of commonsense wisdom in this episode as they refuse to reach a verdict in the case. The foreman rises and says:

> We all agree this has been the most appalling spectacle we've ever seen. The only thing this should be about is did he kill her. No one here cares about that. We refuse to try and reach a verdict. Contempt is what we feel.

"The only thing this should be about is did he kill her." It is perhaps hard to argue with this statement, that does appear to be based on unbiased common sense, yet this logic rests on the assumption that the U.S. criminal justice system, indeed America itself, is completely pure and untainted by racial discrimination. Only under these circumstances would race ever be irrelevant in the courtroom. This is the condition assumed by this program and adopted by the characters, who are completely disdainful about any mention of race in the courtroom. Thus, this episode exemplifies both the notion that the U.S. system is a fair and unbiased one and the ideological belief that "color blindness" equates with a progressive racial stance. This is similar to the conservative repositioning of affirmative action programs as inherently discriminatory because they recognize race as a crucial factor in access to opportunity in the U.S. According to this logic any acknowledgment of race at all can be defined as racist; a position that effectively marginalizes discussion of the real racial inequities that persist in American society.

This episode also seems to evoke unstated allusions to the O.J. Simpson trial, when the defense team was accused of unfairly "playing the race card," despite a history of proven racial discrimination by the Los Angeles Police Department. Thus, when the jury in this fictional courtroom drama scolds the lawyers for introducing race into the proceedings, it may be a revisionist appeal to those viewers who believe that the jury in the O.J. Simpson trial should have done the same. The implied message then might be a steadfast denial that the U.S. criminal justice system is fraught with racism or it might be a sincere yet ultimately simplistic notion that race simply should not matter. Either interpretation however masks the daily realities of institu-

tionalized discrimination in U.S. police stations, courtrooms, and prisons (see Chriss 2007; Cole, 1999; Davis, 2003; Mauer, 1999; Miller, 1996; Parenti, 1999). In particular, the suggestion that the U.S. criminal justice system actually functions in an impartial manner puts an optimistic spin on a severely dysfunctional institution.

This optimism, however, was reinforced throughout the prime-time programs examined here. Repeatedly, episodes of the defense-oriented law drama *The Practice* ended with upbeat happy resolutions, as innocents were freed from prison and the notion that ultimately the fairness of the criminal justice system will prevail was hammered home again and again. This pattern supports Gerbner's contention that:

> [A] tragic sense of violence has been swamped by "happy violence" produced on the dramatic assembly line. This "happy violence" is cool, swift, painless and often spectacular, even thrilling, but usually sanitized. It always leads to a happy ending. After all, it is designed to entertain and not to upset; it must deliver the audience to the next commercial in a receptive mood (2002, p. 294).

For example, an episode of *The Practice* featured the story of a man who had been wrongfully convicted of rape. His attorney, a white female crusader, manages to get him released. In the closing scenes they are together in his cell packing up his belongings. It is a peaceful scene, as sunlight streams into the cell and the attorney and her client talk quietly. He gazes at her: "What do you say to a person who just gave you your life back?" This client has been released because both the prosecutors and the defense worked together to save him. Earlier in the episode there is a direct endorsement of the criminal justice system: As music swells, the prosecutor, another white female, tells the defense attorney, "Your client will be released today. Sometimes justice is a team effort."

Again and again those who in reality are most directly harmed by repressive criminal justice policies, black males, are rescued in these programs by crusading white defenders. As Madison (1999) argues, this construction of white heroism helps to disguise the continuing power of white supremacy under a guise of benign concern and good will. Yet, simultaneously, it positions blacks as vulnerable children who, unable to protect themselves, must rely on the care of a white parental figure. As Lipsitz has argued, in reference to the American film industry, but certainly applicable to these television programs as well: "In Hollywood there is no room for adult blacks operating in their own interests, only for black sidekicks, or terrorized blacks in need of white protection" (1998, p. 145). Ultimately then, these seemingly liberal images and stories reify both white power and black dependence through their sentimental portrayals of effective white advocates and grateful black recipients of white assistance.

Thus, while programs such as this may initially suggest that innocent people *are* imprisoned in this nation, ultimately the message is that there is a happy ending awaiting the victims of such injustices, usually thanks to white crusaders. This promise of a bright future runs contrary to the actual experiences of the ex-inmates I interviewed, who repeatedly brought up their difficulties in finding even entry-level jobs after prison.

Individual Deviance Rather than Systemic Dysfunction

Occasionally programs did end without such upbeat resolutions, and cracks in the facade of the criminal justice system were exposed in order to heighten the dramatic tension in these narratives. Invariably, however, when these dramas did portray cases of injustice, the problems were represented as being caused by deviant and corrupt individuals, rather than being due to any broader systemic flaws. For example, in an episode of *Law & Order*, a forensic scientist is arrested for having lied while submitting testimony in criminal cases. She had falsely claimed a positive match for fingerprints in several cases. In an unlikely plot maneuver, she is found guilty of manslaughter because an innocent man was killed in prison after being sent there based on her testimony. This is not framed as a systemic or institutional problem, however. Instead the injustices were committed solely by one individual deviant, a corrupt and mentally unstable scientist. When she is shown photos of possibly innocent men who had been sent away after she lied about evidence, she appears on the verge of madness as she snarls, "They were guilty. Everybody knew that."

While it is not unreasonable to assume that corrupt individuals do sometimes exert a corrosive influence on criminal justice proceedings for personal reasons, what is notable in these programs as a whole is that this is the only sort of criminal justice problem that is acknowledged. None of the programs, for example, dealt with issues such as the rampant abuses brought on by the use of paramilitary tactics in urban communities, or the differential sentencing that black and white defendants typically receive, or the manner in which the erosion of civil liberties often has the greatest impact on people of color and the poor (see Cole, 1999; Davis, 2003; Mauer, 1999; Miller, 1996; Parenti, 1999). All of these issues, and many more, cannot be separated from the problems brought on by bigoted or corrupt individuals in the criminal justice system. The Rodney King beating, for example, was only one well-publicized incident that is representative of the racially motivated police brutality that occurs on a regular basis in the U.S. Focusing only on the prejudices of the individual officers involved in that case misses most of the story. Similarly, issues such as the abuses that inmates are subjected to in the nation's prisons, or the manner in which black defen-

dants are given longer prison sentences than whites who are convicted of the same crimes, cannot be simply explained by pointing at the individual failings and prejudices of corrections officers, prosecutors, or judges. Yet, in these programs, criminal justice abuses were *always* blamed on deviant individuals.

Viewers who are exposed to these misleading images and stories program after program, year after year, may hold severely distorted notions of the presence or absence of systemic racial discrimination in the criminal justice system. Television's focus on individual deviance may thus not simply miss the point of institutional failure but actually impede any understanding of crucial flaws in the American justice infrastructure.

In an episode of *The Practice*, it is revealed that a police officer lied on the stand and also coerced witnesses into lying about what they saw in a case that sent a mentally retarded man to prison for fifteen years for a rape and murder that he did not commit. In this episode, the District Attorney's office works with the defense attorneys in order to correct the injustice. The prosecutor tells the defense "It's the D.A.'s office who requested the DNA testing on this one, so don't accuse us of not caring, okay?" Similarly, in another episode the opposing sides team up to make sure that justice will prevail. The defense attorney appeals to the prosecutors, "Your office doesn't want the wrong man in prison anymore than I do." When the innocent man is freed we are told that "Justice is a team effort." Music swells as viewers are assured that the wrongs have been righted. Here is evidence that representatives of the system can and do work together to correct the misdeeds of a few deviant individuals. Once again systemic problems are disguised and the actions of individuals are valorized. Importantly though, it is not just any individuals who are positioned as heroic in these narratives. Throughout these dramatic programs agents of the criminal justice system were represented as glamorous defenders of society. This pattern brings us to the fourth key theme I identified in these prime time crime dramas.

Prisoners as Plot Devices

Throughout these programs prisoners were represented not as fully realized, multidimensional characters, but as props or plot devices that were utilized to explore the conflicts and emotions of the "real" characters in the programs, the lawyers and police officers who are the protagonists of these dramas.

Here, Madison's discussion of the manner in which many Hollywood films treat white heroes as the subjects, while making black characters the objects, of their discourse is relevant:

[I]t is the agency and the developing character of the "white" protagonist that is the engine that moves the story along. The "white" protagonist is the subject; we experience "reality" through his or her eyes. In comparison, "black" characters are variously objectified, seen largely from the outside through the eyes of the "white" hero or heroine. These movies delve into the complexity of the experiences of the "white" protagonists and their families. Only the characters and lives of the "white" protagonists are fully developed.... In this way, the "white" protagonists elicit empathy from the audience. We are led by the technical and representational codes in the text to empathize with them and we have been provided with enough depth of portrayal with which to do so (1999, p. 407).

Similarly, in the programs I examined, the "real" characters are the overwhelmingly white police officers and attorneys. The shows are about them, their struggles, their emotions, their lives; they are the subjects of these dramas. The largely black, Latino, and poor and working-class white inmates are merely objects. The programs are not *really* about them. This was obvious again and again throughout the sample of programs.

This theme is signified not so much by what images, language, and narratives are included in the texts, but by what is missing or excluded. An episode of *The Practice*, discussed above, that dealt with a black prisoner who insists that his lawyer use a racially based defense strategy, ends with the jury refusing to reach a verdict and the depressed prosecutor and defense attorney commiserating with each other. We never learn anything about the fate of the man who remains in prison awaiting a new trial. But of course the episode is not really about him. It is about the trials and tribulations of the attorneys who are the protagonists of the program.

Similarly, in an episode of *Law & Order* an Assistant District Attorney tricks a murderer who has taken hostages into surrendering and confessing without revealing her identity as a prosecutor. Later in the episode this man is shown in prison garb in the courtroom, but the episode again is not about him at all. He is a plot device that allows the protagonist and the viewer to explore internal conflicts and the ethical dilemma related to her actions. Prisoners and parolees function in much the same way on *NYPD Blue*, a program which represents its police protagonists as complex, multi-dimensional characters while simultaneously relying on stereotypes and one-dimensional, almost cartoonish, representations of inmates and criminals as a backdrop for the personalities, conflicts, and emotions of the police to play against.

In fact, although prisoners appeared frequently in all of these programs, their actual daily lives were as invisible as they are in television news. Most scenes with prisoners took place in courtroom settings or interview rooms. The actual inner workings of prisons were never shown. The few scenes that were located in residential areas of prisons portrayed solitary prisoners in single-person cells, living in quiet

surroundings. This is a highly misleading image of the overcrowded U.S. prison system.

Thus, throughout these programs the only fully realized human subjects are agents of law enforcement and the criminal justice system. Inmates, people on probation, parolees, and criminals are objects—villains to be vanquished or victims to be rescued. Either way, the police and attorneys emerge as heroic defenders of the public good. This may have a powerful ideological influence, particularly for those viewers whose only experience with the criminal justice system is the pseudo-experience of television. These viewers are treated over and over again to images of violent, savage black, Latino and working-class white inmates and parolees while the harsh nature of the U.S. corrections system is framed as a necessary and just response to these evildoers.

Conclusion

My analysis of broadcast crime dramas suggests that images of prisoners appear frequently as a regular and conventional part of these programs. These images, however, are highly distorted in terms of crucial issues such as race and violence. The narratives of the programs considered in this chapter frequently suggest that prisons are brutal places, but they also justify that brutality as a necessary response to an out-of-control world of vicious crime and savage criminals. Furthermore, despite the frequency with which inmate characters appeared, actual scenes and images of prison life itself, the daily struggles that inmates experience, were absent from these programs. Prisoners are merely window dressing—objects used to move the plot along and foils for the lawyers and police who are the protagonists of these dramas.

In sum, the distortions and misleading images of these programs, and their tendencies to ignore the actual workings of, and conditions inside, U.S. prisons are consistent with the patterns of coverage of incarceration in television news programming. In the next chapter, however, I take a close look at a program that runs against the grain of other television stories about incarceration by going past prison interview rooms, delving into the residential areas and daily routines of the corrections system, and positioning prisoners themselves as the focus of the narratives: the cable television prison drama, *Oz*.

CHAPTER VII

Watching a Nightmare
Oz and the Terror of Images

"That show Oz, that shit real."— "Frankie"

Unlike the television crime dramas discussed in the previous chapter, *Oz* takes viewers directly inside the daily life of an imaginary prison and the prisoners themselves are the central *dramatis personae*, the subjects rather than the objects of the discourse. *Oz* debuted on the Home Box Office (HBO) cable network in 1997. *Oz* is a hyperviolent show that takes full advantage of its status as a premium cable program that is dependent on subscribers rather than advertisers for revenues. This means that rather than being concerned about offending advertisers, HBO attempts to attract subscribers by offering them material that they believe they would be unlikely to see on other networks. In the case of *Oz* this means large portions of foul language, nudity, and graphic scenes of intense violence and sexuality. While broadcast television is also rife with sex and violence, *Oz*, like other HBO programs, pushed this tendency to extremes that would be unlikely to find favor with advertisers who are reluctant to alienate potential customers. While depicting most prisoners as out-of-control savages, *Oz* was routinely lauded by critics, most of whom, presumably, have never been in prison, as one of the most realistic programs on television.

Because HBO is a premium cable channel, their programs reach a relatively small and select audience in comparison to broadcast or basic cable television. However, through rentals and sales of DVDs programs like *Oz* are now more widely available and they should be recognized as potentially potent cultural artifacts. This chapter will thus examine the ideological implications of *Oz*'s hyperviolence, as well as the program's images of sexuality, gender, race, and class as they may contribute to public discourse on crime and punishment in twenty-first-century U.S. culture.

Background on *Oz*

Oz is a serial drama set inside a fictional maximum-security prison, Oswald State Penitentiary. The primary action takes place inside "Emerald City," an experimental unit of the prison that allows inmates considerable freedom of movement while keeping them under technologically enhanced surveillance. Recognizing the historical climate in which *Oz* was created might lead one to argue that *Oz* merely reflects the

realities of the American criminal justice system in its depiction of a violent prison
heavily populated by people of color. Indeed, a recurring theme in critics' appraisals
of the show and interviews with the program's creative personnel is the realism of
Oz's images. In many of these newspaper and magazine features, much is made of the
two years of research that creator Tom Fontana did inside prisons, interviewing in-
mates and guards (see, for example, Sullivan, 1999). The following represent a sam-
ple of media quotes on the realism of *Oz*:

- Producer Tom Fontana in the *New York Times* (7/6/97): "My job is to cast a
 light on a dark place and make people talk about it." And in regard to the fre-
 quent homicides in the first season: "That's the reality. In prison, no one is safe.
 You have to always be looking over your shoulder."
- Television columnist Matthew Dietrich (8/9/98) in a comparison of *Oz* to
 Nightline documentaries on supermax prisons: " *Oz* uses the freedoms afforded it
 by HBO to show prison life in a frighteningly realistic fashion. (The *Nightline*
 specials inadvertently enhance these qualities by showing how closely *Oz*'s por-
 trayal of supermaximum-security prison life mirrors the real thing.)"
- Cultural critic Stanley Crouch in the *New York Times* (9/20/98): "By the last of
 the first eight episodes of this prison drama, I was sure it had set another stan-
 dard for realism.... To my delight, it had a fully integrated cast, with a range of
 characters who 'looked like America' and were conceived with impressively real-
 istic ethnic nuances, from the administrators all the way down to the very lowest
 criminal."
- Magazine journalist Andrew Clark writing in *Maclean's* (8/30/99): "[Fontana's
 shows] are so realistically violent that they are almost unwatchable." And quot-
 ing Fontana: "I think writers in TV face this dilemma every single time they
 write. Do I lie or do I tell the truth.... I give my audience credit. They don't
 want the lie."
- *Boston Globe* headline (7/11/99): "Another season in *Oz*; The HBO series, set in
 a fictional but realistic prison, is more hard-edged than anything else on TV"
- Actor Dean Winters, quoted in the *Boston Globe* (7/11/99): "I have a good
 friend of mine who is in prison right now.... He has written me that it's pretty
 much on the money as far as the stereotypes go."
- Columnist Richard Huff (7/2/2000): "People often imagine what prison
 might be like. But for the last three years, Tom Fontana's HBO series "*Oz*" has
 taken viewers right into the belly of the beast."

- Actor Ernie Hudson, quoted in the *New York Daily News* (7/2/2000): "I've always felt that there are areas in our society that we don't deal with. People like having a glimpse; if the worst happens you could end up there. It's a bad place to be."
- Actor Eamonn Walker, quoted in the *Montreal Gazette* (8/19/2000): "People know it's quality TV. They just wish it wasn't so real.... We've become conditioned to think that it's all right to watch all that violence and, therefore, we can watch it over and over again. The whole point of *Oz* is, yeah, it's harsh. Don't go outside and play with this stuff. You bleed. You die."
- Television host Bill Tush on *CNN Showbiz This Weekend* (8/26/2000): "Let's use a billion adjectives: gritty, brutal, realistic.... You know but it's really true to life. I mean, I don't know what it's like in the big house, but....This is such a real-looking set."

Hyperviolence

The first thing that a viewer is likely to notice about *Oz* is the sheer amount of graphic violence that is portrayed in every episode. This list of violent images from Episode One of Season Five is typical :

00:06:01—Flashback: Group of white inmates brick another white inmate inside a wall as he screams and tries to get away.

00:12:19—Black guard punches Latino inmate in the stomach for talking.
00:14:23—Latino inmate punches another Latino inmate in the face and then is grabbed from behind by a third Latino inmate.

00:16:04—Latino inmate punches white inmate in the face. White inmate responds by head butting Latino inmate in groin and then punching him in the face.

00:20:43—Black inmate punches Latino inmate twice and then both are grabbed by a group of guards.

00:24:09—Flashback to a black inmate violently stabbing two white inmates.

00:24:18—White inmate throws a plate full of food at black inmate's face and is then grabbed by a white guard.

00:27:07—Black inmate tips a cart over on a white inmate and they attack each other. A brawl ensues and guards take the prisoners down. One subdues the black inmate with a nightstick at this throat.

00:37:52—Flashback: White inmate rips a chain off of another white inmate's neck after he has killed him.

00:41:38—Flashback: A white softball umpire is beaten several times with a bat by a white soon-to-be inmate.

00:44:29—A white Guard throws a naked white inmate into the wall of a cell.

Counting only overtly violent scenes such as those, my analysis of the eight episodes that comprised Season Five of *Oz* revealed that on average there were 13.6 violent incidents per hour-long episode (see Table Five). No episode had less than 10 and 2 had as many as 17 scenes of violence. This is not counting the opening credits which themselves include a montage of violent scenes.

Table 5: Frequency of Violent Imagery in *Oz*'s Fifth Season

Episode One	11 incidents
Episode Two	16 incidents
Episode Three	11 incidents
Episode Four	17 incidents
Episode Five	12 incidents
Episode Six	10 incidents
Episode Seven	17 incidents
Episode Eight	15 incidents
Total	109 incidents
Average	13.6 per episode

We can compare this average of almost 14 incidents of violence per hour-long episode to Gerbner's series of studies of prime-time dramatic programs that found that: "The saturation of violent scenes was 5 per hour in 1974, 5 per hour in 1984, and 5 per hour in 1994—unchanged" (2002, p. 15). Thus, despite the frequency with which violence occurs in most prime-time dramatic programming, the frequency of violence on *Oz* is almost three times greater.

One possible interpretation of these results is that it is only logical, or "realistic" for a drama set inside a prison to be this violent. There is no question that America's prisons can be horribly violent environments. The argument here however, is that, as in most television programming, "reality" is amplified to the extent that severe distortions result. The point is simply that the hyperviolence of programs like *Oz* is grossly exaggerated and can contribute to distorted perceptions about who America's prisoners really are in an era when non-violent inmates outnumber those who have been convicted of violent crimes (Dyer, 2000).

An examination of HBO's web site for the program also reveals interesting clues about both the prevalence of violence on *Oz* and the morbid reveling in this violence that the program encourages. For example, a section of the web site is identified as R.I.P. and it features photographs and detailed information about every character that died on *Oz*. During the program's six seasons there were 56 episodes and 72 deaths. Virtually every episode of the program includes the demise of at least one character and many include the deaths of several. As indicated in Table Six, the vast majority of these deaths were classified as murders on the program's web site.

Table 6: Causes of Character Deaths in Six Seasons of *Oz*

	Number	Percentage
Murders	54	75
Executions	5	7
Accidents	5	7
Natural	4	5
Suicide	2	3
Unknown	2	3
Total	72	100

Murder accounts for three out of every four deaths on *Oz*, while the most likely cause of prisoner deaths in the real world—suicide, disease, and old age—*combined* account for only 8% of the deaths on *Oz*. In comparison, Austin and Irwin report data on both public and private institutions that reveals that, "Assaults resulting in inmate deaths were extremely rare at both [type of] institutions" (2001, p. 81). According to Austin and Irwin's data, real-world inmates are more than twice as likely to die as a result of suicide than they are to be murdered. They are more than 14 times as likely to die as a result of unspecified natural causes, including old age. They are also more than 13 times likely to die as a result of AIDS, a problem that *Oz* virtually ignores—only one character in six seasons died as a result of the AIDS virus. Perhaps the program's producers do not believe that the slow torturous demise brought on by AIDS is as likely to grab viewers' attention as bizarre and grisly murders. While it should be acknowledged that *Oz* is a fictional program, and thus relies on a certain amount of narrative license for dramatic purposes, these data should be considered within the context of the popular discourse about *Oz* that consistently refers to the show's "realism" and that it offers viewers a "true-to-life" peek into the nation's prison system.

Furthermore, the violence on *Oz*, in addition to being severely exaggerated in terms of frequency, is also presented in a celebratory manner. This program doesn't just include so many scenes of violence as a logical part of its narrative development; it revels in this hyperviolence. The fact that the program's web site even includes an R.I.P. section is one bit of evidence of this. Another is a short video spot that HBO used to promote the sixth season: A white man is strolling down a city street. He throws some litter at a trashcan and misses. He blithely keeps walking and then stops. Images of extreme violence from past episodes of *Oz* stream through his mind's eye. He runs back to the trashcan and properly disposes of the litter. Words appear on the screen announcing to the viewer: "EIGHT MORE HOURS OF OZ—IT MIGHT MAKE YOU THINK TWICE." What seems to be intended here is an amusing take on the notions of conservative criminologists, politicians, and much of the American public, that severe prison conditions deter crime.

But on another level this commercial promotes the show by highlighting the shock value of its gory images of extreme violence. The humor of the promotional spot then functions in much the same way that lighthearted dialogue accompanying bloody shoot-outs does in Hollywood action films. It creates an environment that Gerbner has called "happy violence" (2002, p. 15). Happy violence disguises the real consequences of violence beneath a veneer of humor and sensational visual effects. Using graphic images of prison violence to draw viewers to a premium cable service such as HBO is ultimately a process of selling fictional portrayals of an agony that some real prisoners do experience. Meanwhile, viewers can sit in the comfort of their living rooms and perhaps cringe, yet ultimately be entertained by, and derive a peculiar sort of pleasure from, the spectacle (see Watts, 1997, for a similar argument about fans' engagement with gangsta rap music in which he advances the notion of "spectacular consumption").

And the violence on *Oz* often is truly spectacular. The producers of this program are not content with simply presenting scenes of beatings or stabbings—the usual sorts of assaults that occur behind prison walls. Rather they emphasize bizarre and sadistic acts of violence. Prisoners brick each other up in walls and are left to die. They kick each other down elevator shafts as the camera lingers on the long fall and the screams echo on the audio track. They shove each other's heads into television sets and twitch and smoke as they are electrocuted in a shower of glass and sparks. They sever each other's arms, and hang each other, and carve epithets in each other's dead chests. They carve holes in their cell walls and then reach through the holes and bash each other's heads in. All of these incidents, and many more acts of bizarre violence, were presented in graphic visual and audio detail during *Oz*'s six seasons. The

producers of *Oz* seemed to be proud about the novel ways of administering pain that they dreamed up. In explaining why he would not be producing any more episodes after the sixth season, the show's creator posted this message on the program's website: "Besides, I really have run out of ways to kill people" (Tom Fontana, no date, http://www.hbo.com/Oz/behind/index.html, no pagination).

Furthermore, the prisoners who commit violence on *Oz* are often depicted as sadists, reveling in the brutality they perpetrate. As the last brick is slid into place during an entombment scene, a prisoner smiles at the victim and says, "You should have just taken the blow job when you had the chance." A flashback is shown of a prison rape where the rapist calmly listens to music through his headphones as he sodomizes the victim. After another rape the perpetrators are shown laughing and celebrating as they play pool. During an episode that featured three prisoners being trained as trainers of seeing-eye dogs, a prisoner taunts one of the three with stories of how he chopped a dog to pieces. When an inmate is found hanging from an electric fence, a group of prisoners laugh as they imitate his death throes.

The overt message of scenes like these is that these men are inhuman monsters who feel no remorse for the evil they perpetrate. Again, the program revels in this sort of representation. At one time the program's web site (http://www.hbo.com/Oz/behind/index.html) featured an image of the regulars on *Oz* and the words, "OH THE EVIL THAT MEN DO... ESPECIALLY IN *OZ*." The clear implication is that these monsters should be feared. As a narrator tells viewers: "*Oz* is filled with murderers, rapists, racists, drug dealers, with the most common of criminals." A guard says, "Every night I get down on my knees and pray to God I don't get shanked when I come to work. I mean, but what if it happens? What if one of these fucking animals ends up butt fucking me?"

In addition to this verbal discourse of fear, visual imagery, also, reinforces the notion that these men are actually "fucking animals" who represent a threat to "ordinary" human beings. The camera lingers on a completely bald member of the Aryan Brotherhood standing in the shadows of a cell in solitary. He is covered with arcane tattoos and has a sneer plastered on his face. He is shot from below, looming over the camera, his face half in darkness and light, looking like the devil incarnate. A black Muslim attacks another inmate with a look of pure monstrous insanity on his face as he spits and rages in a tight close-up. Over and over visual scenes of savage inmates attacking each other, and the guards, and visitors, reinforce the notion that these men and this place represent a threat and should be feared. Even the opening credits for the program, where scenes of riots and brawls and stabbings and rapes are played in quick succession underscored by eerie, percussive, dangerous sounding mu-

sic, convey a message of fear. The most graphic violent scenes are not displayed just once but are shown over and over again in flashbacks. Repeatedly inmates are shown in the possession of weapons; at times almost every person in *Oz* seems to be armed.

This message of fear, repeated over and over on *Oz*, has real public policy implications. If these are the sorts of sadists that fill the nation's prisons, then we obviously must keep them locked up or they will wreak this sort of havoc on the general public. Thus, more policing, stricter and longer sentences, more prisons, all of these measures are necessary to keep us safe from these savages. This message is very consistent with the tendencies in U.S. criminal justice policy during the prison population explosion. Furthermore, the images and narratives of *Oz* seem to suggest the prisons we do have should be much harsher than they already are. *Oz*, after all, is a maximum security prison, yet the prisoners somehow get away with their evil acts because they are frequently left alone with each other in places where weapons are readily available, such as kitchens (stocked with knives), repair shops (surrounded by tools), and weight rooms. They also are frequently shown roaming the interior areas of the prison at will, often committing these horrendous acts without receiving any consequences, even on those occasions when they are observed.

Over and over again on *Oz*, prisoners commit violence and other atrocities and receive little, if any, sanctions for their behavior. In one episode a Latino inmate with a long history of violence gets into two brutal fights shortly after being released from solitary confinement. At one point he assaults an elderly white inmate in the weight room. He receives a stern talking to for his actions. The warden says, "This incident concerns me. You want to stay out of solitary, stay out of trouble." A few episodes later the same inmate goes before the parole board (in and of itself an unlikely scenario) and ends up physically assaulting a member of the board. The only consequence that he seems to receive for this extreme violation is a brief stay in solitary confinement. In another episode, a new inmate attacks another prisoner and the guards pull the attacker off the victim but there is no sanction for his behavior administered at all.

These sorts of (non)responses to prisoner violence might be usefully compared to the things that the ex-inmates I interviewed had to say about consequences for fighting in prison. For example, Johnny related an incident when he was put in isolation based on the mere allegation that he had verbally threatened another inmate:

"I mean he said you threatened him—that's it. You're going to seg." I was in seg for ten days.

Similarly, Jose said that any allegation of a physical incident with a CO would result in a severe increase in the length of one's sentence:

Cause he know you touch like that he gonna give you five years outside charge. [An additional criminal charge above and beyond their original sentence.] Sometime you no touch and he say you touch: "Ah! He touched me! He hit me!" You never touch.

Comments from respondents in another group interview lent credence to what Jose had said about the consequences for hitting a corrections officer:

Will: If you hit a CO you get five years. They say anything, they suspect you on any level... you know, your suppose to just...
Interviewer: So if you hit a CO you get an extra five years tacked on to your sentence?
Will: Uh huh.
Interviewer: What if you just have a fight with another inmate? You get any extra time?
Carla: You get a Class A felony.
Tony: You get an outside charge too. Automatic. They ain't playin' with that no more.
Carla: Well, not necessarily. I guess it depends on how... my brother just got one. He's incarcerated and what they did, he got a lock for 30 days and they may tack on four more months and give him an additional 120 days. But if it's a real bad fight, yeah, you got another assault charge.
Tony: If there's any blood showing, or any type of facial, anything showing, they'll call the state troopers, they call the state troopers, lock you up in seg, fingerprint you, the whole nine, see you in court, that's your second offense. I think that's assault third. Consecutive, not concurrent, consecutive. You got to finish your time, then you got to do that.

Other respondents also talked about unofficial consequences for hitting a CO:

Evan: They get the shit kicked out of them.
Ray: They'd take him to the seg part and they'll turn the camera the other way and they will be stompin' on his face. I mean, they'll just bust him up, you know. And then they'll leave him there until he get nice and sober—you know straight up and everything. And then they'll send him to medical, whatever, so medical won't write on the report, oh this guy came in with a broken this or a broken that or, you know, he got bruises here.
Interviewer: And so what happens to his sentence?
Evan: He'll get more time for assaulting DOC [Department of Corrections].
Ray: He'll get five years.
Evan: I've seen DOC members punch inmates and then when the inmate swings back, three of them come in and stomp the hell out of him. I seen a guy get stomped so bad that he shit, pissed, and puked on himself. They cracked his solar plate, they fractured three disks in his spine, broke his knee, his right knee—shattered it completely. He had fragments of bone poking through his skin. That's how bad they stomped him. And the CO swung at him first. It was on camera. And they didn't do anything about it. All of a sudden the tape disappears.

Thus, both in terms of the frequency and intensity, and in particular, the lack of apparent consequences, *Oz* tends to present a distorted picture of prison violence. Having said that, however, it should be acknowledged again that America's prisons,

particularly maximum-security prisons, can be extremely violent places. Literature by prison inmates and journalistic and sociological ethnographies and other investigations have revealed some of the real brutality that occurs inside America's prisons on a regular basis (see, for example, Abramsky, 2002; Burton-Rose, 1998; Conover, 2000; Davis, 2005; Girshick, 1999; Irwin, 2005; Leder, 2000; Rideau and Wikberg, 1992; Sabo, Kupers, and London, 2001; for just a few examples). Almost all of the ex-inmates I spoke with reported having witnessed or been involved in at least one violent episode while they were incarcerated. Sometimes the respondents said that violence occurred frequently in the prisons and jails they had been in.

However, they also stressed that the amount of violence varies from institution to institution, a fact that a viewer is unlikely to receive from media portrayals, which tend to focus on maximum security and "supermax" type facilities (Van de Bulck and Vandebosch, 2003). Thus, despite the reality of prison violence, the hyperviolence of *Oz* seems particularly misleading when we take into account that we currently have a penal system where the vast majority of inmates have been incarcerated for non-violent offenses. The violence of *Oz* is further distorted because most of it is perpetrated by sadists who behave brutally simply for the pure pleasure it provides them. *Oz* rarely deals with the causes of much real world prison violence—fear, frustration, overcrowding, inhumane treatment. Many of the respondents provided insights into prison violence that *Oz* in particular, and the media in general, omit. Robert, for example, said that inmates "use violence as a last resort." When asked to elaborate on that, he and another ex-inmate related poignant stories of the misery and frustration that results from being forcibly separated from your loved ones:

> Harry: Your whole family can get you so pissed off inside the walls. A woman could be sayin' stuff on the telephone or you can get things in a letter that like... you know, like baby, we've been kickin' it for these two years, but I'm tired of your shit, it's the same ol' shit every day, I'm about to go out on a date. That just opens up your whole life up to another level. The guy that you like as your cellie [cellmate] can come in, you might flip on him.

Carla indicated that she used to fight in prison on purpose because she preferred to be in segregation rather than in the general population. She also talked about her past and how violence had been a part of her childhood:

> I had to grow up quick and take care of my sisters and my brother, and kind of got picked on, so I turned to fighting and violence. So that's how I learned how to fight. I fought anybody... bullies, you know, and that's the way I did things.

Other respondents indicated causes of prison violence that are endemic to the punitive nature of corrections in the U.S. For example, the lack of rehabilitation and

treatment programming and the overcrowding that is the result of harsh sentencing and parole guidelines are issues that came up frequently in these interviews.

> Interviewer: What do people do?
> Tito: As far as what?
> Interviewer: You know, when they're just out trying to kill the day.
> Mike: Walk around the tier. It's like a triangle, like this. That's how you come in. You come in on top, just like a tier—like this. It's all in a triangle. The whole unit is in a triangle. You got a tier that go all the way around. It go like this and then at the end it gets pointy. Then go back that way and it go like that. It's just like a triangle....'Cause when you're stuck somewhere that you're gonna be there for a while you tend to horseplay because they're tired of being bored doing the same cycle every day. It's like you're so bored you want to get into trouble to make something happen you know?

Although *Oz* utilizes prison violence as a spectacle in order to draw viewers' attention, it never provides images or discourses related to the issues that these ex-inmates identified as the primary causes of prison violence: external stressors, overcrowding, horrible boredom, or the mixing of long-term hardened convicts alongside inmates with lesser sentences.

Finally, the ability of prisoners on *Oz* to commit violent acts over and over again without any sanctions is also a distortion of the conditions inside America's maximum-security prisons. For example, the conditions depicted in *Oz*, where freely roaming predators wander the hallways, unsupervised, committing havoc at will, might be compared to this description of life inside Pelican Bay, one of the nation's most violent institutions; a place that defenders of *Oz* might point to when claiming that *Oz* presents a realistic portrayal of how violent the worst prisons can be:

> In Pelican Bay... 40 percent of the 3,242 inmates are lifers. At any one time between 1,300 and 1,500—those deemed a threat to other inmates, those with known gang affiliations—are housed in a Secure Housing Unit. There, behind perforated orange metal doors, they remain isolated in their cells, eight feet by ten feet, approximately twenty-three hours per day. When they receive visits which is rare, since Los Angeles, where most of the prisoners are from, is a sixteen hour drive to the south—they visit through a bulletproof glass window.... Most are there for an "indeterminate sentence," often for years on end. They eat and shit in their cells. They exercise, alone, in barren concrete yards ten by twenty feet. In some SHUs in America, even the showers are built inside the tiny cells (Abramsky, 2002, p. 89).

This is a very different picture than that offered by *Oz* of ungrateful prisoners who are provided with comfortable surroundings and then choose to act like unfettered animals, prowling the prison and wreaking havoc, with little consequences for their actions.

Oz and the Complexity of Contemporary Media Representations of Race

While white, black, Latino, and Asian characters on *Oz* are all depicted as violent and depraved, the association of black masculinity with violence that occurs on *Oz* warrants specific analysis for two reasons. First, although the program promotes itself as "groundbreaking," the images of black males on *Oz* are consistent with a long history of U.S. cinematic and televisual representations of black males as violent savages. Second, the depraved image of black masculinity represented on *Oz* is particularly important ideologically because it appears in the context of a limited spectrum of representations of black masculinity that is available in mainstream media culture. Simply put, people of color do not appear in as wide a range of roles on U.S. television as whites do (Children Now, 2003). Thus, images that highlight criminal and violent black men stand out because there is a more restricted range of images of black males on television in general.

While Latino, Asian, Irish, Italian, and "Aryan" inmates all commit acts of violence and cruelty on *Oz*, African American inmates in particular seem to represent a threat to the stability of the prison, and they are often depicted as being just barely contained by the predominately white corrections officers and administrators. In one story line during the fourth season this is particularly apparent. A black man replaces a fired white man as the administrator of Emerald City, the unit of the prison where most of the action takes place. This new administrator, Querns, quickly is revealed as both corrupt and incompetent. He knowingly and willingly allows black inmates to run wild and take over the unit while most of the white inmates are transferred and those who remain are depicted as victims of the out-of-control black savages. He also places black guards in charge of the unit and they become complicit with the black inmates in their victimization of whites. At one point there is a pseudo-African chanting ritual displayed where all of the black prisoners celebrate in the middle of the unit while white prisoners look on from the edges. One white inmate turns to another and says, "It's the end of the fucking universe."

These scenes are eerily reminiscent of D.W. Griffith's racist paean to the Ku Klux Klan, *Birth of a Nation* (1915), which depicted the post-Civil War South as a place that had fallen into chaos because of emancipation. Thus, rather than being groundbreaking or innovative in any way, at least in terms of the racial imagery that it often employs, *Oz* has roots that go as deep as the beginnings of U.S. electronic mass communication. Hall has noted that "particular versions [of racist imagery] may have faded. But their traces are still to be observed, reworked in many of the modern and up-dated images" (1995, p. 22). Thus, he observes:

Popular culture is still full today of countless savage and restless "natives," and sound-tracks constantly repeat the threatening sound of drumming in the night, the hint of primitive rites and cults... and against them is always counterposed the isolated white figure, alone "out there," confronting his Destiny or shouldering his Burden in the "heart of darkness," displaying coolness under fire and an unshakeable authority... (1995, p. 21).

The picture painted by Hall is astonishingly appropriate as a description of *Oz*, a program that frequently juxtaposes images of "savage" black prisoners with those of the white guards whose "burden" it is to control them. Even the soundtrack is laden with percussive, vaguely African or Afro-Cuban, music that peaks at moments of violence. As Hall notes, these are not new images, rather they are traces of the past; what Williams (1973) might have called residual aspects of culture, which continue to play a role in contemporary relations.

For example, we might consider Bogle's historical typology of stereotypes of African Americans in U.S. films. Bogle identifies a number of mythic types that appear repeatedly throughout the history of American cinema. One figure in particular resonates with the repeated imagery of *Oz*—what Bogle calls the brutal black buck who appeared almost a century ago in *Birth of a Nation*. Bogle writes, "The black brute was a barbaric black out to raise havoc. Audiences could assume that his physical violence served as an outlet for a man who was sexually repressed. In the *Birth of a Nation*, the black brutes, subhuman and feral, are the nameless characters setting out on a rampage full of black rage" (1993, p. 13).

This is the image of black masculinity that is invoked in every episode of *Oz*. Incidentally this is also the image that the Bush campaign used so adroitly to capitalize on white fears during the 1988 election. The caricature of Willie Horton manufactured for Republican political advertisements could have been seamlessly introduced as a character on *Oz*. The historical continuity is very clear between these images and long-standing media stereotypes. Bogle argues that in *Birth of a Nation*, "Griffith seemed to be saying that things were in order only when whites were in control and when the American Negro was kept in his place" (1993, p. 10). This was clearly one of the implicit messages of the Horton advertisements, and, one could argue, of *Oz*.

As Gray (1995b) has suggested about late-twentieth-century stereotypes of black males in the U.S. popular imagination:

Consider how, for example, neo-conservatives used the black male body under Reaganism.... Discursively located outside of the 'normative conceptions,' mainstream moral and class structure, media representations of poor black males... served as the symbolic basis for fueling and sustaining panics about crime, the nuclear family, and middle-class security while they displaced attention from the economy, racism, sexism, and homophobia. This figure of black masculinity consistently appears in the popular imagination as the logical and legiti-

mate object of surveillance and policing, containment and punishment. Discursively this black male body brings together the dominant institutions of (white) masculine power and authority—criminal justice system, the police, and the news media—to protect (white) Americans from harm (1995b, p. 402).

Thus, reviewing Bogle's historical analysis congruently with Gray's, we can see a strong continuity between recent media images of black masculinity and historical stereotypes. This is not to say that recent images are not more nuanced and complex than they were in the days of *Birth of a Nation*. For example, the Head Warden of *Oz* is played by African American actor Ernie Hudson. Consider also that many of the white inmates of *Oz*, particularly the Aryans, are depicted as being just as vicious and brutal as the black or Latino inmates. Thus, in recent racial imagery in popular culture the categorizations are not as rigid, not as... black and white. Yet, as noted in the previous chapter's discussion of prime-time dramas on broadcast television, this "progress" is often a deliberate strategy on the part of television and film producers that is used to insulate them from criticism of the underlying stereotypes that still lurk in their products despite these nuances.

Like *NYPD Blue*, for example, *Oz* features blacks, whites, and Latinos as both criminals and authority figures, as both threats to and protectors of mainstream society. Yet there is still an underlying tendency to demonize poor and working-class blacks, while blacks who have attained managerial-professional status are either depicted as corrupt, incompetent or even deranged, or as singular, tokenistic exceptions to the general pattern of representations in the program.

Oz and the Race/Class Nexus

Thus, what we see today in programs like *Oz* and the other prime-time dramas discussed in the previous chapter, is in many ways a type of racism that is articulated to notions of class—a complex association that links poor, working-class, or uneducated whites, such as the Italian, Irish, and "Aryan" thugs of *Oz*, with a large number of black or Latino characters in supporting roles who are depicted as criminals and hoodlums—while simultaneously linking a very small number of prominent African American characters with a large proportion of middle-to-upper class whites, who are depicted as leaders, authority figures or managers and professionals—Lt. Fancy and the one black police officer in the squad on *NYPD Blue*, Warden Glynn on *Oz*, etc.

The racism and classism of *Oz*, like that of other contemporary prime-time dramas, is thus more complex, perhaps, but not any less pernicious than the racism and classism that has been a consistent, if ever mutating, theme in American film and television right from the beginning. This argument that the violence of *Oz* is articu-

lated to notions of both race and class, despite the fact that white, black, and Latino inmates are depicted as fairly equal in the amount of violence that they perpetrate, is supported by an examination of some of the discourse in the mainstream press about this program.

For example, writing about the character Beecher, a white attorney who is sentenced to *Oz* after accidentally killing a young girl in a drunk driving accident, one journalist wrote: "Fontana said he put Beecher into the cast to represent the audience, most of whom can better identify with him than with the other inmates" (Dietrich, 1998, p. 52). Thus, while it is a highly unlikely scenario that an attorney who committed vehicular manslaughter would be placed in a maximum-security prison like *Oz*, the creators of the program seemed absolutely certain that without this character to identify with the average viewer would be unable to relate to this program. This became particularly apparent during the final season of *Oz* when Beecher, who had been paroled, was immediately returned to the prison after another inmate set him up to violate his parole. One interpretation of this rather contrived plot development is that the producers of the program seemed unable to imagine episodes of *Oz* that did not feature a white, middle-class protagonist at the heart of the action.

Thus, the audience that is envisioned by the producers of the show is a white, middle-class audience who might be expected to identify with a mild-mannered white professional, who, because of an unfortunate accident, has been thrown into the middle class's worst nightmare—forced into intimate contact with blacks, Latinos, and the white lumpenproletariat. While this image of the program's viewers is telling, to a certain degree it is not a misleading or false representation. Considering HBO's status as a premium cable program—one that can only be accessed by those who have the financial means to afford both a monthly basic cable bill and the extra charges for a set-top decoder box and a premium channel—it is actually quite a logical expectation that the audience for HBO would be skewed toward the middle and upper classes.

At the same time, despite the multi-cultural makeup of the actors who play inmates on the program, the image of ultra-violent prisoners is also subtly, and sometimes not so subtly, articulated to images of young black masculinity. Consider, for example, the syndicated music columnist who, in reviewing a CD of soundtrack music from *Oz* writes this about the rap and hip-hop music featured on the soundtrack:

> At last a soundtrack that makes sense. Even though many of the characters on *Oz*, HBO's unsettling drama about prison life, probably wouldn't listen to rap music, it's the most compatible genre for the show. The soundtrack wouldn't resonate with the program's older prisoners, transvestites, somber Muslims and (especially) white supremacists, yet who better to reflect an outlaw's life than thug rappers? (Campbell, 2001, no pagination).

Aside from the illogical essentialism lurking in this description—transvestites would not be expected to listen to rap music?—this is a fascinating example of the sometimes-subtle racial articulations in discourse about popular culture. While the author notes the diverse makeup of the inmates represented on *Oz*, he simultaneously links the criminal lifestyle and violence with a musical genre most often associated with young black males and then polishes it off with the implication that this is all just common sense: "who better to reflect an outlaw's life." This type of racial articulation often occurs on *Oz* semiotically, through a confluence of visual images and soundtrack music as rap, hip-hop and even African music typically underscore scenes of chaos and violence in the program. While black characters are certainly not the only ones to commit violence on *Oz*, the program does however seem to suggest an articulation between violence and the "underclass"—a concept that, as Reed (1999) points out, itself represents an articulation between class and race; with Latinos and blacks associated with deviance and criminality in the white imagination (see also Entman and Rojecki, 2000).

Thus, *Oz* uses graphically explicit violence and intense images of chaos as a spectacle to draw viewers' attention. This spectacle however may also perform another, latent function, that of reinforcing viewers' fear of inmates while simultaneously articulating those fears to stereotypical notions of race and class. As Watts and Orbe argue in their discussion of what they call the spectacular consumption of African American culture: "Illustrations of black communalism are shaped at the outset so that the anxiety and fear aroused in white viewers can supercharge the consumption of black humor or black sex" (2003, p. 10). One might add the consumption of black violence to their list in order to understand how *Oz*'s images of savage blacks in the communal setting of a prison may simultaneously titillate and frighten white viewers in an interdependent strategy of marketing a discourse of chaos, misery, and terror.

Yet *Oz*'s violence is not committed only by blacks and Latinos. Thus, the notion of the underclass as a powerful discursive construction (Reed, 1999) must also recognize that poor whites are often similarly positioned as dangerous Others who represent a threat to middle-class norms and values. Class thus meshes with race and blacks, Latinos and poor and working-class whites are all represented as violent savages in *Oz*'s representation of the incarcerated.

Oz, Sexuality, and Gender

Oz's representation of gender and sexuality is clearly as deserving of analysis as its discourse on race and class. While it is true that the vast majority (about 90%) of

America's prisoners are male, the fictional Oswald Penitentiary is an all-male facility and therefore the inmates depicted on *Oz*, with only one exception, have been all male. The only exception to this was the character Shirley Bellinger who appeared in Seasons Two through Four. In an unlikely plot twist, this white woman is placed on Death Row at the Oswald State Penitentiary after being convicted of murder, despite the fact that *Oz* is an institution for male prisoners. Bellinger is portrayed as a psychotic, sexually voracious, racist who ends up being hanged. The only other female characters who appear on the program are staff members or visitors. One of the two female guards who have appeared on the program is a violent and abusive woman who forces male prisoners into sexual relations and treats them sadistically. The other female guard murders an inmate during Season Two.

Oz is thus a hypermasculine program, not only in the sense that the vast majority of its characters are male but also in the manner in which both men and women are portrayed in this series. Mosher and Sirkin (1984) identify three dimensions of hypermasculinity: a callous attitude toward sex, an attraction to danger, and a tendency to perceive violence as manly. Hall (1992) suggested that a fourth dimension of hypermasculinity is a tight control over displaying "feminine" emotions such as fear or compassion. Interestingly, although Scharrer (2001) points out that most research on hypermasculinity has regarded it as a male phenomenon, several of the relatively few female characters on *Oz* also exhibit the traits listed above.

In its representation of prison as a hypermasculine environment, *Oz* does not mislead viewers. This is an apt description of the nation's penal institutions (see Courtenay and Sabo, 2001; Holmberg, 2001; and Kupers, 2001a). However, what an ideological analysis of this program might critique is the manner in which this hypermasculinity is presented as a spectacle and a commodity rather than as a phenomenon that warrants social commentary.

For example, hypermasculinity is treated as a spectacle in frequent graphic scenes of sexual violence. Violence and sex are equated on *Oz*, as in a scene where a young Italian man who had previously been raped by a black inmate is raped again by the leader of the Aryan Brotherhood. Schillinger, the rapist, says to his victim: "Was Adebisi's dick as big as mine? You be the judge." Many of the sexual liaisons between the female guard, Officer Howell, and a number of inmates also have violent overtones.

Yet, despite the hypermasculine tendencies in the program and the frequency with which sexual activity between male characters on *Oz* is depicted as violent rape, the program does offer a somewhat nontraditional representation of homoeroticism and homosexuality. For example, the frequent scenes of gratuitous male nudity—

prisoners being thrown naked into solitary, parading around in the shower room, even urinating and defecating—is on one level an indication of the way the show self-consciously positions itself as "realistic." On another level this nudity is indicative of the manner in which HBO tries to distinguish its programs from broadcast television through the use of naked bodies, profanity, intense graphic scenes of sex and violence, etc. However, there is also an element of hypermasculinity in the program's depiction of inmates as naked savages and there is simultaneously more than a trace of homoeroticism in the lingering shots of well-muscled nude men that appear in virtually every episode of *Oz*.

The self-conscious nature of these images is particularly apparent during one episode when the narrator, Augustus Hill, a character who comments on the action throughout the program's six seasons, addresses the camera directly and talks about the sexual crimes that have landed some of the inmates in *Oz*. As he talks the background scene is filled with dozens of naked men walking around the common room where the prisoners gather during the day. As with other scenes where the narrator talks directly to the viewer, these scenes are not meant to be taken as a realistic moment in the linear narrative. Rather, they are used theatrically, with the narrator functioning in much the same manner as a chorus in classic Greek drama, commenting on the action and twists and turns of the plot.

During this particular scene the narrator invokes Oscar Wilde's imprisonment for homosexuality and then appears dressed as him and engages a naked inmate in a gentle kiss. In general, *Oz* tends to present a contradictory image of homosexuality, in many scenes depicting sexual relations between male prisoners as pure depravity, and in others providing a glimpse of real devotion and tenderness between male lovers. To a certain extent this accurately reflects the complexity of homosexual relationships in the nation's prisons where there is a spectrum ranging from violent rapes, to arrangements made for protection, to long-term mutually committed romances. As Kupers notes:

> The Federal Bureau of Prisons estimates that between 9 and 20 percent of prisoners become victims of sexual assault.... But these figures do not include the huge numbers of men who "consent" to having sex with a tougher con or consent to having sex with many other prisoners only because they are very afraid that, if they do not, they will be repeatedly beaten or perhaps even killed. In my view, this kind of coerced sex also constitutes rape (2001b, p. 111).

However, while in this statement Kupers acknowledges that rape itself is complex, and does not necessarily require physical force, but just implied threat and consequent fear, he does not mention prison sex that could not be accurately categorized

as rape, even under this broader conceptualization: freely engaged in sexual encounters between men who may or may not consider themselves homosexual. Later in his essay, Kupers does make note of consensual sex between male prisoners and says that, "There is even affection—sometimes great affection—but this kind of innovation in male intimacy does not attract the kind of media attention that rape receives" (2001b, p. 115).

Oz, then, is unique in its occasional depictions of romance rather than just sexual assault between male prisoners, particularly in the representation of the relationship between the middle-class professional Beecher and a serial killer, Chris Keller. This relationship began as a brutal beating, during which Keller and another inmate broke Beecher's legs, but evolved into a romance. Thus, the ideological tendencies in this representation are complex and contradictory. From one perspective the program's depiction of true intimacy and love, including romantic love and sexual congress, between male prisoners may be considered a sign of progress in a media culture that still tends to avoid overt images of male-to-male sexuality. On the other hand, a feminist reading of Beecher and Keller's dysfunctional relationship may find the suggestion that a brutal beating can spark a romance to be particularly offensive, a new spin, if you will, on the notion that women secretly desire abusive treatment from their partners.

Keller and Beecher's relationship is complex and contradictory both in a narrative sense and in an ideological sense. Keller's loving/abusive treatment of Beecher seems to have awakened Beecher's latent homosexual desires. During Season Four he begins having sex with other male prisoners in order to make Keller jealous. This plot development may suggest a challenge to rigid notions of sexuality typically found in mainstream discourse. As Donaldson notes when discussing the frequency of male to male sexual contact in prisons:

> The salient fact that the overwhelming majority of young males in confinement, freed from the fetters of social disapproval, will seek sexual gratification from members of the same sex strongly implies that the capacity for male homoeroticism is nearly universal, its suppression a matter of cultural mores and the availability of women (2001, p. 125).

Thus, the representation of Beecher's fluid sexuality may be considered a progressive challenge to traditional mores and cultural representations of binary homosexuality and heterosexuality. However, the transformation of Beecher and Keller's relationship from one of harsh abuse to one of loving intimacy seems to simultaneously disguise the real damage inflicted in abusive sexual relationships. What is clear is that Oz does at least attempt to represent the diverse nature of sexual relations in men's prisons despite the frequent use of images of rape and sexual violence.

When asked to describe sexual behavior in prison, the ex-inmates I interviewed expressed their opinions that there are more mutually agreed upon sexual encounters than there are rapes, and that this is often misrepresented in media images. These respondents indicate that they perceive much of the sex in prison to be a matter of mutual consent, although they also hint at the possibility that what is consensual or nonconsensual in matters of prison sexual relationships is not always quite so clear cut. One respondent indicated that he had been scared to go to prison because of fears of being raped but then he went on to add that he hadn't expected to see consensual sex. He also noted that much of the sex in prison is consensual and yet rapes still do occur, particularly with young inmates as the victims.

Thus, the respondents in these interviews indicated that prison sexuality is a complex phenomenon with many variations, not just simply rape or romantic love (see Donaldson, 2001, for a discussion of the limitations of a binary opposition between consensual sex and rape in prison). While *Oz* distinguishes itself from traditional media stories about prison by featuring at least one mutually consensual homosexual relationship, in general the images of *Oz* tend to emphasize rape and the violent aspects of prison sex, rather than a more nuanced representation of the many ways that sexuality manifests itself behind bars.

Prisoners as Real People

The fact that *Oz* features a romantic relationship between two male inmates, however, is reflective of the manner in which *Oz* at times does portray inmates as multidimensional human beings, despite the contradictory and stereotypical tendency to depict them as savage beasts discussed above. Especially in comparison to the one-dimensional images in other television dramas, the inmates of *Oz* do tend to be more fully realized as characters. In the previous chapter I argued that inmate characters in *NYPD Blue*, *Law & Order*, and *The Practice* were utilized merely as objects to move the plot along and provide something for the real protagonists, the police, attorneys, and judges, to do. This is not a criticism that can be fairly directed at *Oz*. On the contrary, although some of the key administrative personnel on *Oz* are also important to the program, in general the prisoners are the primary subjects of this drama. Because of this, there is a tendency in the program to somewhat mitigate, or even contradict, the frequent scenes of hyperviolence by juxtaposing them with scenes that reveal that inmates experience a spectrum of emotions other than just anger and hate.

For example, during the opening episode of the fifth season, much of the action takes place on a bus that is transporting family members to visits with inmates in *Oz*. Conversations on the bus, and back at the prison where the men eagerly await their

visitors, demonstrate that the inmates are real human beings who love and are loved by mothers, wives, and children. At the end of the episode the driver of a tractor-trailer is shown nodding off at the wheel and the bus is run off the road, rolling over and killing many of the passengers inside. In a moving scene the Warden reads a list of those killed to the inmates who are awaiting their loved ones. Poignant spiritual music fills the soundtrack and while the viewer can see the Warden speaking, his voice is initially absent and then can just barely be discerned underneath the music. Close-ups of the prisoners' faces, however, reveal that the Warden is informing them of the tragedy and several prisoners are shown breaking down in misery. This is a scene that would be unlikely to appear in any other television drama where the emphasis is on police work, courtroom battles, and the emotional lives of the representatives of the criminal justice system—not that of criminals and inmates. This scene poignantly reveals that the monsters of *Oz* are also human beings who can experience real emotional pain. There may also be a moral message to this turn of events. After all, if the men had not been in prison their loved ones would not have had to take the bus ride that would end their lives.

Other moments in several episodes also focus on the emotional lives of prisoners and their vulnerability. These scenes break through the hypermasculinity of the program and contradict the "tough guys" image that tends to prevail on *Oz* and in much media culture (see Katz, 2006; Kellner, 2008). An inmate who is thrown into solitary is depicted sobbing in the cell. A mentally retarded inmate, Cyril O'Reilly, is often shown crying and expressing his fears. His brother, Ryan, who is also an inmate in *Oz*, and who is frequently depicted as a violent monster, is also often shown expressing real love and devotion for his brother. In one episode, Ryan breaks into tears while thinking about his past and is hugged and comforted by his cellmate. During this episode another inmate also dissolves into tears when he thinks about how he got a close friend hooked on drugs. During the poignant opening episode of the fifth season discussed above an inmate is devastated by the news that his wife is divorcing him.

Other episodes feature scenes of inmates talking about their hopes and dreams and disappointments and failures. During one episode an inmate who has been depicted as a drug addict and a sociopath who cannot control his violent rages, breaks down and confesses that he always harbored a dream of becoming a singer. A group therapy session depicted in the same episode includes scenes of inmates talking about the pain associated with losing their women. A group of Muslim inmates are shown engaging in a philosophical discussion about spiritual matters. During another episode an inmate talks about having been abused by his father. In one particularly

poignant subplot an elderly white inmate becomes obsessed with trying to find a bone marrow donor for his grandson who has leukemia. This becomes an all-consuming endeavor for him, and when he ultimately fails and his grandson dies in a later episode, it is likely viewers would feel sympathy for this character. While sympathy is not necessarily the most productive emotion that prisoners might want from the general public, it is certainly a positive step away from the feelings of repulsion and fear that are invoked in other television dramas and that are normally a key thematic element of *Oz*.

Implications for Public Opinion/Policy: The Cases of Parole, Supervision, and Rehabilitation

Despite the multidimensional and nuanced representations of inmates that are quite frequent on *Oz*, the hyperviolence of the program may overwhelm any sense that the inmates depicted on the program are real human beings who deserve humane treatment and sympathy, or even the more productive empathy. While the section above noted many instances when inmates' humanity, their feelings and emotions, were explored, almost invariably the same characters continue to be depicted as sadistic monsters during the action segments that drive each episode. From one perspective this may reflect the sophistication of the program's scripts, where characters are not depicted simplistically as purely good or purely evil. Rather, the writers seem to strive for a "realistic" portrayal of prisoners who may commit vile acts and yet must still be understood as multifaceted human beings. A different reading, however, might argue that these conflicting images merely reinforce the notions that prisoners should not be trusted, and that even "sympathetic" inmates still require severe restrictions and harsh punishment in order to keep their violent natures in check.

A recurring plot device on *Oz* simultaneously seems to suggest that the U.S. criminal justice system is not doing enough to contain dangerous predators. Nearly every episode of *Oz* includes at least one black-and-white flashback to the crimes that led to particular characters' sentences. During these flashbacks, the brutality of the crime is displayed in graphic detail while the narrator intones the prisoner's name, number, date of conviction, crime, and sentence. There is always an emphasis on the disparity between the original sentence and the date when the prisoner may be eligible for parole. This emphasis on the notion that violent criminals may only have to serve a fraction of their sentence seems to directly play into the mainstream political discourse that calls for longer, harsher sentences and less opportunities for alternatives to incarceration or parole. From this perspective, the narrative and images of *Oz* have the potential to reinforce public fears and the call for more police, more prisons,

and more restrictive criminal justice policies (see Parenti, 1999, for a critical analysis of criminal justice practices and rhetoric in the last decades of the twentieth century. See Hall et al., 1978, for a historical precedent to this process of media discourse feeding and nurturing regressive political movements).

In other ways, also, the images of *Oz* seem to indicate that the U.S. prison system is not "tough" enough. As noted above, even the most violent inmates on *Oz*, men who have repeatedly committed havoc within the prison, over and over again, seem to roam freely, with little supervision from the guards. These images suggest that prisoners do not receive strict enough supervision while incarcerated. The ex-inmates I interviewed told stories that sharply contradict this notion. For example, the normal prison routine was described thusly:

> Carla: When you wake up in the morning, you have to make your bed, you have a schedule to keep, you have a chore to do, you have to go to breakfast, you have to follow a routine.

The more serious the offense, the more restrictions the inmate faces while incarcerated:

> Evan: I was in maximum security... an everyday thing was, if you wanted rec [recreation time], you come out in tethers—which are shackles that are behind your back, to your ankles, and around your waist, so you can't do anything.

During other interviews respondents described their experiences in maximum-security institutions similarly:

> Mike: 23-hour lock down... you got a single cell—you got a TV in the cell.
> Interviewer: You were just by yourself in the cell?
> Mike: Yep! By yourself.
> Interviewer: So what was that time like?
> Mike: It was tough. It was tough. They got shackles on you, you got to strip every time you leave the cell for recreation.

Jimmy described a disciplinary measure used in the facilities he had been in:

> You're not allowed to come out of your room for at least 30 days. They let you come out, eat, back to your room, take a shower, back to your room. If you're allowed to use the phone, use the phone, you can't.... you know what I'm sayin' you can't have a lot of rec, you got one hour rec. It's 23-hour lockdown.

Oz also often seems to imply that rehabilitation is an unrealistic goal because prisoners will always revert to their natural proclivities toward violence and savagery. A page on HBO's web site (www.hbo.com), advertising a book based on the program, makes this implication overt:

> Emerald City, the experimental unit of Oswald State Correctional Facility, was originally de-
> signed to help prisoners rehabilitate themselves within a nontraditional environment. But
> from day one it was clear that Emerald City—as it was called on the inside—was just an-
> other breeding ground for rape, corruption, murder, and drugs.

Frequent scenes of prisoners using and selling drugs in prison, and raping and violently attacking one another, as well as guards and visitors, without much in the way of reprisal, thus suggest that inmates will simply abuse innovative programs that are designed to encourage rehabilitation. While one might argue that these images could also constitute a critique of incarceration itself, it is telling that *Oz* is set primarily in Emerald City, an experimental unit that, as the excerpt from the program's website quoted above notes, is supposedly meant to embody a more humane form of imprisonment and encourage rehabilitation. The fact that the prisoners of Emerald City instead descend naturally, "from day one," into chaos does seem to suggest that it is not so much incarceration as it is misguided liberal thinking about incarceration that is behind the brutality that occurs daily in *Oz*. Thus, in its stance on criminal justice policy issues such as parole, the treatment of inmates while they are incarcerated, and rehabilitation, *Oz* ultimately may reinforce the conservative message on crime and criminals—that only increasingly harsh responses are adequate forms of retribution, containment, and punishment of America's "superpredators." Again, the articulation to race is apparent, despite *Oz*'s multicultural cast. Because, as Mauer argues, during the latter part of the twentieth century:

> [L]eading academics, political pundits, and members of Congress began to refer to this new
> generation of criminals as containing a group of "superpredators." The animal imagery is in-
> escapable here; consider whether most people conjure up the image of a white teenager when
> thinking of a "superpredator." Hardly. But a baggy pants-wearing black kid with a handgun
> fits the bill perfectly (1999, pp. 125-126).

With its focus on hyperviolent inmates committing horrible acts, *Oz* may reinforce precisely this sort of political rhetoric.

Criticisms of the Penal System

Yet, the messages of *Oz* are not quite as clear-cut on these issues of public policy as the analysis offered above may suggest. Again, as Kellner (1995) points out, much of our media culture is ideologically complex and contradictory. Thus, despite the tendencies for the images and narrative of *Oz* to support conservative corrections policies, there are moments of criticism of the U.S. penal system that also crop up from time to time in this program.

For example, in the ongoing character of Governor James Devlin, *Oz* represents an unscrupulous, corrupt politician who advances a "tough on crime" rhetoric merely to bolster his own political ambitions. Governor Devlin gives a press conference during which he proudly states: "Let the word go forth to friend and foe alike that we will spare no expense, no time, no effort in housing and punishing the bottom feeders of our society." While this type of language might be interpreted as fully consistent with *Oz*'s visual images of prisoners as savage beasts that must be contained by the state, because it is Devlin who utters these words, an alternative reading seems to be intended. Devlin is consistently portrayed as immoral and unethical, a man who will engage in any sort of misconduct if he believes he can benefit from it politically. Thus, this proud proclamation is framed as a cynical attempt to win voter approval, and its inclusion in the episode seems to offer a somewhat subtle condemnation of politicians who base their campaign strategy on similar rhetorical strategies.

This interpretation is supported by the comments of the narrator during this episode. Addressing the camera directly at several moments during the episode, a wheelchair bound black inmate, Augustus Hill, runs through a litany of famous historical personages who had been imprisoned during their lifetimes, and he appears dressed as many of these individuals. The list includes many of the great heroes of Western civilization: Thomas Paine, Thomas More, Gandhi, Marco Polo, Christopher Columbus, Oscar Wilde, Joan of Arc, Galileo, Socrates, Christ. Could the invocation of these heroic figures in these non-realist interludes be suggesting that incarceration is sometimes unjust? If so, is there also a suggestion here that implies criticism of the punitive nature of the U.S. criminal justice system? Again, this interpretation seems to be supported by a non-realist break in the linear narrative late in the episode. In the final scene, Hill, dressed once again as himself, addresses the audience directly. As the camera pans in to an extreme close-up of his face he says: "One of the last things Jesus did on earth was invite a prisoner to join him in heaven. He loved that criminal. I say he loved that criminal as much as he loved anyone. Jesus knew in his heart, it takes a lot to love a sinner. But the sinner, he needs it all the more." The scene fades to black and the theme music kicks in. This powerful scene seems to be a fairly blatant call for an empathetic approach to criminal justice.

The narration in the following episode also seems to suggest a criticism of penal policies. Hill once again addresses the camera, this time reading a list of absurd laws that are supposedly still on the books, all of which can land a person in prison. The episode begins with Hill assuming the role of a philosopher and musing on the arbitrary nature of criminal justice:

There are three kinds of laws which govern us all. First and foremost are the laws of God fol-
lowed closely by the laws of nature, and running a distant third, the laws created by man.
You see, in order for man to create a law, a group of people have to get together and decide
that they have come up with the ultimate truth. A basic inherent truth by which every citizen
must conduct themself or be punished. The only problem is the group of people who de-
cides on the ultimate truth is a bunch of politicians. Given the choice would you rather be
judged by a whim of the Almighty or a vote by Congress?

Throughout the episode Hill interrupts the narrative to share: "real laws that are
currently on the books. Laws that, if you broke you would end up in jail." He reads
various city statutes that make it a crime to do things such as throw pickle juice on a
trolley, toss loose confetti, wear suspenders, allow a dog and a cat to fight, etc. This
seems on the surface to be an indictment of incarceration policies, yet Hill's addresses
to the camera are accompanied by images of violence and havoc committed by Oz's
inmates. These visual images seem to somewhat mitigate the critique offered by his
words: "Yes," they seem to suggest, " those antiquated laws are silly but despite these
laughable laws look at the real horror that prisoners commit." Or the suggestion may
be that if you throw pickle juice on a trolley you may end up imprisoned with these
animals. This recalls the Oz promotion noted earlier where a man envisions himself
being locked up in Oz for littering. While absurd on the surface, taken in context the
message ultimately is one of social control—behave yourself or the consequences will
be severe. These non-realist interludes thus seem to simultaneously critique and rein-
force the aims of the U.S. penal system, recalling Kellner's (1995) point that media
texts are sometimes contradictory in their implications.

It is not just the non-realist breaks in the narrative that allow space for criticisms
of incarceration during episodes of Oz, however. Particular characters, such as the
therapist and nun, Sister Peter Marie Reimondo, function as voices of critique. She
confronts the Warden on the issue of sexual assault in prison after a young inmate
confesses to her that he was gang raped. Warden Leo Glynn tells her that he wants to
minimize the number of rapes that get reported and that rape has a "leveling effect,"
in other words it helps keep prisoners in line. Sister Peter Marie replies "You want
rape to do your job." This brief dialogue alludes to a real issue in unofficial prison
administration policies. As Donaldson (2001) reports, prison officials do sometimes
allow rape to occur as a means of punishing certain prisoners or to keep the offenders
mollified. This is an issue that is rarely dealt with in mass media and even this brief
allusion to it demonstrates moments of real criticism that appear from time to time
during Oz.

Similarly, through the character of Cyril O'Reilly the producers of Oz have ex-
plored the moral implications of the death penalty, in particular the execution of

mentally retarded inmates. During one episode an inmate refers to this explicitly as unconstitutional because it is "cruel and unusual," and Sister Peter Marie also utters dialogue that specifically criticizes the practice of executing the mentally retarded. When Cyril is executed at the end of the following season, all of the inmates, black, white, and Latino simultaneously rise, go into their cells and began pounding rhythmically on their cell doors with their fists. As the noise becomes deafening the camera pans across various inmates with stoic expressions on their faces expressing their outrage in a rare moment of prisoner solidarity. Without referring explicitly to data, and functioning primarily through visual/emotional cues, this scene represents perhaps one of the most powerful critiques of criminal justice policy to appear on U.S. television.

Sometimes however, criticisms of the penal system in *Oz* are met with attempts to marginalize this sort of critique. For example, during the first episode of Season Five, a black woman who is riding the bus to go visit her husband directly confronts the prison priest, Father Ray Mukada, with data about the racism of the U.S. penal system. An older black woman, framed as the voice of wisdom, tells her: "Your head's all crammed with facts and figures, but a cold hard fact is never as good as a simple truth. Your husband... did he hurt you and your children when he was addicted?" The younger woman looks chastised and sheepish as she has to admit that he did. She then says that since then her husband has gotten off drugs. The older woman replies, "That's the story you need to be telling. That's what people want to hear." This voice of wisdom, as framed by the episode's narrative, thus suggests that facts and figures, sociological data, about real racism in the U.S. penal system are irrelevant. People don't want to hear it and the only thing that really matters is the individual story of this husband and wife. This is a deeply conservative perspective that reinforces the notion that, in Margaret Thatcher's words, "There is no such thing as society, there are only individuals and their families."

Thus, *Oz* is ultimately a complex media text. While primarily seeming to reinforce conservative stances on criminal justice policy, there are moments of critique that crop up in the program from time to time. Sometimes this critique is mitigated by the narrative or visual images, yet at other moments criticism of the U.S. penal system are presented fairly blatantly, albeit in the context of individual stories that dramatize and commodify the misery of the program's characters.

Conclusion

My examination of *Oz* suggests that while this program is unique in the way that it brings viewers inside the daily workings of a fictional maximum security prison and

offers more multifaceted portrayals of inmates than are normally on display in U.S. television, it also recreates archetypal stereotypes of the so-called underclass, and especially black males, as savage, sexually predatory, and in desperate need of white engineered systems of control. In doing so, it may be argued, *Oz* represents a continuation of the historically racist/classist tendencies of the American film and television industries (see Bogle 1993, 2001; Corea, 1995; Gray, 1995b; and Guerrero, 1993, among many others for analysis of the history of racism in American films and television). The recurring image of hyperviolent inmates on *Oz* is thus generally consistent with the discourse about incarceration and the incarcerated offered throughout the U.S. commercial television system, in both entertainment and news programming.

However, it is also true that the commercial logic of *Oz* and its cable outlet, HBO, is different than that of advertising supported television. Producers and marketers of original programs for premium cable networks such as HBO attempt to attract subscribers by offering them something they feel they cannot get from other channels. Thus HBO attempts to distinguish itself from other cable and broadcast channels through the slogan—"It's not TV—It's HBO." But of course it is still television—and it does still operate within a profit-oriented media system, albeit with different constraining variables in terms of organizational structure, funding, and production routines. While HBO's original series like *Oz* typically feature more intense images and stories than can be found in traditional network programming, the entire process is still one of commodification. This is readily apparent through even a cursory examination of the network's website where *Oz* T-shirts, books, soundtracks, and the like are all for sale.

Thus, despite some of the differences of *Oz*, both in terms of its relationship to the political economy of television and its content, the emphasis on presenting a spectacle of horrific violence to draw the viewer's gaze is consistent with the tendencies in U.S. electronic media to utilize images of graphic violence and sexuality to capture viewers, whose time and attention are themselves increasingly precious commodities in a cluttered media environment. The fact that this program appeared at the height of the U.S. prison population explosion highlights what Jhally has called the colonization of political realities by the "commodity image-system" (1995, p. 83). In the case of *Oz*, the spectacle that is being used to lure viewers is one of misery and chaos and terror. *Oz* thus represents a particularly pernicious example of the commercial media system's willingness to exploit literally *anything* in order to turn a profit. The distortions of *Oz*, become a matter of vital importance when we acknowledge that media representations are crucial components in shaping reality itself. In

fact, as Angus and Jhally point out, "the distinction between 'images' and 'real life'... can no longer be regarded as tenable. Social representations constitute social identities. The real is always mediated through images" (1989, p. 6).

Thus, rather than merely reflecting reality, films and television programs like *Oz* that depict most African American and Latino characters, along with working-class whites, as threats to society, play a part in reproducing and legitimizing a discriminatory criminal justice system. While *Oz* is certainly a compelling program, the horrific images that are so central to *Oz's* narrative may also serve to cultivate fear in viewers who have few alternative representations of inmates to draw upon (see Shanahan and Morgan, 1999 for a thorough overview of cultivation theory and research, and the relationship between television, fear, and social control). This fear can be a valuable resource for those forces in our society who wish to pursue a repressive and punitive response to individual criminals rather than a proactive approach to the social and structural inequities that breed crime. I will address this notion in more depth in the next chapter.

CHAPTER VIII

Conclusion
Television, Incarceration, Imagination

Stories are powerful.

In this book I have employed cultural analysis and criticism, including semiotic and narrative theory and ideological critique, to investigate how the television industry offers viewers a set of stories about prisons and prisoners that are very different than the stories told by people who have spent time in prison. I have argued that the stories of television frame incarceration in very particular ways, and that these frames may play a significant role in shaping viewers' imaginations about imprisonment, and in cultivating fears about the incarcerated that are politically exploitable.

While conducting the research that went into this book, I was frequently asked by friends and colleagues whether I was afraid to be alone in a room with a group of ex-inmates. While this is merely an anecdote, it does suggest that many Americans have a perception of the nation's incarcerated as dangerous, violent individuals. From local and national television news, to prime-time cable and broadcast dramas, U.S. television viewers receive, on a nightly basis, images that suggest that the unprecedented prison population explosion that has been generated by increasingly punitive criminal justice policies is a necessary response to an out-of-control, dangerous society.

The analysis I have presented in the preceding pages is a case study in the construction of a hegemonic moment. It has become a matter of common sense in the U.S. that building more prisons, incarcerating more people, enforcing mandatory minimums and "three strikes" sentences for even minor crimes, treating drug addiction as a crime rather than a disease, and other, similar, criminal justice policies advocated by vote-seeking politicians, are steps that must be taken in order to keep US safe from those savage OTHERS who are roaming our streets, merely waiting for an opportunity to strike if nothing is done to stop them. While there are voices in American society who question both the morality and the efficacy of turning the U.S. into a nation of the incarcerated, they have largely been relegated to the margins, framed as unrealistic and naive—out-of-touch intellectuals or weak-hearted liberals. Media images play a key role in shaping this discourse and in building and reinforcing a fearful perception of prisoners in the U.S., just as they have influenced a more generalized public anxiety about crime and criminals (Altheide, 2002; Austin and Irwin, 2001; Dyer, 2000; Mauer, 1999; Shanahan and Morgan, 1999).

Media images and stories are thus crucial to the legitimization of the current trends in criminal justice policy that have resulted in the U.S. now imprisoning a larger proportion of its citizens than any other nation on the planet. As the National Criminal Justice Commission reports, "Since 1980, the United States has engaged in the largest and most frenetic correctional buildup of any country in the history of the world" (Donziger, 1996, p. 31). This same commission identified the media as central players in this process as images of crazed, violent criminals and messages of fear inundated the airwaves, even when crime itself was on the decline. A public whose anxiety about crime is nurtured by fear-engendering images in films, television dramas, and news is primed to accept severe criminal justice policies that politicians promise will make us safer.

In this concluding chapter I will briefly summarize the recurring tendencies in television images and stories of incarceration and delve deeper into the political ramifications of the television construction of prisons and prisoners.

Television News—Arrest... Sentencing... Invisibility

While local television news is the primary source of information for most Americans (Lipschultz and Hilt, 2002), these programs actually offer little in terms of what might be typically called "hard news," devoting, instead, most of their time to sports, weather, celebrity gossip, and the like. The actual news that is featured tends to be random tales of mayhem and violence—fires, crime, accidents, etc. (Downie and Kaiser, 2002; Iyengar, 1991; Lipschultz and Hilt, 2002). Local television news does not provide the deeper story that could allow viewers to understand the true nature of incarceration in the United States. Instead, stories that featured images of, or references to, prisoners tend to be episodic in nature (see Iyengar, 1991), providing little context or background information, but rather just focusing on isolated fragments of information about individual crimes that had been committed or sentences that were handed down. This type of reportage offers little insight into the larger social issues related to crime and punishment in the U.S. Instead, viewers get tabloid-style news coverage, including an emphasis on violence, frequent use of verbal descriptions of prisoners that were rife with negative connotations, a reliance on loaded visual images such as mug shots and video of inmates in shackles, and a focus on bizarre, quasi-celebrity crimes and criminals.

Just as with local television news, while crime is a central focus of the network news, what happens to criminals after they are sentenced to prison is rarely mentioned. The relatively rare stories that did deal with incarceration in the U.S. tended to emphasize the most out-of-the-ordinary aspects of prison life: riots, escapes, and

unique recreation programs. Throughout the broadcasts inmates were depicted as dangerous and violent. They were also framed as liars, cheats, and parasites. In general, both local and national television news frame the U.S. prison system as a just institution that protects ordinary citizens from the ever-growing army of superpredators threatening to overwhelm our society.

There are many reasons for the infrequent and distorted coverage of incarceration on television news. This is a story that has no readily identifiable beginning, middle, and end, and is thus not easily digestible into the fragments that television news favors. Even more important, however, is the fact that most of the people in prison simply do not come from the types of backgrounds that make audience members important to political powerbrokers or attractive to commercial television networks and the advertisers that finance them. America's prisoners originate overwhelmingly from the lower rungs of the economic ladder (Reiman, 2001). Just as the poor and the working class are generally invisible throughout much of the media environment, so too are the problems that they face and the obstacles that they must confront. The prison population explosion and the conditions in these institutions are thus simply not germane, according to the worldview of profit-oriented news industries.

This is not the case, however, when it comes to fictional media portrayals of incarceration. Every year, for example, there are several films released that are set, at least partially, inside jails and prisons. In the world of entertainment media, images and stories of the underbelly of American culture, the backstage areas of danger and deviance, are considered titillating spectacles that can successfully lure viewers' attention.

Broadcast Network Dramas—The Incarcerated without Incarceration

While television news about incarceration is relatively rare, fictional images of the incarcerated appeared frequently in prime-time crime dramas. In fact, across all three programs that I examined, inmates, ex-convicts, and parolees appeared in two out of every three episodes. The dearth of television news media coverage of the prison system accompanied by frequent dramatic images of prisoners in entertainment programming suggests that it is Hollywood's version of prisons and prisoners that is most likely to be encountered by television viewers.

Most of the inmate characters in these dramas were represented as violent criminals, whereas the vast majority of real-world inmates are incarcerated for nonviolent offenses. In the world of commercial television, however, violence is used as a for-

mula—a simple way to produce attention-getting visuals, ready-made and easily un-
derstandable conflicts, and quick resolutions on the assembly line of weekly television
production. Stories that focus on gory murders or violent rapes are thought to attract
viewers in a way that tales of possession of marijuana or petty thievery would not.
Thus, viewers enter an unreal world, while simultaneously being persuaded, through
handheld camera shots of busy New York streets, casual banter between detectives,
and the occasional explicit message (such as *Law & Order*'s motto—"Ripped from the
Headlines"), that they are getting a slice of reality.

When race and violence are considered together, the distortions of these pro-
grams are particularly disturbing. Blacks and Latino inmates were more likely to be
depicted as violent than white inmates. The brutality of prisons was framed as a nec-
essary intervention when dealing with the savage "Other." This discourse of legiti-
mate brutality was developed through images and narratives that suggested that harsh
treatment of prisoners is both necessary and deserved, that the criminal justice system
is often too "soft" on inmates, that rehabilitation is a misguided goal, that both in-
mates and parolees are dangerous, and that the death penalty is the ultimate answer to
violent crime. All of this was included in narratives that simultaneously framed U.S.
prisons as fundamentally just institutions. This notion was exemplified through tales
of primarily white defense attorneys, good-hearted prosecutors, and honest cops.

Despite the frequency with which inmate characters appeared in these programs,
their daily routines and struggles were as invisible as in the news programming dis-
cussed above. Most of the scenes that included images of inmates were set in court-
rooms or interrogation rooms rather than in the bowels of prisons themselves. Images
of the daily lives of prisoners, their conflicts and tribulations, friends and enemies,
victories and defeats, were entirely absent from these programs.

In sum, in the many ways that the make-up of the U.S. prison population was
distorted in these programs, and in the tendency to ignore the actual workings of,
and conditions inside, U.S. prisons, the images and stories of broadcast network
crime dramas are quite consistent with the images and stories of broadcast network
news programming.

Oz—Inside a Nightmare

Unlike the other programming I examined, *Oz* actually takes viewers inside the daily
workings of a maximum-security prison, albeit in a fictional setting. Despite this pro-
gram being entirely imaginary, both the program's creative personnel and the popular
press have lauded *Oz*'s "realism." What is most often defined as real in these apprais-
als is *Oz*'s frequent and graphic portrayals of intense violence. Most of the commen-

tators who praised the show for its realism seemed to base this assessment on the level of violence in the program. Yet, as demonstrated in the previous chapter, often *Oz*'s violence is pushed to extreme levels and includes bizarre images of people being buried alive, electrocuted when their heads are shoved into television sets, pushed to murder by ghostly visitations, and the like. Despite this, it seems that the manner in which rampant violence has become routine and conventional in American films and television programs has cultivated in at least some observers of popular culture the notion that it is this sort of imagery that is required for a program to be considered an accurate reflection of real life. Rather than being criticized as a cynical and all too easy strategy of lazy writers, directors and producers, violence is instead embraced as a necessary component of electronic media.

Violence is also associated with manliness on *Oz*, as it is in much media culture, resulting in a hypermasculine distortion of gender roles (see Katz, 2006 and Kellner, 2008). Subscribers may be simultaneously repulsed and attracted, initially recoiling, yet ultimately drawn to, and entertained by, the spectacle of *Oz*'s orgy of violence (see Watts, 1997, on spectacular consumption). *Oz* does push the limits of what has traditionally been acceptable on television, even cable television, and thus may possess a certain sort of mystique for viewers who are curious about just how far the program will go. People who have grown up with films and television programs that have become increasingly more violent with time may come to unconsciously seek ever escalating levels of violence in order to continue to be thrilled and titillated, in order for the novelty to endure. Much as an alcoholic requires more and more alcohol in order to feel the same buzz, viewers who are drawn to programs like *Oz* because of their promise to deliver more intense violent imagery may also be caught up in an addictive process. Savvy marketers understand, and capitalize on, addiction as the ultimate foolproof way to move product, the ultimate in commodification.

Simultaneous to this process of commodification, however, there is also potentially a process of social control at work here and in the other programming I examined. The commodification of terror may also cultivate fear in those viewers who, in the absence of alternative perspectives or countervailing experiences, have only television images to draw on when imagining who the incarcerated are or what goes on inside U.S. prisons.

Thus, there are some potential public policy implications of the misleading images and distorted discourses of a program like *Oz*. After all, *Oz* seems to suggest that America's prisons are filled with naturally sadistic monsters who are allowed to commit havoc even while incarcerated. If this is the case then hard-line, ultra-conservative, punitive criminal justice policies may in fact be justified. Commonsense,

and a lifetime of Hollywood films and television shows, tells us that we must keep monsters under tight lock and key or they will terrorize the innocent. More policing, stricter and longer sentences, more and harsher prisons—all of these measures are necessary to keep us and our loved ones safe from the Others, according to this fear-driven rhetoric.

Of course, as Hall et al. (1978) described brilliantly, crime-related fear often has an underlying racial foundation. This was true during the panic over "mugging" that arose in Great Britain during the 1970s (which Hall and his colleagues analyzed in *Policing the Crisis*, their landmark study of the construction of a specific moment of conservative hegemony), and it is no less true of similar U.S. panics over "wilding" and "superpredators"—panics which have fed the current American prison boom. Hall et al.s' analysis reveals the manner in which media discourses often play a central role in the creation and reinforcement of such racially driven panics.

Researchers, for example, have demonstrated that many Americans seem to almost automatically associate criminality with blackness. Gilliam and Iyengar (2000) reported the results of an experiment that revealed that even in the absence of any images of or references to criminal suspects, 42% of viewers of television news stories about crime thought they remembered having seen a suspect and two-thirds of those viewers said that the suspect they saw was black.

While individuals of disparate racial and ethnic backgrounds were all depicted as violent in the programming I analyzed, television's racial characterizations must be considered in the larger context of both historical and contemporary media representations of black men. The image of black masculinity on the news, and on *Oz* and other dramatic programs is consistent with the history of U.S. cinematic and televisual articulations of blackness with savagery. Furthermore, this savage representation appears in the contemporary context of a fairly limited spectrum of images of black masculinity on U.S. television. Content analysis has revealed that blacks simply do not appear in as wide a range of roles on U.S. television as whites (Children Now, 2003). Thus, images of brutally violent black men are rhetorically powerful both because they resonate with historical representations and because there is a more restricted range of potentially countervailing images of black males on television in general.

Listening to Other Stories

Television is the central storyteller in American culture (Gerbner, Gross, Morgan, Signorelli, and Shanahan, 2002), but it is only one potential source of stories about incarceration. Those who have actually experienced life in America's prisons have

their own stories to tell, and the ex-inmates I interviewed told stories about incarceration that were often quite disparate from the stories told by U.S. television. Ex-inmates, for example, described prison environments that are much more controlled than those depicted on U.S. television—with tight supervision, limited freedom of movement and strict routines to follow. While acknowledging that many prisons can be very violent places, these respondents also tended to refute television's hyperviolent image of incarceration where rapes, murders and riots are routine occurrences committed by naturally brutal and sadistic hypermasculine individuals. Instead, the stories told by ex-inmates offer insights into how the structural aspects of the U.S. penal system often encourage rather than discourage brutality, and the complex nature of prison violence and sexuality.

Interviewees also spontaneously brought up many issues that were rarely or never dealt with in either dramatic or news programming. Issues such as poor nutritional and health care services; limited opportunities to participate in educational, vocational, or other rehabilitation programs; frequent verbal and physical abuse by corrections staff; complicity of corrections staff with the prison drug trade; the difficulties released prisoners have in finding employment; and high turnover rates and inadequate training programs for COs, came up in every interview and yet were almost entirely absent from the television discourse about incarceration. Other issues that arose during my interviews that were not dealt with in television programming at all included the additional hardships that female prisoners must face in U.S. prisons, and the problems caused by the placement of non-violent prisoners alongside offenders with violent records.

It should be noted that it is not really surprising, however, that television stories about incarceration do not address key issues such as those noted above. In order for television news producers, for example, to even consider these sorts of potential stories as newsworthy, the entire culture of commercial journalism in the U.S. would have to change. A move away from purely episodic reporting of dramatic events and conflicts, a move away from the reliance on the public relations of corporate and government spokespeople as sources of information, a move away from celebrity news and gossip, all of this would be required before the concerns of the individuals I spoke with had any chance of being aired on American television.

Media Spectacles and Social Control

In the introduction to *Policing the Crisis*, Stuart Hall and his colleagues write that while their book is concerned with the moral panic over the socially constructed crime of 'mugging,' in Britain in the 1970s, "this relates to the larger 'panic' about the 'steadily

rising rate of violent crime' which has been growing through the 1960s. And both these panics are about other things than crime, *per se*" (Hall, Critcher, Jefferson, Clarke, and Roberts, 1978, p. vii). My contention is that the United States, in the last decades of the twentieth century, experienced a similar panic about crime that resulted in the extraordinary buildup of the prison-industrial complex and the triumph of the "law and order state" (Hall et al., 1978, p. 323). However, just as Hall and his co-authors contend that this panic was about other things than crime, was about a larger crisis in national, class, and race hegemony, so to, the incarceration boom in the U.S. is one element in a larger crisis.

This is a crisis in the legitimacy of previously secure power blocs. Elite groups sense that their power is crumbling. Marginalized people increasingly refuse to be kept in their places. Economic, environmental, and domestic and foreign policy disasters expose the tenuous grasp on power that previously secure groups assumed to be their birthright. As Davis suggests,

> The moral panic around crime is not related to a rise in crime in any material sense. Rather, it is related to the problem of managing large populations—particularly people of color— who have been rendered dispensable by the system of global capitalism (2005, p. 43).

The rabid buildup of the prison industrial complex has been one response to this crisis. The media play a key role in helping to create a sense of panic in the first place, and then offering a solution to the crisis in terms of a social lockdown on a massive scale.

Thus, the dramatic and news programs I examined do much more than just reflect reality—they shape, twist, and filter reality to fit the needs of a commercial media system that is a servant of the larger state order. In the case of television images of incarceration this filtering of reality is vitally important because it is the public imagination, and public policy, that is being twisted in an oppressive and dangerous direction. Just as in the era that Hall and his colleagues analyzed, the crisis is real but "It is how that real crisis is perceived and controlled which contains the seeds of political and ideological distortion" (Hall et al., 1978, p. 322).

Television programs that portray most African American and Latino characters (along with working-class whites) as savage beasts, play a key role in scapegoating the most vulnerable members of U.S. society, blaming them for failing economic, social, and political systems, and providing rhetorical justification for a discriminatory and oppressive criminal justice system. The fear that television representations of incarceration may cultivate in viewers is a central element in a process of social control, as those elements in our society who wish to pursue repressive policies play on our anxieties in order to justify their own agendas (see Gerbner and Gross, 1976a, for a

more general argument about television as a force of social control). As Shanahan and Morgan note:

> [A] heightened and widespread sense of fear, danger and apprehension can bolster demands for greater security; this in turn can mean greater legitimacy of the authority that can promise to meet those demands, creating conditions highly conducive to repression and undermining support for civil liberties (1999, p. 49).

In all of the programming I examined, archetypal images of scary, violent, evil prisoners committing havoc resonated across genres and channels. Despite Bohm's (1986) contention that the vast majority of us have committed acts for which we could, potentially, have been incarcerated, television represents inmates as Other— alien creatures who should be feared and shunned. As noted above, and just as in the crisis that Hall and his colleagues analyzed (Hall et al., 1978), this construction of inmate as Other often has disturbing racial undertones in television images and stories of imprisonment. The archetypal articulation of people of color and violence is perpetuated and reinforced throughout the programs I examined.

Yet in the wake of the election of Barack Obama there is much ongoing discussion of whether the United States has entered a post-racial era. It is my opinion that the significance of the Obama election should not be downplayed and that it represents the important strides that have been achieved in race relations in the U.S. Yet we have heard this story about the end of racism before. And powerful institutions such as the U.S. media and the criminal justice system have proven to be resilient in their attachment to racist ideologies and practices. As Angela Davis writes:

> Despite the important gains of anti-racist social movements over the last half-century, racism hides from view within institutional structures, and its most reliable refuge is the prison system. The racist arrests of vast numbers of immigrants from Middle Eastern countries in the aftermath of the attacks on September 11, 2001, and the subsequent withholding of information about the names and numbers of people held in INS detention centers, some of which are owned and operated by private corporations, do not augur a democratic future (2003, p. 103).

As noted in the introduction, the images from Abu Ghraib prison that came to light in 2004 showed evidence of the global expansion of the U.S. prison-industrial complex. From this perspective, it was no coincidence that the images also inadvertently revealed that the captors were overwhelmingly white Americans and the captives were dark-skinned men of Middle Eastern origins.

Furthermore, in the early days of 2009, two tragic incidents involving young black men and white police officers reveal that we shouldn't be too quick to assume that Obama's election will somehow signify the end of the U.S. criminal justice sys-

tem's search and destroy (Miller, 1996) approach to African American and Latino communities. On New Year's Day 2009 a group of police officers in Oakland, California, detained a number of young blacks in the subway and a white officer fatally shot unarmed 22-year-old Oscar Grant in the back despite the fact that he was already subdued and lying face down on the ground. The horrifying images were captured by cell phone cameras and subsequently posted on YouTube. A few days later, another unarmed young black man in Texas, Robbie Tolan, was shot by police in his own driveway after they erroneously assumed the vehicle he was driving was stolen. The vehicle was expensive, the neighborhood was white, and Robbie Tolan is black. This is a deadly recipe, as most people of color know. Although Tolan survived the shooting it is important to note that he and Grant are just the latest examples that have received media attention. As advocates for racial justice well know, incidents such as this occur frequently in the U.S. Any individual case is symptomatic of the larger structural rot that is at the foundation of the American criminal justice system. This foundation has not been rebuilt by the Obama victory.

Television images and narratives play a key role in both disguising the racism of the U.S. criminal justice system and providing justification for systematic brutality within that system. With relatively few contradictions, these stories cohere into a powerful discourse that plays on audience anxieties while providing rhetorical justification for the increasingly reactive, punitive response to crime, and the subsequent prison population explosion, of the last decades of the twentieth century and the beginning of the twenty-first. While the U.S. television news media virtually ignore these trends in incarceration, turning a blind eye to what actually occurs in the nation's prisons, television dramas utilize frequent images of the incarcerated in presenting spectacles of misery and terror for our entertainment (see Kellner, 2003, on media spectacles).

The lack of coverage of the prison population explosion in television news, coupled with the use of prison imagery in entertainment programming to intrigue and captivate viewers, is not surprising in an era where a handful of huge conglomerates control almost all of the nation's media outlets. In this context, informing the American public of an important sociopolitical issue is nowhere near as important as using provocative images and stories to generate a profit. Thus, spectacular media images of prisons and prisoners represent the ultimate in commodifying and depoliticizing a serious social problem—one that would be considered a national crisis if it impacted on whites from middle- and upper-class backgrounds as much as it does on people of color and the poor and working class (McChesney, 1999).

Yet, in its consequences this commodification may not actually lead to *depoliti-cization* at all. While media conglomerates benefit financially from luring viewers to their fictionalized, spectacular representations of incarceration, those who consume these hyperviolent images of terror and chaos may also be receiving messages of fear that ultimately serve a process of social control, priming us to accept increasingly draconian measures in order to feel safe and secure, protected from the Others who would surely rampage in the absence of a strong system of containment. As Morgan writes about the potential of television in general as an instrument of social control:

> Television is by no means the most powerful influence on people, but it is the most *common*; what it teaches most people, most of the time, is of the highest political, cultural and moral importance. As mass media become more centralized and homogenous, the cultural currents become narrower, more standardized, and more sharply defined, and mass communication becomes a more effective mechanism of social control (1989, p. 252, emphasis in the original).

In the case of television and the stories about prisons and prisoners that it tells, and doesn't tell, the lessons may be contributing to one of the most flagrant expressions of governmental power that the U.S. has ever experienced. Despite its severity, this lockdown of a nation (see Parenti, 1999) is proceeding quietly, and almost banally, in no small measure because of the corporate media's refusal to seriously interrogate why more and more of the nation's citizens wake up behind bars every morning. Instead of any serious investigation of one of the most significant trends of the last several decades, the incarceration explosion is implicitly, and sometimes explicitly, justified through a tidal wave of images and stories of rampaging criminals who clearly require harsh intervention by the state in order to keep Us safe from Them.

Finally, I would like to acknowledge that my focus on specific sorts of televised messages, such as network dramas and evening news broadcasts, while attending to the most popular forms, simultaneously neglects alternative types of televisual discourse on incarceration such as those that might be found on the 24-hour cable news networks, such as Fox News, MSNBC, or CNN. MSNBC, for example, now offers on-going news documentaries on prison life. Close analysis of these programs is needed in order to determine if they have the potential to reveal important truths about U.S. prisons and prisoners, or if they simply function as another source of exploitable, titillating images that do little other than lure viewers with the promise of violent spectacles. Other potential sources of television representations of incarceration that I did not examine include magazine-style shows such as *60 Minutes* or

20/20, reality shows such as *Cops* or *America's Most Wanted*, and documentaries that appear on cable channels such as Court-TV, The History Channel, The Learning Channel, and the like. In addition, while television is still the most attended to medium, a comprehensive understanding of the entire media system's representation of incarceration would have to take into consideration stories and images of prisons and prisoners that may be found in other forms of media such as film, newspapers, magazines, radio, or the Internet.

My analysis should thus be considered a starting point for further exploration of the relationship between the media system and the penal system in the U.S. and beyond.

In the past fifty years, the cultures of the industrialized societies of the earth have become defined by media images and stories. As Kellner writes:

> Social and political conflicts are increasingly played out on the screens of media culture, which display spectacles such as sensational murder cases, terrorist bombings, celebrity and political sex scandals, and the explosive violence of everyday life. Media culture not only takes up always-expanding amounts of time and energy, but also provides ever more material for fantasy, dreaming, modeling thought and behavior, and identities (2003, p. I).

Analysis of the social problems of the twenty-first-century must therefore take into account the role that media play in informing or misinforming the public, and in illuminating or disguising the key issues of the day. In the preceding pages I have attempted to provide insights into the relationship between television images and one crucial social problem—the detainment and incarceration of literally millions of Americans. The analysis offered here, it is hoped, can serve as just one step in confronting the complex relationship between television images and stories of incarceration and contemporary penal philosophies and policies.

REFERENCES

7UP to pull TV ad under pressure from human rights groups (2002). Available at http://www.spr.org, no pagination.

Abbott, J.H. (1981). *In the belly of the beast: Letters from prison.* New York: Random House.

Abramsky, S. (2002). *Hard time blues: How politics built a prison nation.* New York: St. Martin's Press.

Abu-Jamal, M. (1995). *Live from death row.* New York: Avon books.

Altheide, D.L. (2002). *Creating fear: News and the construction of crisis.* Hawthorne, NY: Aldine De Gruyter.

Althusser, L. (1971). *Lenin and philosophy and other essays.* London: New Left Books.

Amnesty International (2001). *Abuses continue unabated? Cruel and inhumane treatment at Virginia supermaximum security prisons.* Available at http://web.amnesty.org.

Angus, I. and Jhally, S. (1989). Introduction. In I. Angus and S. Jhally (Eds.), *Cultural politics in contemporary America* (pp. 1-14). New York: Routledge.

Armour, J.D. (1997). *Negrophobia and reasonable racism: The hidden costs of being black in America.* New York: New York University Press.

Arons, S., and Katsh, E. (1977, March). How TV cops flout the law. *Saturday Review,* pp. 11-19.

Austin, J. and Irwin, J. (2001). *It's about time: America's imprisonment binge* (3rd edition). Belmont, CA: Wadsworth.

Bagdikian, B. (2004). *The new media monopoly.* Boston: Beacon Press.

Bailey, F. and Hale, D. (1998). Popular culture, crime and justice. In F. Bailey and D. Hale (Eds.), *Popular culture, crime and justice* (pp. 1-20). Belmont, CA: West/Wadsworth.

Barthes, R. (1977). *Image-music-text.* New York: Hill and Wang.

Barthes, R. (1988). *The semiotic challenge.* New York: Hill and Wang.

Baum, D. (2000, December 7). Invisible nation. *Rolling Stone,* pp. 44-45, 124.

Bennett, W. L. (2001). *News: The politics of illusion.* New York: Longman.

Berger, A. A. (1997). *Narratives in popular culture, media, and everyday life.* Thousand Oaks CA: Sage.

Berger, P.L. and Luckmann, T. (1967). *The social construction of reality.* Garden City, NY: Anchor Books.

Best, J. (1999). *Random violence: How we talk about new crimes and new victims.* Berkeley: University of California Press.

Bleyer, W. (1927). *Main currents in the history of American journalism.* Boston: Houghton Mifflin.

Bogle, D. (1993). *Toms, coons, mulattoes, mammies, and bucks: An interpretive history of blacks in American films.* New York: Continuum.

Bogle, D. (2001). *Prime time blues: African Americans on network television.* New York: Farrar, Straus and Giroux.

Bohm, R. (1986). Crime, criminal and crime control policy myths. *Justice Quarterly 3*(2), 193-214.

Bortner, M.A. (1984). Media images and public attitudes toward crime and justice. In R. Surette (Ed.), *Justice and the media* (pp. 15-30). Springfield, IL: Thomas.

Brosius, H.B. and Kepplinger, H.M. (1990). The agenda setting function of television news: Static and dynamic views. *Communication Research 17*, 183-211.

Brown, N.J. (2001). A comparison of fictional television crime and crime index statistics. *Communication Research Reports 18*(2), 192-199.

Burton-Rose, D. (Ed.) (1998). *The celling of America: An inside look at the U.S. prison industry.* Monroe, ME: Common Courage Press.

Campbell, C. (2001). "*Oz*": The soundtrack. *The Nando Times,* (no pagination). Available at http://www.nandotimes.com

Campbell, C.P. (1995). *Race, myth and the news.* Thousand Oaks, CA: Sage.

Carlson, J. (1985). *Prime time law enforcement: Crime show viewing and attitudes toward the criminal justice system.* New York: Praeger.

Cavender, G. and Bond-Maupin, L. (1993). Fear and loathing on reality television: An analysis of *America's Most Wanted* and *Unsolved Mysteries. Sociological Inquiry 63,* 305-317.

Center for Media and Public Affairs (2000). Network news coverage over time. Available at http://www.cmpa.com/.

Chambliss, W.J. (1999). *Power, politics, and crime.* Boulder, CO: Westview Press.

Cheatwood, D. (1998). Prison movies: Films about adult, male, civilian prisons: 1929-1995. In F. Bailey and D. Hale (Eds.), *Popular culture, crime, and justice* (pp. 209-231). Belmont, CA: West/Wadsworth.

Chermak, S. (1994). Body count news: How crime is presented in the news media. *Justice Quarterly 11,* 561-582.

Chermak, S. (1995). Crime in the news media: A refined understanding of how crimes become news. In G. Barak (Ed.), *Media, process, and the social construction of crime* (pp. 95-129). New York: Garland.

Chermak, S. M. (1998). Police, courts, and corrections in the media. In F. Bailey and D. Hale (Eds.), *Popular culture, crime, and justice* (pp. 87-99). Belmont, CA: West/Wadsworth.

Chibnall, S. (1977). *Law-and-order news.* London: Tavistock.

Children Now (2003). *Fall colors 2003-04: Prime time diversity report.* Available at http://www.childrennow.org

Chriss, J.J. (2007). *Social control: An introduction.* Malden, MA: Polity Press.

Cirino, R. (1972). *Don't blame the people.* New York: Vintage Books.

Cleaver, E. (1968). *Soul on ice.* New York: Dell.

Cloud, D. (1998). *Control and consolation in American culture and politics: Rhetoric of therapy.* Thousand Oaks, CA: Sage.

Cohen, B.C. (1963). *The press and foreign policy.* Princeton, NJ: Princeton University Press.

Cohen, S. (1987 [1972]). *Folk devils and moral panics.* Oxford, U.K.: Basil Blackwell.

Cole, D. (1999). *No equal justice: Race and class in the American criminal justice system.* New York: New Press.

Comstock, G. and Scharrer, E. (1999). *Television: What's on, who's watching, and what it means.* San Diego, CA: Harcourt Brace.

Conover, T. (2000). *New jack: Guarding Sing Sing.* New York: Random House.

Corea, A. (1995). Racism and the American way of media. In J. Downing, A. Mohammadi, and A. Sreberny-Mohammadi (Eds.), *Questioning the Media* (pp. 345-361). Thousand Oaks, CA: Sage.

Cose, E. (2000, November 13). The prison paradox. *Newsweek,* pp. 40-49.

Courtenay, W.H. and Sabo, D. (2001). Preventive health strategies for men in prison. In D. Sabo, T.A. Kupers, and W. London (Eds.), *Prison masculinities* (pp. 157-172). Philadelphia: Temple University Press.

Crowther, B. (1989). *Captured on film: The prison movie.* London: B.T. Batsford.

Davis, A.Y. (2003). *Are prisons obsolete?* New York: Seven Stories Press.

Davis, A.Y. (2005). *Abolition democracy: Beyond empire, prisons, and torture.* New York: Seven Stories Press.

Derrida, J. (1988). *Limited, Inc.* Evanston, IL: Northwestern University Press.

Dietrich, M. (1998, August 9). Koppel, 'Oz' explore chilling reality of prison. *The State Journal-Register,* p. 52.

Dixon, T.L. and Linz, D. (2000). Overrepresentation and underrepresentation of African Americans and Latinos as lawbreakers on television news. *Journal of Communication 50*(2), 131-154.

Dominick, J. (1973). Crime and law enforcement on prime-time television. *Public Opinion Quarterly 37*, 241-250.

Dominick, J. (1978). Crime and law enforcement in the mass media. In C. Winick (Ed.), *Deviance and mass media* (pp. 105-128). Thousand Oaks, CA: Sage.

Donaldson, S. (2001). A million jockers, punks, and queens. In D. Sabo, T.A. Kupers, and W. London (Eds.), *Prison masculinities*(pp. 118- 126). Philadelphia: Temple University Press.

Donziger, S. R. (Ed.) (1996). *The real war on crime: The report of the National Criminal Justice Commission.* New York: Harper Collins.

Douglas, M. (1966). *Purity and danger.* London: Routledge.

Downie, L. and Kaiser, R.G. (2002). *The news about the news: American journalism in peril.* New York: Alfred A. Knopf.

Dyer, J. (2000). *The perpetual prisoner machine: How America profits from crime.* Boulder, CO: Westview Press.

Eaton, H., Jr. (1989). Agenda setting with bi-weekly data on content of three national media. *Journalism Quarterly 66*, 942-948, 959.

Elliot, J. M. (1993, August). The 'Willie' Horton nobody knows. *The Nation*, Vol. 257, Issue 6, pp. 201-206.

Entman, R. (1992). Blacks in the news: Television, modern racism, and cultural change. *Journalism Quarterly 69*, 41-61.

Entman, R. (1993). Framing: Toward clarification of a fractured paradigm. *Journal of Communication 43*(3), 51-58.

Entman, R. and Rojecki, A. (2000). *The black image in the white mind: Media and race in America.* Chicago: University of Chicago Press.

Ericson, R.V., Baranek, P.M., and Chan, J.B.L. (1991). *Representing order: Crime, law, and justice in the news media.* Toronto: University of Toronto Press.

Feagin, J.R. and Vera, H. (1995). *White racism.* New York: Routledge.

Ferrell, J. and Sanders, C. (1995). Culture, crime, and criminology. In J. Ferrell and C. Sanders (Eds.), *Cultural criminology* (pp. 3-24). Boston: Northeastern University Press.

Fisher, W. (1987). *Human communication as narration: Toward a philosophy of reason, value, and action.* Columbia: University of South Carolina Press.

Fiske, J. (1990). *Introduction to communication studies.* London: Routledge.

Foucault, M. (1995). *Discipline and punish: The birth of the prison.* New York: Vintage Books.

Fox, R.L. and Van Sickel, R.W. (2001). *Tabloid justice: Criminal justice in an age of media frenzy.* Boulder, CO: Lynne Rienner Publishers.

Freeman, R.M. (1998). Public perceptions and corrections: Correctional officers as smug hacks. In F. Bailey and D. Hale (Eds.), *Popular culture, crime and justice* (pp. 196-208). Belmont, CA: West/Wadsworth.

Funkhouser, G.R. (1973). The issues of the sixties: An exploratory study in the dynamics of public opinion. *Public Opinion Quarterly 37*, 62-75.

Gabriel, J. (1998). *Whitewash: Racialized politics and the media.* London: Routledge.

Gans, H. (1979). *Deciding what's news: A study of CBS Evening News, NBC Nightly News, Newsweek, and Time.* New York: Vintage Books.

Garofalo, J. (1981). Crime and the mass media: A selective review of research. *Journal of Research in Crime and Delinquency 18*, 319-350.

Gerbner, G. (1992). Violence and terror in and by the media. In M. Raboy and B. Dagenais (Eds.), *Media, crisis and democracy: Mass communication and the disruption of social order* (pp. 94-107). London: Sage.

Gerbner, G. (1999). What do we know? Foreword in Shanahan, J. and Morgan, M., *Television and its viewers: Cultivation theory and research.* Cambridge, UK: Cambridge University Press.

Gerbner, G. (2002). The stories we tell. In K.B. Massey (Ed.), *Readings in mass communication: Media literacy and culture, 2nd edition* (pp. 10-20). Mountain View, CA: Mayfield.

Gerbner, G. and Gross, L. (1976a). Living with television: The violence profile. *Journal of Communication 26*(2), 173-199.

Gerbner, G. and Gross, L. (1976b). The scary world of TV's heavy viewer. *Psychology Today 9*(11), 41-45, 89.

Gerbner, G., Gross, L., Morgan, M., and Signorielli, N. (1980). The "mainstreaming" of America: Violence profile no. 11. *Journal of Communication 30* (3), 10-29.

Gerbner, G., Gross, L., Morgan, M., and Signorielli, N. (1982). Charting the mainstream: Television's contributions to political orientations. *Journal of Communication 32*(2), 100-127.

Gerbner, G., Gross, L., Morgan, M., and Signorielli, N. (1994). Growing up with television: The cultivation perspective. In J. Bryant and D. Zillman (Eds.), *Media effects: Advances in theory and research* (pp. 17-41). Hillsdale, NJ: Lawrence Erlbaum.

Gerbner, G., Gross, L., Morgan, M., Signorielli, N., and Shanahan, J. (2002). Growing up with television: Cultivation processes. In J. Bryant and D. Zillman (Eds.), *Media effects: Advances in theory and research* (2nd edition) (pp. 43-67). Mahwah, NJ: Lawrence Erlbaum.

Gilens, M. (1996). Race and poverty in America. *Public Opinion Quarterly 60*, 515-541.

Gilliam, F. and Iyengar, S. (2000). Prime suspects: The impact of local television news on attitudes about crime and race. *American Journal of Political Science 44*(3), 560-573.

Girshick, L.B. (1999). *No safe haven: Stories of women in prison.* Boston: Northeastern University Press.

Goffman, E. (1959). *The presentation of self in everyday life.* New York: Doubleday.

Graber, D.A. (1980). *Crime news and the public.* New York: Praeger.

Gramsci, A. (1971). *Selections from the prison notebooks.* New York: International Publishers.

Gray, H. (1995a). Television, black Americans, and the American dream. In G. Dines and J.M. Humez (Eds.), *Gender, race and class in media* (pp. 430-437). Thousand Oaks, CA: Sage.

Gray, H. (1995b). *Watching race: Television and the struggle for "blackness."* Minneapolis: University of Minnesota Press.

Griffin, E. (2000). *A first look at communication theory.* Boston: McGraw Hill.

Gross, L. (1984). The cultivation of intolerance: TV, blacks and gays. In G. Melischek, K. Rosengren, and J. Stappers (Eds.), *Cultural indicators: An international symposium* (pp. 345-363). Vienna: Verlag der Osterreichischen Akademie der Wissenschaften.

Guerrero, E. (1993). *Framing blackness: The African American image in film.* Philadelphia: Temple University Press.

Hall, J.A. (1992). *Development and validation of the expanded hypermasculinity inventory and the ideology of machismo scale.* Unpublished master's thesis, University of Connecticut, Storrs, CT.

Hall, S. (1973). The determination of news photographs. In S. Cohen and J. Young (Eds.), *The manufacture of news* (pp. 176-191). Beverly Hills, CA: Sage.

Hall, S. (1982). The rediscovery of 'ideology': Return of the repressed in media studies. In M. Gurevitch, T. Bennett, J. Curran, and J. Woollacott (Eds.), *Culture, society and the media* (pp. 56-90). London: Routledge.

Hall, S. (1988). *The hard road to renewal: Thatcherism and the crisis of the left.* London: Verso.

Hall, S. (1990). The emergence of cultural studies and the crisis of the humanities. *October 53*, 11-23.

Hall, S. (1995). The whites of their eyes: Racist ideologies and the media. In G. Dines and J.M. Humez (Eds.), *Gender, Race and Class in Media* (pp. 18-22). Thousand Oaks, CA: Sage.

Hall, S., Critcher, C., Jefferson, T., Clarke, J., and Roberts, B. (1978). *Policing the crisis: 'Mugging', the state, and Law & Order.* London: Macmillan.

Hancock, L. (2003, January/February). Coloring the Central Park jogger case. *Columbia Journalism Review*, pp. 38-42.

Hardt, H. (1992). *Critical communication studies: Communication, history and theory in America.* New York: Routledge.

Hartnett, S.J. and Stengrim, L.A. (2006). *Globalization and empire: The U.S. invasion of Iraq, free markets, and the twilight of democracy.* Tuscaloosa: University of Alabama Press.

Head, S.W., Spann, T., and McGregor, M.A. (2001). *Broadcasting in America: A survey of electronic media* (9th edition). Boston: Houghton Mifflin.

Herman, E. and Chomsky, N. (1988). *Manufacturing consent: The political economy of the mass media.* New York: Pantheon.

Hersh, S. (2004, May 10). Torture at Abu Ghraib. *The New Yorker*, pp. 42-48.

Holmberg, C.B. (2001). The culture of transgression: Initiations into the homosociality of a midwestern state prison. In D. Sabo, T.A. Kupers, and W. London (Eds.), *Prison masculinities* (pp. 78- 92). Philadelphia: Temple University Press.

hooks, b. (1992). *Black looks: Race and representation.* Boston: South End Press.

Humphries, D. (1981). Serious crime, news coverage and ideology: A content analysis of crime coverage in a metropolitan paper. *Crime and Delinquency* 27, 191-205.

Irwin, J. (2005). *The warehouse prison: Disposal of the new dangerous class.* Los Angeles: Roxbury.

Iyengar, S. (1991). *Is anyone responsible? How television frames political issues.* Chicago: University of Chicago Press.

Iyengar, S. and Kinder, D.R. (1987). *News that matters: Agenda-setting and priming in a television age.* Chicago: University of Chicago Press.

Jackson, G. (1970). *Soledad brother.* Chicago: Lawrence Hill Books.

Jamieson, K.H. (1992). *Dirty politics: Deception, distraction, and democracy.* New York: Oxford University Press.

Jamieson, K.H. (1993). The subversive effects of a focus on strategy in news coverage of presidential campaigns. In Twentieth Century Fund Task Force on Television and the Campaign of 1992 (Eds.), *1-800 President: Television and the Campaign of 1992* (pp. 35-61). New York: Twentieth Century Fund Press.

Jensen, C. and Project Censored (1997). *20 years of censored news.* New York: Seven Stories Press.

Jerin, R. and Fields, C. (1995). Murder and mayhem in USA Today: A quantitative analysis of the national reporting of states' news. In G. Barak (Ed.), *Media, process, and the social construction of crime* (pp. 187-202). New York: Garland.

Jhally, S. (1990, July). Image-based culture: Advertising and popular culture. *The World and I*, pp. 506-519.

Jhally, S. and Lewis, J. (1992). *Enlightened racism: The Cosby Show, audiences, and the myth of the American dream.* Boulder, CO: Westview.

Kappeler, V.E., Blumberg, M., and Potter, G.W. (2000). *The mythology of crime and criminal justice.* Prospect Heights, IL: Waveland Press.

Katz, J. (2006). *The macho paradox: Why some men hurt women and how all men can help.* Naperville, IL: Sourcebooks.

Kellner, D. (1995). *Media culture: Cultural studies, identity and politics between the modern and the postmodern.* London: Routledge.

Kellner, D. (2003). *Media spectacle.* London: Routledge.

Kellner, D. (2008). *Guys and guns amok.* Boulder, CO: Paradigm Publishers.

Klein, N. (2007). *The shock doctrine: The rise of disaster capitalism.* New York: Picador.

Klite, P., Bardwell, R.A., and Salzman, J. (1997). Local TV news: Getting away with murder. *Harvard International Journal of Press/Politics 2*, 102-112.

Kupers, T.A. (2001a). Mental health in men's prisons. In D. Sabo, T. A. Kupers, and W. London (Eds.), *Prison masculinities* (pp. 192-197). Philadelphia: Temple University Press.

Kupers, T.A. (2001b). Rape and the prison code. In D. Sabo, T.A. Kupers, and W. London (Eds.), *Prison masculinities* (pp. 111-117). Philadelphia: Temple University Press.

Lasorsa, D., Danielson, W., Wartella, E., Whitney, D.C., Klijn, M., Lopez, R., and Olivarez, A. (1998). Television visual violence in reality programs: Differences across genres. In Hamilton, J.T. (Ed.), *Television violence and public policy* (pp. 163-178). Ann Arbor: University of Michigan Press.

Laswell, H.D. (1948). The structure and function of communication in society. In L. Bryson (Ed.), *The communication of ideas* (pp. 37-51). New York: Harper.

Lawes, L.E. (1932). *Twenty thousand years in Sing Sing.* New York: Ray Long and Richard R. Smith.

Leder, D. (2000). *The soul knows no bars: Inmates reflect on life, death, and hope.* Lanham, MD: Rowman & Littlefield.

Lewis, J. (1991). *The ideological octopus.* New York: Routledge.

Lewis, J. (2001). *Constructing public opinion: How political elites do what they like and why we seem to go along with it.* New York: Columbia University Press.

Lewis, R. (1984). The media, violence and criminal behavior. In R. Surette (Ed.), *Justice and the media* (pp. 51-69). Springfield, IL: Thomas.

Lichter, L. and Lichter, S. (1983). *Prime time crime.* Washington, DC: Media Institute.

Lippmann, W. (1922). *Public opinion*. New York: Macmillan.

Lipschultz, J.H. and Hilt, M.L. (2002). *Crime and local television news: Dramatic, breaking, and live from the scene*. Mahwah, NJ: Lawrence Erlbaum.

Lipsitz, G. (1998). *The possessive investment in whiteness: How white people profit from identity politics*. Philadelphia: Temple University Press.

Little, G.D. (1998). Representing Arabs: Reliance on the past. In Y. R. Kamalipour and T. Carilli (Eds.), *Cultural diversity and the U.S. media* (pp. 261-272). Albany: State University of New York Press.

Lotz, R. (1991). *Crime and the American press*. New York: Praeger.

Lowery, S. and DeFleur, M.L. (1983). *Milestones in mass communication research: Media effects*. New York: Longman.

Lowry, D. (1971). Gresham's law and network tv news selection. *Journal of Broadcasting 15*, 397-408.

Lowry, D.T., Nio, T.C.J., and Leitner, D.W. (2003). Setting the public fear agenda: A longitudinal analysis of network TV crime reporting, public perceptions of crime, and FBI crime statistics. *Journal of Communication 53*(1), 61-73.

Macek, S. (2006). *Urban nightmares: The media, the right, and the moral panic over the city*. Minneapolis: University of Minnesota Press.

Mackuen, M.B. (1981). *More than news: Media power in public affairs*. Beverly Hills, CA: Sage.

Madison, K.J. (1999). Legitimation crisis and containment: The "anti-racist-white-hero" film. *Critical Studies in Mass Communication 16*(4), 399-416.

Maguire, B. (1988). Image vs. reality: An analysis of prime-time television crime and police programs. *Crime and Justice 11*(1), 165-188.

Marx, K. and Engels, F. (1981). *The German ideology*. New York: International Publishers.

Mason, P. (1995). Prime time punishment: The British prison and television. In D. Kidd-Hewitt and R. Osborne (Eds.), *Crime and the media: The post-modern spectacle* (pp. 185-205). London: Pluto Press.

Mason, P. (1998). The prison in cinema. *Images: A journal of film and popular culture 6*, no pagination. Available at http://www.imagesjournal.com/issue06/features/prison.htm

Mauer, M. (1999). *Race to incarcerate*. New York: New Press.

Mazzetti, M. and Glaberson, W. (2009, January 21). Obama issues directive to shut down Guantánamo. *The New York Times*, p. A1.

McChesney, R.W. (1999). *Rich media, poor democracy*. Urbana: University of Illinois Press.

McChesney, R.W. (2004). *The problem of the media: U.S. communication politics in the 21ˢᵗ century.* New York: Monthly Review Press.

McCombs, M. (1997). New frontiers in agenda setting: Agendas of attributes and frames. Paper presented at the annual convention of the AEJMC, Chicago, IL.

McCombs, M.E. and Shaw, D.L. (1972). The agenda setting function of mass media. *Public Opinion Quarterly 36*, 176-187.

McNeely, C.L. (1995). Perceptions of the criminal justice system: Television imagery and public knowledge in the United States. *Journal of Criminal Justice and Popular Culture* 3 (1), 1-20.

Metz, C. (1974). *Film language: A semiotics of the cinema.* New York: Oxford University Press.

Meyrowitz, J. (1985). *No sense of place: The impact of electronic media on social behavior.* New York: Oxford University Press.

Miller, J.G. (1996). *Search and destroy: African-American males in the criminal justice system.* Cambridge, U.K.: Cambridge University Press.

Morey, A. (1995). The judge called me an accessory. *Journal of Popular Film and Television* 23 (2), 80-88.

Morgan, M. (1989). Television and democracy. In I. Angus and S. Jhally (Eds.), *Cultural politics in contemporary America* (pp. 240-253). New York: Routledge.

Mosher, D.L. and Sirkin, M. (1984). Measuring a macho personality constellation. *Journal of Research in Personality 18*, 150-163.

Mouffe, C. (1991). Hegemony and ideology in Gramsci. In T. Bennett et al. (Eds.), *Culture, ideology and social process* (pp. 219- 234). London: Open University.

Munro-Bjorkland, V. (1991). Popular cultural images of criminals and prisoners since Attica. *Social Justice 18*(3), 48-70.

Nellis, M. and Hale, C. (1982). *The prison film.* London: Radical Alternatives to Prison.

Newman, G. (1990). Popular culture and criminal justice: A preliminary analysis. *Journal of Criminal Justice 18*, 261-274.

Noelle-Neumann, E. (1993). *The spiral of silence.* Chicago: University of Chicago Press.

Oliver, M. (1994). Portrayals of crime, race, and aggression in "reality-based" police shows: A content analysis. *Journal of Broadcasting and Electronic Media 38*, 179-192.

Papke, D. (1987). *Framing the criminal.* Hamden, CT: Archon Books.

Parenti, C. (1999). *Lockdown America: Police and prisons in the age of crisis.* London: Verso.

Parenti, M. (1992). *Make-believe media: The politics of entertainment.* New York: St. Martin's Press.

Parenti, M. (1993). *Inventing reality: The politics of news media.* New York: St. Martin's Press.

Parish, J.R. (1991). *Prison pictures from Hollywood.* Jefferson, NC: McFarland.

Peffley, M., Shields, T., and Williams, B. (1996). The intersection of race and crime in television news stories: An experimental study. *Political Communication 13,* 9-27.

Phillips, P. and Roth, A. (2008). *Censored 2009: The top 25 censored stories of 2007-2008.* New York: Seven Stories Press.

Pines, J. (1995). Black cops and black villains in film and TV crime fiction. In D. Kidd-Hewitt and R. Osborne (Eds.), *Crime and the media: The post-modern spectacle* (pp. 67-77). London: Pluto Press.

Potter, W. J. (2001). *Media literacy.* Thousand Oaks, CA: Sage.

Prejean, H. (1993). *Dead man walking.* New York: Vintage Books.

Querry, R.B. (1973). Prison movies: An annotated filmography 1921-present. *Journal of Popular Film 2*(2), 181-197.

Rafter, N. (2000). *Shots in the mirror: Crime films and society.* New York: Oxford University Press.

Rapping, E. (1999). Aliens, nomads, mad dogs, and road warriors: Tabloid TV and the new face of criminal violence. In C. Sharrett (Ed.), *Mythologies of violence in postmodern media* (pp. 249-273). Detroit, MI: Wayne State University Press.

Reed, A. (1999). *Stirrings in the jug: Black politics in the post-segregation era.* Minneapolis: University of Minnesota Press.

Reed, I. (1993). *Airing dirty laundry.* New York: Addison Wesley Longman.

Reiman, J. (2001). *The rich get richer and the poor get prison: Ideology, class and criminal justice.* Boston: Allyn & Bacon.

Rhodes, J. (1993). The visibility of race and media history. *Critical Studies in Mass Communication 10*(2), 184-190.

Rideau,W. and Wikberg, R. (Eds.) (1992). *Life sentences: Rage and survival behind bars.* New York: Times Books.

Roffman, P. and Purdy, J. (1981). *The Hollywood social problem film: Madness, despair, and politics from the depression to the fifties.* Bloomington: Indiana University Press.

Romer, D., Jamieson, K.H., and deCoteau, N.J. (1998). The treatment of persons of color in local television news—Ethnic blame discourse or realistic group conflict? *Communication Research 25*(3), 286-305.

Rose, T. (1994). *Black noise: Rap music and black culture in contemporary America.* Hanover, NH: Wesleyan University Press.

Sabo, D., Kupers, T.A., and London, W. (Eds.) (2001). *Prison masculinities.* Philadelphia: Temple University Press.

Said, E. (1978). *Orientalism.* New York: Vintage Books.

Saussure, F. (1959). *Course in general linguistics.* New York: Philosophical Library.

Scharrer, E. (2001). Tough guys: The portrayal of hypermasculinity and aggression in televised police dramas. *Journal of Broadcasting and Electronic Media* 45(4), 615-634.

Scheuer, J. (1999). *The sound bite society.* New York: Four Walls Eight Windows.

Schirato, T. and Yell, S. (2000). *Communication and culture.* London: Sage.

Schwartz, J. (1989). Promoting a good public image. *Corrections Today* 51, 38-42.

Seiter, E. (1992). Semiotics, structuralism, and television. In R.C. Allen (Ed.), *Channels of discourse, reassembled* (pp. 31-66). Chapel Hill: University of North Carolina Press.

Shadoian, J. (1973). 20,000 years in Sing Sing. *Journal of Popular Film* 2(2), 165-180.

Shadoian, J. (1977). *Dreams and dead ends: The American gangster/crime film.* Cambridge, MA: MIT Press.

Shaheen, J.G. (2001). *Reel Bad Arabs: How Hollywood Vilifies a People.* Northampton, MA: Interlink.

Shanahan, J. and Morgan, M. (1999). *Television and its viewers: Cultivation theory and research.* Cambridge, U.K.: Cambridge University Press.

Shapiro, B. (2000, January 31). The ghosts of Attica. *The Nation,* p. 4.

Sheley, J. and Ashkins, C. (1981). Crime, crime news, and crime views. *Public Opinion Quarterly* 45, 492-506.

Sherizen, S. (1978). Social creation of crime news. In C. Winick (Ed.), *Deviance and mass media* (pp. 203-224). Thousand Oaks, CA: Sage.

Shoemaker, P.J. (1987). The communication of deviance. In B. Dervin (Ed.), *Progress in communication science, Vol. 8* (pp. 151-175). Norwood, NJ: Ablex.

Shoemaker, P.J., Danielian, L.H., and Brendlinger, N. (1991). Deviant acts, risky business, and U.S. interest: The newsworthiness of world events. *Journalism Quarterly* 68, 781-795.

Simons, H.W. (2001). *Persuasion in society.* Thousand Oaks, CA: Sage.

Sloop, J.M. (1996). *The cultural prison: Discourse, prisoners, and punishment.* Tuscaloosa: University of Alabama Press.

Smith, S.L., Nathanson, A.I., and Wilson, B.J. (2002). Prime-time television: Assessing violence during the most popular viewing hours. *Journal of Communication* 52(1), 84-111.

Sontag, S. (2004, May 23). Regarding the torture of others. *The New York Times Magazine,* pp. 22-30.

Stabile, C. (2001). Conspiracy or consensus? Reconsiderations on *Policing the Crisis*. *Journal of Communication Inquiry* 25(3), 258-278.

Stark, S. (1987). Perry Mason meets Sonny Crockett: The history of lawyers and the police as television heroes. *University of Miami Law Review 42*, 229-283.

Sturken, M. and Cartwright, L. (2001). *Practices of looking: An introduction to visual culture*. Oxford: Oxford University Press.

Sullivan, J. (1999, July 11). Another season in '*Oz*'. *Boston Globe*, p. N1.

Surette, R. (1989). Media trials. *Journal of Criminal Justice 17*, 293-308.

Surette, R. (1998a). Prologue: Some unpopular thoughts about popular culture. In F. Bailey and D. Hale (Eds.), *Popular culture, crime, and justice* (pp. xiv-xxiv). Belmont, CA: West/Wadsworth.

Surette, R. (1998b). *Media, crime, and criminal justice: Images and realities* (2nd edition). Belmont, CA: West/Wadsworth.

Tuchman, G. (1978). *Making news: A study in the construction of reality*. New York: Free Press.

Van den Bulck, J. and Vandebosch, H. (2003). When the viewer goes to prison: Learning fact from watching fiction. A qualitative cultivation study. *Poetics 31*, 103-116.

Volosinov, V.N. (1973). *Marxism and the philosophy of language*. New York: Seminar Press.

Vosters, H. (1999). Media lockout: Prisons and journalists. *MediaFile 18*(5), no pagination. Available at http://www.media-alliance.org/mediafile

Wasko, J. (2001). *Understanding Disney*. Cambridge, U.K.: Polity.

Watts, E.K. (1997). An exploration of spectacular consumption: Gangsta rap as cultural commodity. *Communication Studies 48*, 42-58.

Watts, E.K. and Orbe, M.P. (2003). The spectacular consumption of "true" African American culture: "Whassup" with the Budweiser guys? *Critical Studies in Media Communication 19*(1), 1-20.

West, C. (1994). *Race matters*. New York: Random House.

West, D. (2001). *Air wars: Television advertising in election campaigns, 1952-2000* (3rd edition). Washington, DC: CQ Press.

Williams, R. (1973). Base and superstructure in Marxist cultural theory. *New Left Review 82*, 3-16.

Williams, R. (1977). *Marxism and literature*. Oxford: Oxford University Press.

Wilson, C.C. and Gutierrez, F. (1995). *Race, multiculturalism, and the media*. Thousand Oaks, CA: Sage.

X and Haley (1964). *The autobiography of Malcolm X*. New York: Ballantine.

Zaner, L.O. (1989). The screen test: Has Hollywood hurt corrections' image? *Corrections Today 51*(1), 64-65, 94-98.

INDEX